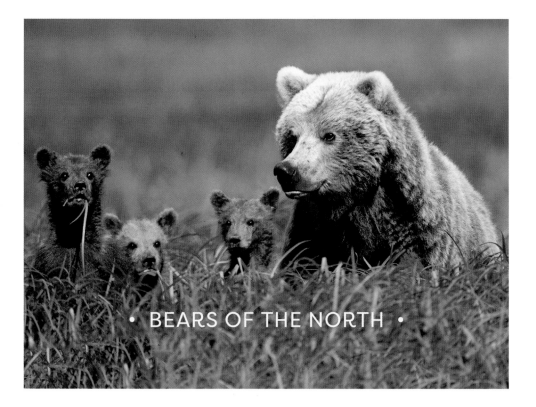

· BEARS OF THE NORTH ·

TEXT AND PHOTOGRAPHS BY
Wayne Lynch

BEARS

· OF THE NORTH ·

A Year Inside Their Worlds

JOHNS HOPKINS UNIVERSITY PRESS BALTIMORE

▶ Play, in all species of bears, reinforces social bonds • PAGE i: Four-month-old cubs will eat sedges, but milk is still their principal food until late summer • PAGES ii–iii: Off the eastern coast of Baffin Island, Nunavut, most nonpregnant polar bears continue to hunt during the many months of polar night

© 2021 Johns Hopkins University Press
All rights reserved. Published 2021
Printed in China on acid-free paper
9 8 7 6 5 4 3 2 1

Johns Hopkins University Press
2715 North Charles Street
Baltimore, Maryland 21218-4363
www.press.jhu.edu

Library of Congress Cataloging-in-Publication Data

Names: Lynch, Wayne, author.
Title: Bears of the north : a year inside their worlds / Wayne Lynch.
Description: Baltimore : Johns Hopkins University Press, 2021. | Includes bibliographical references and index.
Identifiers: LCCN 2020006004 | ISBN 9781421439419 (hardcover) | ISBN 9781421439426 (ebook)
Subjects: LCSH: Bears.
Classification: LCC QL737.C27 L96 2021 | DDC 599.78—dc23
LC record available at https://lccn.loc.gov/2020006004

A catalog record for this book is available from the British Library.

Special discounts are available for bulk purchases of this book. For more information, please contact Special Sales at specialsales@jh.edu.

Johns Hopkins University Press uses environmentally friendly book materials, including recycled text paper that is composed of at least 30 percent post-consumer waste, whenever possible.

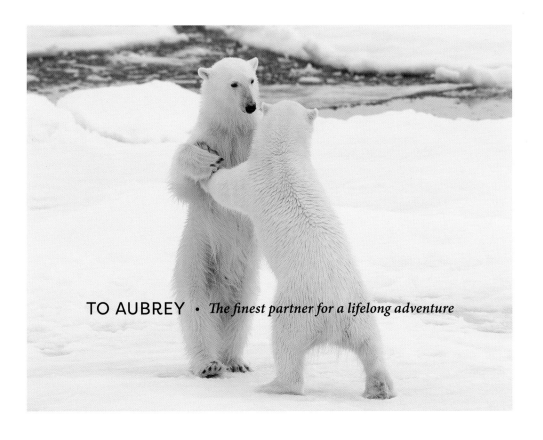

TO AUBREY • *The finest partner for a lifelong adventure*

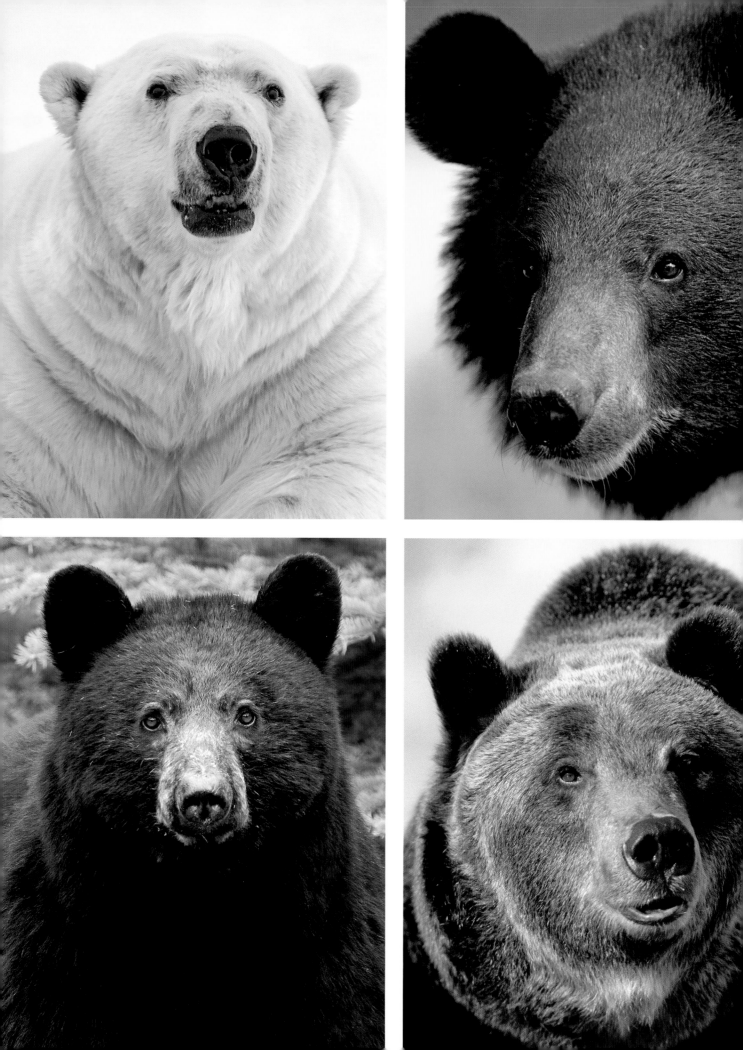

• CONTENTS •

◄ The four northern bears (clockwise from top left): polar bear, Asiatic black bear, American black bear, and brown bear

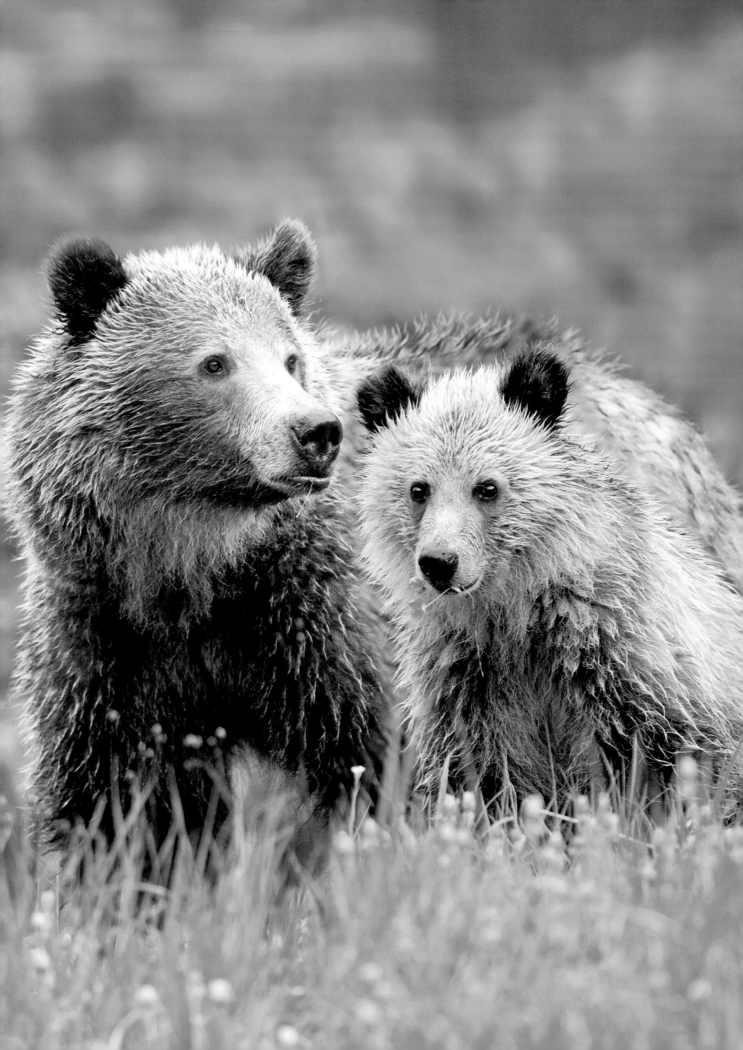

WHEN I WAS A BOY, bears were the demons in my nightmares. During the day, they lurked in the dark recesses of my imagination, and at night they skulked from the shadows to stalk and chase me. I stopped having those frightening dreams 60 years ago, but I have never stopped thinking about bears.

In September 1982, I was putting the finishing touches to a book on the ecology of the prairie grasslands, entitled *Married to the Wind,* and I wondered which book project I should tackle next. The prairie book had taken five years to research and write, and I wanted my next one to take less time to complete for the simple practical reason that I needed to make a living.

I got the idea to write about bears when I read Paul Schullery's fine book *The Bears of Yellowstone.* I thought, "Why not write about the bears of the Northern Hemisphere?" Since there are only four species of northern bears, surely there couldn't be more than a few hundred key references to read, and maybe I could finish the book in three years. I called my wife, Aubrey, to tell her how excited I was about my new plan. I recall her response: "Don't you know that bears are dangerous and difficult, if not impossible, to photograph? A book on bears is a crazy idea." I knew she was right, as she so often is, but something in her logic made the challenge even more appealing. Aside from my naïveté about the amount of technical material I would need to review, I didn't count on the seductiveness of the animals themselves, or how forgiving they can be to a well-intentioned photographer. Once I was immersed in the project, I became obsessed with these remarkable animals.

The book, *Bears: Monarchs of the Northern Wilderness,* would take nine years to complete. I would review thousands of technical papers and attend dozens of scientific meetings. During those years, I would take more than 30,000 photographs, travel over 140,000 miles (225,000 km) visiting many of the major bear habitats in North America, and spend hundreds of hours observing bears in the wild. And when it was over, I would lie in bed and wish I could start again. I had become a bear junkie.

Fast forward to 2020. In the intervening decades, I moved on to writing books about penguins, the Arctic and boreal forest ecosystems, and the biology of prairie birds, as well as more than 40 books for children and young adults on nature topics ranging from the biology of poop (my bestselling book of all time) to the lives of koalas, three-toed sloths, and leatherback sea turtles. For Johns Hopkins University Press, I was privileged to do books on the owls of Canada and the United States, the Florida manatee, and most recently, American alligators. Maybe it was time to return to bears? Aside from several bear books for children, I hadn't written another adult book about these charismatic carnivores since the 1990s, although I had

◀ A yearling cub still relies on its mother to sense the danger potential in every circumstance

continued to read the scientific literature on bears and photograph and observe them in even more locations than I had before: Norway's remote and glacier-sculpted Svalbard Archipelago, Russia's legendary Wrangel Island, the temperate rain forests and ancient red cedars of coastal British Columbia, the addictive hinterlands of Canada's Arctic tundra, the mountains of central Japan, the cypress swamps of the Louisiana bayou, and the impenetrable oak woodlands of New Mexico and Arizona. I can't imagine a time in my life when I will not be fascinated by bears and the wildlands they inhabit.

For thousands of years, bears have captivated the human imagination, and stories about them have become woven into a rich fabric of myths, legends, and anecdotes, often embellished and modified around campfires, where entertainment ranks above accuracy. My intention in this book is to dispel the stereotypes and untruths but none of the magic that surrounds these magnificent carnivores. In the decades since writing my first book on bears, scientific methods have forged ahead, and researchers now have many more tools with which to delve into the secret lives of these elusive mammals. Satellite telemetry can unveil the purposeful meanderings of bears, the great distances they sometimes cover, and even the meticulous details of their minute-by-minute movements. Who would have thought that a polar bear might walk hundreds of miles in a month or a black bear move scarcely a dozen? The analysis of DNA taken non-invasively from hair samples can reveal the relatedness of bears within a population, the sexual partners of resident males and females, and even the identity of a cub's father. Did anyone predict that a female bear might mate with multiple partners just to confuse the paternity of her cubs and protect them from being killed? It's CSI (crime scene investigation) for bear biologists. Then there is the study of stable isotopes—chemical markers found in blood, hair, and bone—and the analysis of fatty tissue, which collectively can reveal surprising dietary details. Bears, like humans, are what they eat, but what they eat can vary tremendously, and the consequences are sometimes startling. Imagine, bears—and their appetite for Pacific salmon—can fertilize towering coastal forests and all that live in them. No one saw that one coming.

Although I hope biologists and bear researchers will find value in this book, I have written it for those who live in bear country and want a better understanding of the bears with which they live, and for those who visit bear country and are eager to interpret their wilderness experience. This book is also for those who may never see a bear but who nonetheless want these animals to survive because they fuel the human spirit.

Worldwide there are eight species of bears. Four of them live primarily in the planet's temperate and polar latitudes: the abundant American black bear, the enigmatic Asiatic black bear, the highly adaptable brown bear, and the poster-child polar bear, a bellwether of climate change. The remaining four live in generally more tropical climes: the termite-slurping sloth bear, the honey-hungry sun bear, the Andean bear—the last in a legacy of giants—and the bamboo-dependent giant panda.

This is a book about the four northern species. It seems natural to discuss them together for a number of reasons. First, the northern bears have been studied longer, and in much greater detail, than their tropical counterparts and there is a wealth of new information that makes a comparative discussion revealing and entertaining to discover.

A second reason to group the northern bears together is that they are closely related to each other and share a common scientific group, the genus *Ursus.* The tropical bears are a more diversely related group since four distinct genera are represented.

A third link among the northern bears is that they share similar northern environments, and their ranges often overlap.

Finally, only the northern bears hibernate; this fascinating metabolic adaptation to winter is not seen in any of the tropical bears.

Scientists are just beginning to unravel the life details of the four species of tropical bears, with the possible exception of the giant panda, which has been studied quite intensively in the last 40 years. Appendix A contains a brief summary of our current knowledge of the four tropical species.

In *Bears of the North,* you will accompany me on a journey that I never planned. As we delve into the lives of the northern bears, you will discover surprising similarities with our own lives. Bears can be tender and gentle, frightened and angered, idle or busy. I hope that after reading this book you will understand what it means to be a bear, and you will never look at these animals in the same way again. I also hope the book will influence how you view every other creature with which we share this planet.

▶ An American black bear in a balsam poplar tree

· BEARS OF THE NORTH ·

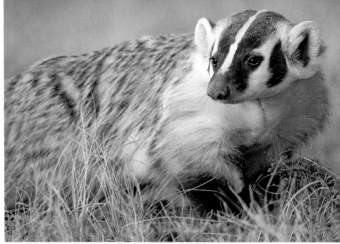
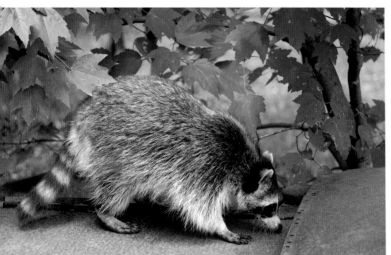

• INTRODUCTION •

THE CARNIVORES

BEARS BELONG TO THE carnivore group of mammals, and carnivores have always fascinated humankind. When we think of them, we think of large, powerful predators equipped with deadly canine teeth and long, sharp claws. We imagine them to have senses far superior to our own, hunting with stealth, speed, and coordination, and dispatching their victims with surgical precision. These attributes, whether real or imagined, have always filled humans with awe and envy. Because of this, we have often used the images of carnivores to adorn our flags, emblems, and armor. Still today, for many, killing a large carnivore is an implied act of bravery and prowess, even when the animal is baited and outranked by sophisticated modern weaponry.

Today, out of a total of 6,399 mammalian species, only 285 belong to the order Carnivora. They vary dramatically in size from the 1.75-ounce (50-g) least weasel, which is small enough to squeeze through a wedding ring, to the colossal male southern elephant seal, which can weigh more than 10,000 pounds (4,536 kg)—roughly 90,000 times the weight of the diminutive weasel.

A carnivore is not simply a mammal that eats meat. Protein is a vital dietary nutrient for all mammals, and many of those mammals that are not officially classified as carnivores include meat in their diet if an opportunity arises. For example, red squirrels

◀ The Suborder Caniformia comprises nine distinct families. Besides bears, which belong to the Ursidae, the suborder includes (from left to right, top to bottom) the red fox in the Canidae, the American badger in the Mustelidae, the North American raccoon in the Procyonidae, the red panda in the Ailuridae, the Steller's sea lion in the Otariidae, the striped skunk in the Mephitidae, the bearded seal in the Phocidae, and the walrus in the Odobenidae.

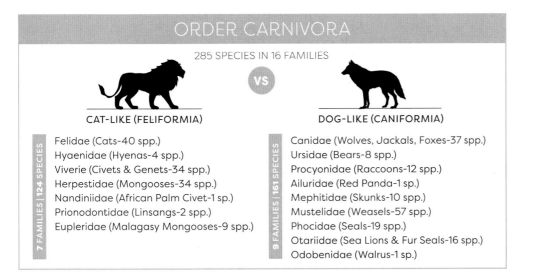

ORDER CARNIVORA

285 SPECIES IN 16 FAMILIES

VS

CAT-LIKE (FELIFORMIA)

7 FAMILIES | 124 SPECIES

Felidae (Cats-40 spp.)
Hyaenidae (Hyenas-4 spp.)
Viverie (Civets & Genets-34 spp.)
Herpestidae (Mongooses-34 spp.)
Nandiniidae (African Palm Civet-1 sp.)
Prionodontidae (Linsangs-2 spp.)
Eupleridae (Malagasy Mongooses-9 spp.)

DOG-LIKE (CANIFORMIA)

9 FAMILIES | 161 SPECIES

Canidae (Wolves, Jackals, Foxes-37 spp.)
Ursidae (Bears-8 spp.)
Procyonidae (Raccoons-12 spp.)
Ailuridae (Red Panda-1 sp.)
Mephitidae (Skunks-10 spp.)
Mustelidae (Weasels-57 spp.)
Phocidae (Seals-19 spp.)
Otariidae (Sea Lions & Fur Seals-16 spp.)
Odobenidae (Walrus-1 sp.)

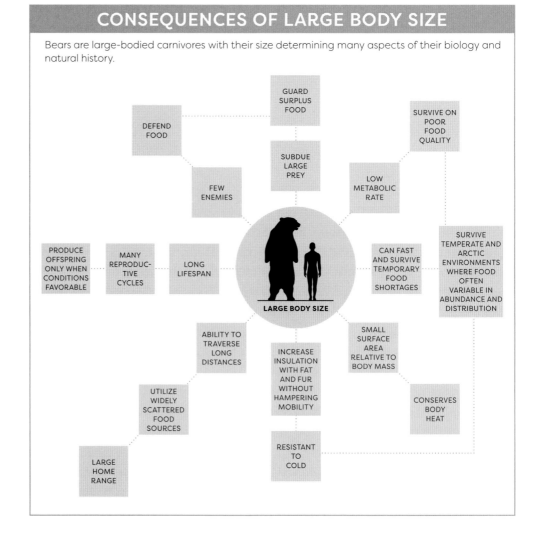

CONSEQUENCES OF LARGE BODY SIZE

Bears are large-bodied carnivores with their size determining many aspects of their biology and natural history.

hunt and kill baby snowshoe hares, Franklin's ground squirrels eat nestling ducks and songbirds, Arctic hares scavenge from the carcasses of winter-killed muskoxen, and caribou sometimes eat lemmings. In my numerous safaris to Africa, I have seen many unexpected examples of animals with a taste for meat: a common warthog killing and eating a venomous puff adder, an olive baboon stealing a Thomson's gazelle kill from a cheetah, and a common hippopotamus scavenging the floating corpse of a drowned wildebeest. Today, all of the mammals classified as carnivores in the order Carnivora arose from a common ancestor, the miacids, roughly 60 million years ago. When I wrote my first book on bears, three decades ago, taxonomists—the scientists in the business of naming and classifying organisms—divided carnivores into seven families. DNA analysis changed all of that. Currently, the order Carnivora comprises 16 families, split between two subgroups: the cat-like group, suborder Feliformia, with seven families, and the dog-like group, suborder Caniformia, with nine families. Bears are one of the nine families in the suborder Caniformia.

THE BEAR FAMILY: FAMILY URSIDAE

Bears are large, heavy-bodied carnivores with thick, powerful limbs, which evolved for strength, not speed. They are the largest of the terrestrial carnivores, and in the order Carnivora, only the ocean-foraging walrus and a few of the seals and sea lions are heavier. The African lion, often touted as the King of Beasts, is no match for most adult brown bears or polar bears. In the arenas of ancient Rome, where lions were sometimes pitted against brown bears, the burly bruins invariably killed the lions.

A large body size confers many benefits to bears. They have a relatively low metabolic rate, which enables them to fast and survive temporary food shortages and to subsist on a poor-quality diet, which in turn, allows them to inhabit temperate and polar habitats where food is often variable in quality, abundance, and distribution. By being large, they can more easily cover great distances and forage widely. Because of their size and strength, bears can subdue large prey if necessary and defend their kill from rivals. When needed, an animal with a large body is also able to insulate itself with thick fur or fat without markedly hampering its mobility, thus increasing its tolerance to the seasonally cold climate of high latitudes. And finally, large animals have longer lifespans so they experience multiple breeding cycles and can wait to produce offspring when conditions are favorable.

Besides their large body size, bears have other defining characteristics. They walk on the soles of their feet, as humans do, not on their toes, as most other carnivores do. A bear's feet are flat and broad, and they are armed with five heavy, curved, nonretractile claws. When a bear walks, its front feet turn inward. This rotational mobility enables bears to climb and dig better.

All bears have large heads with small eyes and small rounded ears. Their coats are usually long with very few markings, although half the species can have a white or cream-colored chest patch, and the giant panda, of course, has very distinctive markings. The shaggy coat of many bears hides their very short tail, which is rarely over 4.5 inches (12 cm) long.

Except for the polar bear, bears are predominantly plant eaters, although all of them will hunt and scavenge meat if an opportunity arises.

Taxonomy, the Naming Business

Most well-known animals have a common name as well as a scientific name, but common names vary greatly from region to region, and from one language to another, which can lead to misunderstanding. For example, the "koala bear" of Australia is not a bear at all but a pouch-possessing marsupial, and the bearcat of Southeast Asia is not closely related to either bears or cats, but rather it is related to civets and genets in the family Viverridae. The honey bear of South America's tropical rain forests, also known as the kinkajou, is actually in the raccoon family, and the ant bear (which is the Spanish name for the giant anteater) would never be mistaken for a bear, despite its confusing common name. Thus, the need for scientific names.

An animal's scientific name not only identifies it to scientists of all nationalities and languages, but it also identifies an animal's relatedness to other similar animals. Consider three different species of bears: the brown bear, the polar bear, and the Andean bear. The scientific name for the brown bear is *Ursus arctos*, for the polar bear it is *Ursus maritimus*, and for the Andean bear it is *Tremarctos ornatus*. The fact that the brown bear and the polar bear share the same genus, *Ursus*, shows that they are more closely related to each other than either is to the Andean bear, which belongs to a different genus, *Tremarctos*.

Early in the business of taxonomy, bears, and all other mammals, were assigned

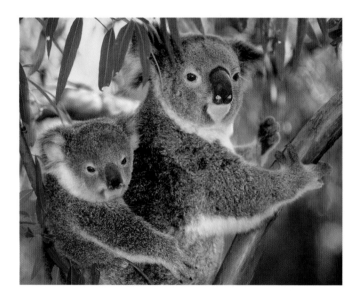

their scientific names based primarily upon characteristics of their skeletons, as well as certain behavioral traits that they shared with presumably closely related species. What early taxonomists failed to recognize was that the behavior *and* the skeleton of an animal species may vary tremendously, depending on where the animal lives. Thus, taxonomists often assigned a new scientific name to a member of a known species when it came from a different geographical location. The presence of minor differences made taxonomists assume they were dealing with a new species, when in fact it was just a local variant of a single wide-ranging species.

In 1918, C. H. Merriam identified 86 different kinds of grizzlies and brown bears in North America alone. We now recognize only *one* species of brown bear, which ranges from the Cantabrian Mountains of Spain across eastern Europe and the breadth of Russia into Alaska and down through western Canada into the northern United States. Today, in different parts of North America, for example, the brown bear is called the coastal brown bear, the Alaskan brown bear, the Kodiak bear, or the grizzly bear, but whichever common name you assign to the animal, there is still only one species of brown bear in the world—*Ursus arctos*.

The methods used in taxonomy today are much more sophisticated than they were in the days of Merriam. Scientists now use molecular techniques to compare DNA to determine the relatedness between species. Currently, taxonomists recognize eight species of bears. Four are the northern bears that are the focus of this book: the polar bear, brown bear, American black bear, and Asiatic black bear. The remaining four, which I discuss in Appendix A, I arbitrarily group together as the "tropical bears": the sun bear, sloth bear, Andean bear, and giant panda.

Bear Beginnings
Just for fun, I want to review the history of life on planet Earth and pinpoint when bears eventually entered the scene. The story begins with the "Big Bang," the term

A young koala stays with its mother until it is a year old, nursing for roughly half that time. Before it can digest the aromatic eucalyptus leaves that will be the mainstay of its diet, it must first acquire the necessary intestinal bacteria by eating its mother's droppings, something that baby giant pandas must also do. The koala, sometimes referred to as the koala bear, is not a bear at all but an Australian marsupial.

commonly used by astrophysicists to describe the birth of the universe, roughly 13.8 billion years ago. This is the farthest back that scientists can "see." American astrophysicist Neil deGrasse Tyson suggests the story is easier to appreciate if we compress this vast span of time into a single calendar year. Each month of our imaginary year represents around a billion years, each day spans 40 million years, every hour, 1.66 million years, and every minute, 28,000 years.

Everything gets started with the Big Bang on January 1. The Milky Way galaxy, in which we humans live, eventually coalesces from star dust sometime around March 15, but it takes more than five months, or 5.5 billion years, for our planet to finally form on August 31—4.5 billion years ago. Roughly a month after that, on September 21, the very first life appears on Earth—blue-green algae; this starts the so-called slime world, which dominates the planet for at least another billion years. Eventually, by early November, multicellular creatures are eating, breathing, and having sex. They are thriving. However, not until a billion years later, in mid-December, do the first animals with a backbone finally drag themselves out of the ocean and crawl onto land. After that, squeezed into the last half of December, we have the arrival and entire evolution of every reptile, bird, and mammal that has ever lived.

The earliest mammals—small, scarce, nocturnal, and mouse-size—appear around December 25, roughly 220 million years ago. For the next 150 million years, or roughly four days of our fictional calendar, these ancestral, fur-clad runabouts scuttle in the underbrush alongside the dinosaur tribe, the smallest of which was many times larger than the largest mammal. Ultimately, the mammals did not escape from under the looming dominance of the dinosaurs until around noon on December 30—a mere day and half before the end of our imaginary year. That day, 66 million years ago, a small asteroid, estimated to be just 6 to 10 miles (10–16 km) in diameter, hurtled across the sky and exploded on the present-day Yucatan Peninsula of Mexico, blanketing the entire planet in a shroud of deadly dust, and plunging it into darkness. Globally, photosynthesis stalled, food chains collapsed on land and at sea, and 75% of all species became extinct. In the words of Aristotle, *Nature abhors a vacuum*. Fate now favored the mammals. It was time for them to step out of the shadows, grow larger, flourish, and diversify.

During the next 400,000 years—a mere 14 minutes of our fictionalized timeline— the ancestors of all placental mammals evolved. This was the "Big Bang" moment of mammalian diversification. The first bear-like ancestor appears around 40 million years after the asteroid impact, roughly 22 million years ago. Taxonomists call this ursine forerunner *Ursavus elmensis*, the dawn bear. It was a carnivore about the size of a fox terrier. Around 18 to 20 million years ago, the first of today's existing subfamilies in the family Ursidae, the Ailuropodinae, branched off from the main line of bear evolution. Ultimately, this initial branching led to the modern giant panda, which today clings precariously to survival in the bamboo forests of China. Between 12 and 15 million years ago, a second lineage of bears branched off. These were the so-called short-faced bears, in the subfamily Tremarctinae, the only surviving member of which is the Andean bear of South America. Multiple species of tremarctine bears once roamed the hinterlands of North and South America. They ranged in size from relatively small bears, weighing 330

pounds (150 kg), to the largest bear that has ever lived. *Arctotherium angustidens* tipped the scales at up to 2,650 pounds (1,200 kg). I discuss the subfamily Tremarctinae in more detail when I review the biology of the Andean bear in Appendix A.

The six other species of bears living today all belong to the subfamily Ursinae. All of these bears share a common ancestor, thought to be *Ursus minimus,* which began to break into independent lines of evolution roughly 3 to 4 million years ago. At the time, the world's climate was becoming drier, grasslands and savannahs were expanding, and hoofed mammals were becoming more abundant, diversified, and larger. In response, there was an explosion in the diversity of predators, and following that, numerous species of bears evolved, many of which eventually went extinct.

Today, we are living in an interglacial period that began roughly 12,000 years ago. It is the latest warm period in an ice age that began 2.6 million years ago. This ice age, called the Quaternary glaciation, can best be described as a successive series of episodes in which glaciers grew and covered great areas of the continents, then melted and retreated. Geologists call these sequential episodes "glacial" and "interglacial" periods, respectively. This was the background against which the Ursinae evolved. Populations repeatedly shrank and became isolated, then multiplied and expanded. Recent DNA analysis has shown that the different bear species frequently interbred, and that genes flowed extensively between them. As a result, hybrids came and went, sometimes adding genetic vigor to the survivors as the environments around them continually evolved and changed. The end result is that sun bears living in the tropics of Borneo today carry some of the same genes as polar bears living in the Canadian High Arctic. Referring back to our imaginary calendar year, all of these bear happenings were occurring in roughly the last 90 minutes before midnight on December 31. I discuss more of the recent evolution of bears in Chapter 3 when I review the origins of the polar bear.

Since humans are a self-interested species, it's informative for us to see where we fit into my fictional calendar year of evolution. *Homo sapiens* first appeared in Africa roughly 200,000 years ago. That means we arrived on the scene just seven minutes before midnight in the final moments of the calendar year. All of recorded human history happened in the last 14 seconds of the year. Humans didn't even begin to scientifically explore the planet until the very last second! As a sage once said of us, *So young, with so much to learn.*

The next section offers a brief overview of the four species of northern bears.

◄ The Andean bear is the only surviving member of the subfamily Tremarctinae, which branched off from the main bear lineage 12 to 15 million years ago

THE POLAR BEAR

The magnificent polar bear is arguably the largest of all of the bears, although some coastal brown bears can reach the size of the largest polar bears. Adult male polar bears weigh between 600 and 1,760 pounds (270 and 800 kg). Standing on all fours, a large male may be 5 feet (1.5 m) tall at the shoulder and stretch 8.5 feet (2.6 m) from the tip of its nose to the end of its tail. If a huge male polar bear were to rear up on its hind legs immediately in front of you, the animal's massive size and 11-foot (3.4-m) height would instantly concentrate your thoughts on the afterlife. Female polar bears range between

• BEARS ON VACATION •

POLAR BEARS TEND TO CONCENTRATE on the sea ice overlying the Arctic continental shelves, where the relatively shallow water depths—frequently less than 800 feet (250 m) deep—attract the greatest number of seals on which the bears depend. Even so, polar bears sometimes end up far beyond these productive coastal waters, carried away by shifting ice or inspired by purposeful wandering in search of food.

In September 1999, two vacationing fishermen from Oklahoma were shocked when a subadult polar bear swam out to their boat on a remote lake in northeastern Saskatchewan, 280 miles (450 km) inland from Hudson Bay. Surprisingly, the bear was not frightened away by the noise from the men's outboard motor and swam to within 60 feet (18 m) of them. When the concerned fishermen moved to another location 0.6 miles (1 km) away, the bear continued to follow them. After the men fled a second time, the persistent paddler disappeared and was never seen again. This was the first confirmed sighting of a polar bear in Saskatchewan.

In 2001, a record of a different kind was set. I'm often asked whether polar bears live at the North Pole. At that location, the water depth is 13,980 feet (4,261 m) deep and the surface is typically covered by pack ice 6.5 to 10 feet (2-3 m) thick.

Here, seals are scarce and hunting conditions for a hungry bear are bleak. Nonetheless, on August 5 of that fateful year, my good friend Rinie Van Meurs, while traveling aboard a Russian icebreaker, sighted an adult polar bear walking on the sea ice at 89°45˝ North, a mere 15.5 miles (25 km) from the North Pole. It was the most northern polar bear sighting ever reported.

Unusual sightings of bears on vacation still continue today. Residents on the northern tip of Newfoundland, Canada's easternmost province, are accustomed to seeing polar bears along their shores every summer when unsuspecting bears are ferried south by the Labrador Current on rafts of disintegrating pack ice. In 2019, one bear made an especially big splash in the tiny community of St. Lunaire-Griquet. Each year the local residents host an Iceberg Festival, and the closing event of the weekend is a polar bear dip in the icy offshore waters. In June that year one of the participants was a furry swimmer with exceptional polar credentials. During the festivities, a polar bear suddenly appeared and swam ashore, peeked into a shed, paddled around the harbor for a while, then climbed around some old beached boats before peacefully lumbering away.

Mother and yearling cubs attempting to hide in an autumn forest of golden tamaracks many miles inland from the coast of Hudson Bay

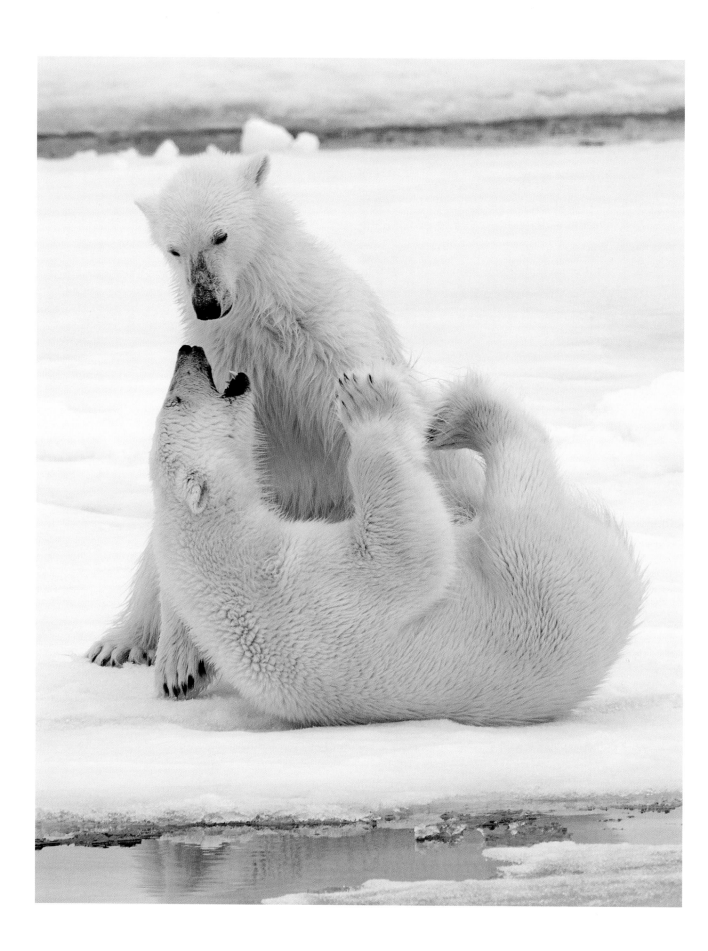

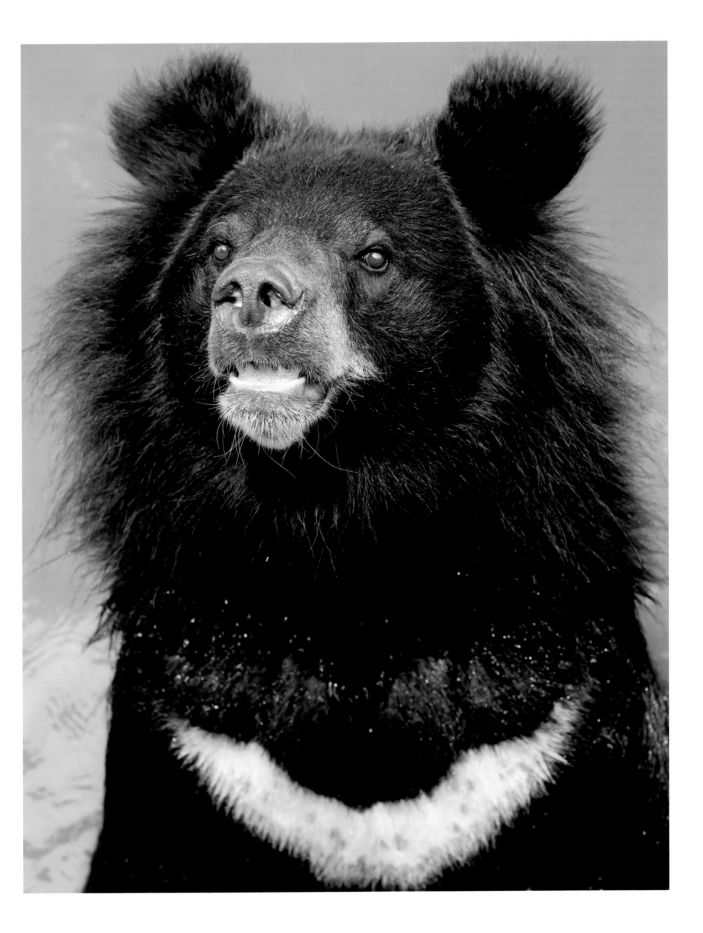

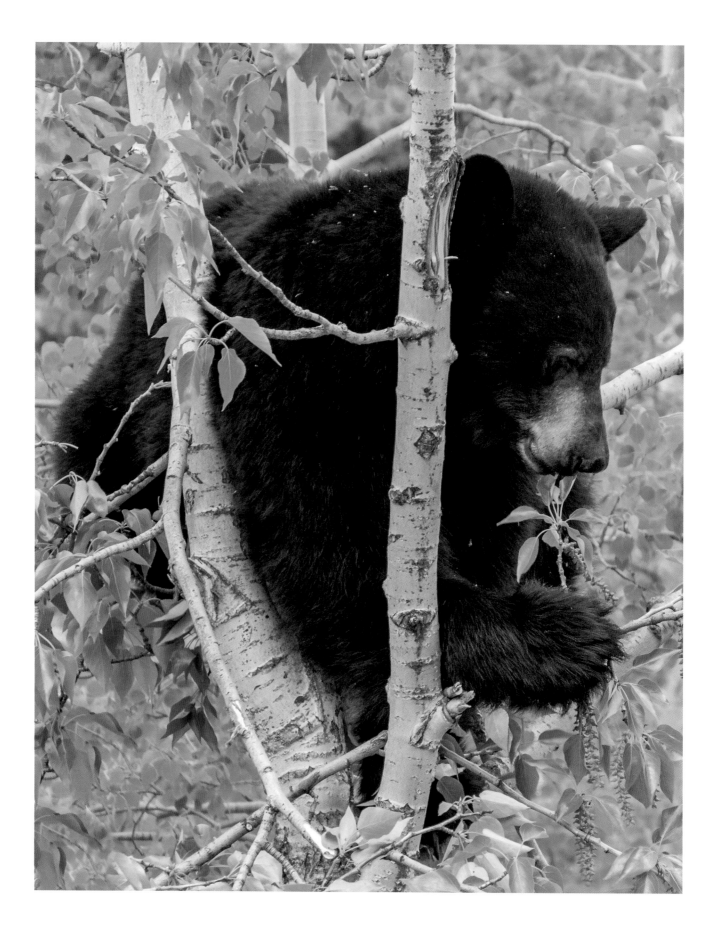

THE AMERICAN BLACK BEAR

The American black bear, *Ursus americanus*, vastly outnumbers all of the other bears combined, with a total population estimated between 850,000 and 950,000. Since the late 1980s, the number of American black bears has been slowly increasing. In the northeastern United States, abandoned farms, formerly cleared by early settlers, have begun to revert to forests, creating ideal habitat for black bears. Another contributing factor is the change in the animal's status from vermin to valued big-game animal. This change has led to better management of bear populations everywhere. Furthermore, the widespread use of poisons has been banned from most public lands, and as a consequence, fewer bears are now indiscriminately killed.

The black bear's adaptability and ability to co-exist with humans are likely two big reasons for its success. American black bears can, and do, live in association with people if they are given the chance. A good example of this is seen in a housing development in northeastern Pennsylvania. There are over 2,000 homes in this forested housing development, called Hemlock Farms, covering an area of less than 8 square miles (21 sq. km.). In reference to Hemlock Farms, former Pennsylvania Game Commission bear biologist Gary Alt said, *If you showed this area to most bear experts in the world, they would likely say that it's impossible for any bear to exist in a place like this.* He told me that, at times, more than 20 black bears had lived in this housing development. *In fact, one female bear raised 29 cubs in 10 years, a world's record, without losing a single cub.* Alt concluded, *It isn't the bears that lack the ability to adapt, it's the people. And the problem is, it isn't what the bears* do *that frightens people so much as what the people* think *they might do.*

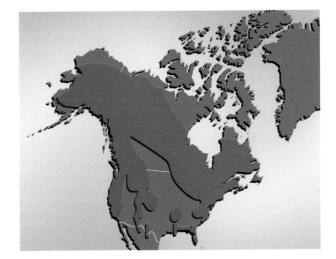

The American black bear population is larger than the populations of the seven other bear species combined, and it is the only one that is increasing

The adaptable American black bear is found throughout the forested regions of North America. As shown in the accompanying distribution map, the bear is found in six states in northern Mexico, all of Canada's provinces and territories except Prince Edward Island (where the last black bear was shot in 1927), and in 41 of the 50 US states. American black bears thrive in perhaps a greater variety of habitats than any other bear. They live in the temperate rain forests of the Pacific coast, in the boreal forest that stretches across the breadth of the continent from Alaska to Newfoundland, and beyond the tree line in the Ungava Peninsula of northern Quebec. They are even found out on the sea ice along the coast of Labrador, an area that seems more suited to polar bears than black bears. The versatile American black bear also flourishes in the Rocky Mountains, in the desert scrub of Arizona, in the hardwood forests of the eastern states, in the cypress swamps of Georgia, Louisiana, and Florida, and in the gigantic redwood forests of California.

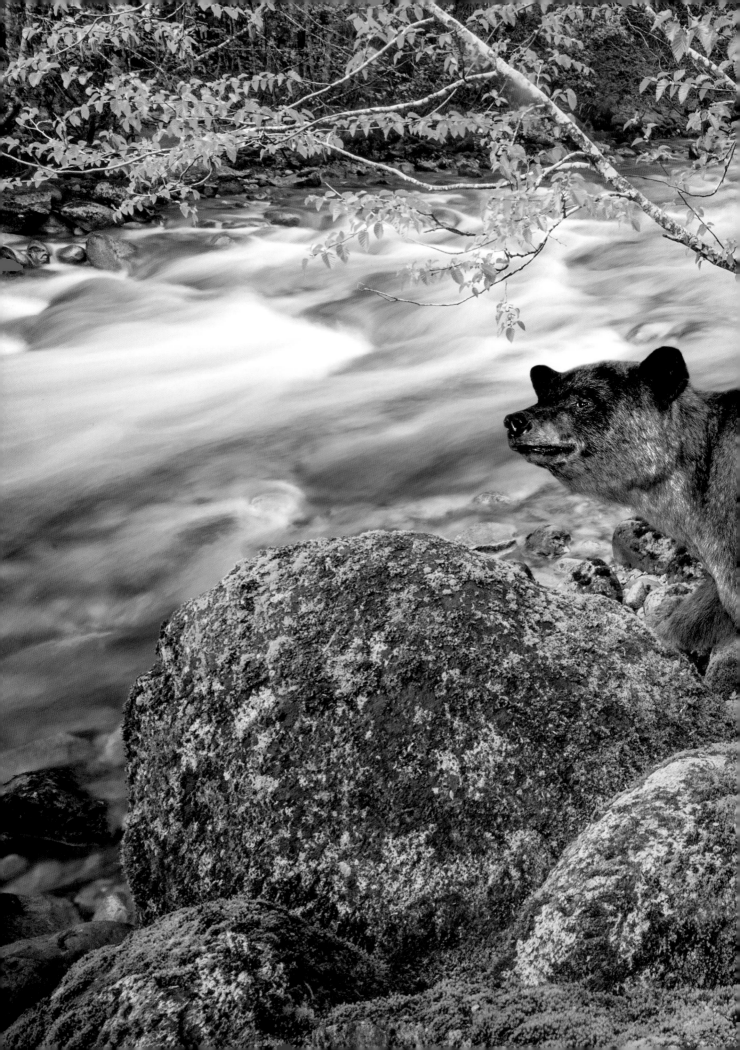

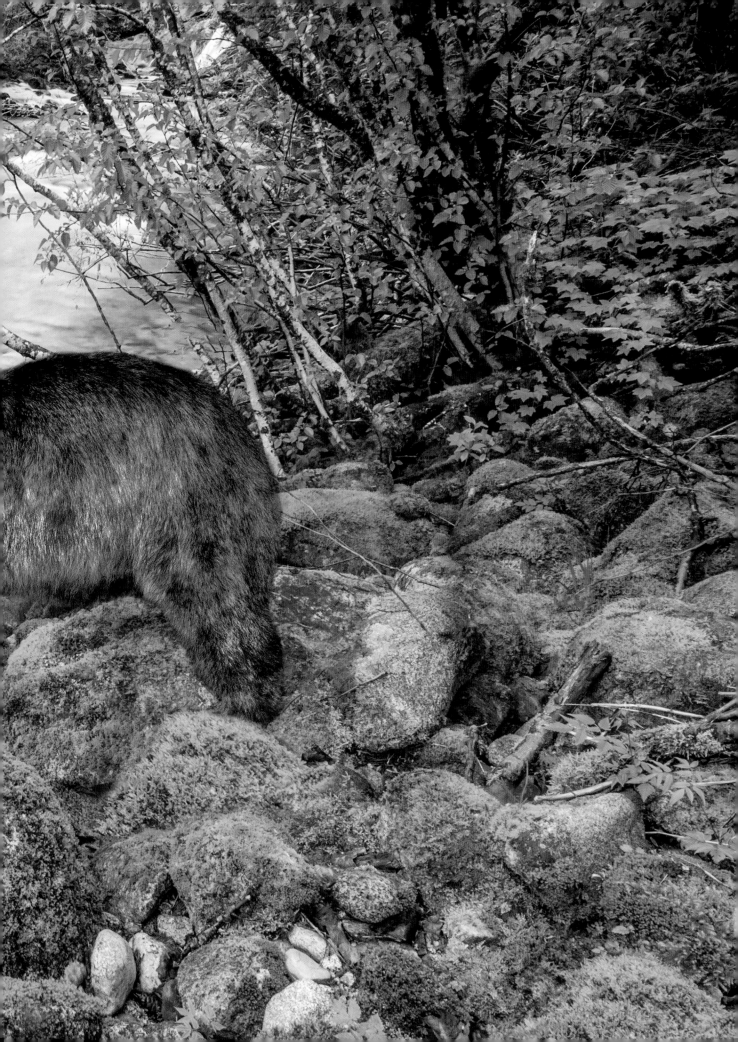

◀ The ancestral Tlingit
people of southeastern
Alaska called the glacier
bear the "snow-like" bear
and believed it resulted
from an ancient union
between a common
black bear and a moun-
tain goat

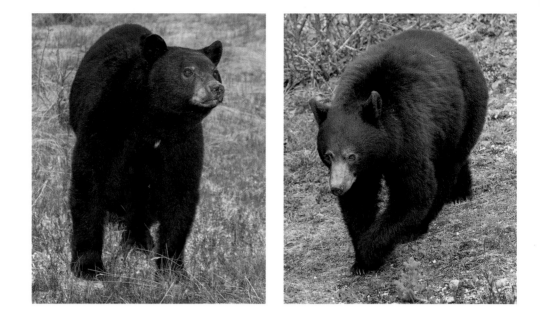

The American black bear's diet varies from one region to another, and over time, the different diets have helped produce bears of different sizes. Average weights range from 90 to 150 pounds (41–68 kg) for adult females and from 130 to 300 pounds (59–136 kg) for adult males. The dimensions of American black bears are similar to those of the Asiatic black bear.

Despite these average weight values, male American black bears weighing over 600 pounds (272 kg) have been reported from many areas of eastern North America, and there is even a report of an 802-pound (364-kg) male bear from Riding Mountain National Park in southern Manitoba. A black bear of that size is larger than most interior brown bears in North America.

American black bears, unlike most of their Asiatic counterparts, are not always black, and the bears regularly occur in a number of different color variations. Many carnivores, especially some canids, occur in a range of colors. Gray wolves may be gray, black, or white. The Arctic fox, in its winter coat, may be either all white or a dull slate gray, and the red fox, especially those animals that live in cold regions, can be red, black (the "silver" fox), or a beautiful gray and red combination referred to as a "cross" fox. The American black bear, however, shows the greatest color variation of any of the carnivores.

Nearly all of the black bears in Alaska, northern Canada, and the eastern third of the continent from Newfoundland to Florida are black. Like all American black bears, the muzzle on these animals is often tan or brown, and some of them have a small white or cream-colored chest blaze. As you move west, the bears occur in a variety of shades of brown, including cinnamon, honey, light brown, and dark chocolate. In Minnesota, 6% of the black bears are brown; in central British Columbia, 40% are brown; in Idaho, 63% are brown; and in New Mexico, 75% of the bears are blond, cinnamon, dark chocolate, or liver-colored. In some areas of Arizona, more than 95% of the black bears are shades of brown. Researchers in Utah found that 28% of bears in their state were black,

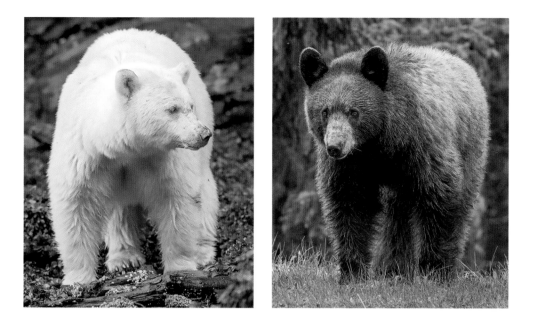

The American black bear has the greatest range of fur colors of any carnivore. An individual's color persists throughout its life, although it often bleaches during the summer months.

43% were brown, 17% were cinnamon, and 12% were blond. In New Mexico, the hue of the brown-colored individuals varied due to bleaching and shedding, and it differed depending upon the season. Many bears with light-colored coats during spring and summer were observed with dark brown coats in fall or winter.

In general, brown-colored black bears are more common in open areas. Black livestock are known to absorb greater quantities of solar energy and are more likely to suffer from heat stress than lighter-colored livestock. The same may apply to bears, and the light brown coats of many animals in the warm areas of the American Southwest may be a strategy to reduce heat stress.

In the Pinaleño Mountains of Arizona, biologists found that there was a tendency for the darker bears to be found on the cooler, wetter northern side of the mountains. Most of the paler brown-colored bears, and all the blond bears, were found on the drier, warmer southern slopes.

The two rarest coat colors of the black bear are the white spirit bear and blue glacial bear. The spirit bear is definitely white-colored, and I discuss this in detail in the accompanying box. The color of the glacial bear, on the other hand, is not what I would describe as blue but rather gray. This unusual color variation is only found in a small area of northwestern British Columbia and southeastern Alaska. Most of the black bears in this heavily forested coastal region are actually black, and the blue color phase is exceedingly rare.

In the following chapters I discuss the four northern bear species simultaneously, following them through the months of the year. You will discover how each bear is adapted to its own environment and how the environment, in turn, has influenced the individual species' behavior. You will also learn what each species of bear is doing at different times of the year, and the differences and similarities that exist between them.

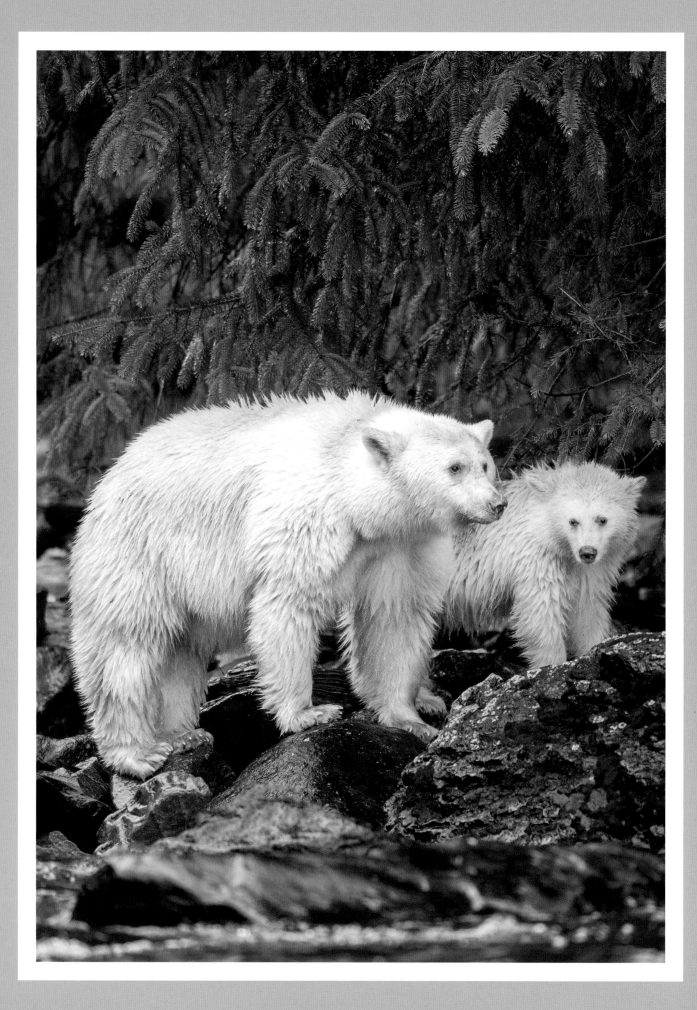

• SPIRIT BEARS •
OF THE RAIN FOREST

FOR ME, THE MOST BEAUTIFUL color phase of black bear is the rare spirit bear, officially known as Ursus americanus kermodei. It was named in 1904 by William Hornaday in honor of Francis Kermode, the director of the Royal British Columbia Museum who had issued him the permit to collect a specimen for the New York Zoological Park, known today as the Bronx Zoo.

The white spirit bear is not an albino black bear. It has dark brown eyes and a blackish nose as do all black bears, but its claws are ivory-colored instead of the usual black.

Ninety-seven percent of white spirit bears occur on just four nearshore islands along the central coast of British Columbia, in the heart of the province's vulnerable temperate rain forests. The most northern of these islands is Gribbell Island where researchers estimate that 43% of the small population of 100 to 150 black bears are white. Princess Royal Island, the largest of the four islands, has the largest population of black bears, 900 to 1,250, and 17% of these are thought to be white. The two most southern islands, Roderick and Pooley, each has 200 to 260 black bears, of which just 10% are white. Thus, the total number of white bears is precariously low, and ranges from 200 to 328.

The white coloration in the spirit bear is the work of a recessive gene, and for a recessive trait to be expressed, the individual must have two copies, one inherited from each of its parents. Suppose two black parents, each with one recessive copy of the white gene, produce four cubs. Statistically, one cub will be a white spirit bear with two copies of the recessive gene, and the three others will be black. Two of the black cubs will be carriers, with a single copy of the gene, and one black cub will have no copies of the gene. In another instance, if one of the parents is a white spirit bear and it mates with a black partner that is a carrier of the recessive gene, half of their cubs will be black carriers and half will be white spirit bears. And finally, if two spirit bears should chance to mate, then all of their cubs will be white. Similar recessive genes in humans determine our eye color, the presence of dimples, freckles, a cleft chin, or left-handedness.

The recessive gene in spirit bears arose as a chance mutation, but when it arose is unclear. Some have suggested that it occurred during the Ice Age when white coloration may have conferred an advantage, but there is no scientific support for that conclusion. The white bears do, in fact, have one slight advantage over black individuals which may have enabled the trait to persist and be passed along. Researcher Dan Klinka studied the fishing activity of black bears along a salmon stream on Gribbell Island. He found that daytime capture success was slightly higher in white spirit bears than it was in black-colored bears (31% versus 26%). He wondered if the reason might be that salmon use vision to avoid predators and are more evasive during daylight than they are after dark. To test his hypothesis he imaginatively dressed himself in green rubber boots and covered his body with either a white or a black linen costume and waded into the stream to see how the fish would react. After a number of trials he determined that salmon avoided him twice as often when he was a black-cloaked wader then when he was dressed in white. He concluded that the persistence of the spirit bear gene may be helped by the enhanced salmon-fishing success it seems to confer.

In 2006, the white spirit bear became the official provincial mammal of British Columbia

JANUARY · FEBRUARY · MARCH

When all the dangerous cliffs are fenced off,
all of the trees that might fall on people are cut down,
all of the insects that bite have been poisoned . . .
and all the creeks bridged so no one gets wet or drowns,
and all the grizzlies are dead because they are occasionally dangerous,
the wilderness will not be made safe.
Rather, the safety will have destroyed the wilderness.

E. YORKE EDWARDS, *Canadian environmentalist*

THE FIRST TIME I handled a bear cub was on a picture-perfect afternoon in March 1986. I had struggled up a mountain in western Alberta with biologist Orvall Pall to a thick stand of lodgepole pine where a mother American black bear and her two cubs were denned.

As we approached the den, I could clearly hear the squeal of cubs from 30 feet (9 m) away. The bear family was home and the sound of the cubs made my heart race. I prepared myself for the protective mother to burst from her den, roaring and drooling, eyes ablaze, flailing her claws, and tearing Orvall and me to shreds. But the mother bear had never read a hunting magazine and didn't know the proper way to react to our intrusion. Instead, she remained placidly inside her den after she was injected with an anesthetic dart, as I have seen many other bears do since then.

Once the mother was anesthetized, we pulled the bear family out of their den. The cubs whined like babies and clung to my chest as if they were made of Velcro. The young bears were less than two months old and weighed only 4.5 to 6.5 pounds (2–3 kg) each. When I stuck the smallest one inside my coat to keep it warm, it squirmed to the top of my shoulder, nestled its nose against the base of my neck, and fell asleep.

It's exhilarating to touch a wild creature, and I savored the moment as I squatted beside the mother bear. I slowly ran my fingers through her fur, buried my nose in her pelt to inhale the scent of wildness, and examined her body with medical precision. I wanted to know bears as well as I could. When I examined the curve of her claws and the points on her teeth, I didn't see instruments of injury but tools of survival. On that afternoon in March, I discovered another side of the bear, a side that is never publicized—the vulnerable side.

For many bear biologists, February and March are the months for "den work"— locating radio-collared bears in their winter dens to examine the new litters of cubs.

◀ In the northern Rocky Mountains, the local bears spend five to six months in hibernation

At that time, bears are near the end of their winter hibernation when they do not eat, drink, urinate, or defecate for months at a time—a metabolic feat unmatched in the animal world.

A BEAR IN HIBERNATION, DOWN BUT NOT OUT

Black bears and brown bears living in northern environments den for the same reason that most other mammals den—to conserve energy at a time of the year when weather conditions are severe and food is scarce. In warmer climates, such as those in Mexico, Florida, Taiwan, Spain, and Greece, where winters are less severe, many of the local bears may be active throughout the winter.

For pregnant polar bears, denning is a reproductive strategy. A den is a sheltered environment in which to have cubs, and all pregnant female polar bears den in the winter. Most of the other polar bears in a population spend the winter hunting on the sea ice, although as satellite tracking has revealed in recent years, some bears other than pregnant females shelter for part of the winter in a temporary den when hunting conditions are especially difficult. More on that topic later.

Most brown bears and black bears den for four to six months every year—a third to half of their lives. Denning consumes more time in a bear's life than any other activity. American black bears from southern Alaska, near the northern extreme of the species' range, spend the longest recorded time in dens; they are routinely down and out for six to seven months. As far as I know, the record is held by an adult female black bear that denned for 247 days—8.25 months.

Bears, like most other denning mammals, are dormant while in their winter dens, a phenomenon commonly called hibernation. Although mammals—including such unrelated species as tenrecs, echidnas, mouse lemurs, bats, rodents, and bears—are said to hibernate, the details of how these different animals undergo their dormancy often vary considerably.

An adult Richardson's ground squirrel is active above ground for as short a time as possible to lessen the risk from predators. Once the brief spring breeding season ends, an adult female, such as the one pictured here, slips into hibernation by early July—many weeks before the halcyon days of summer are over.

Hibernation has been studied most thoroughly in rodents, and especially in North American ground squirrels. When a ground squirrel slips into hibernation, most of its bodily functions slow down drastically. Over the course of a day or two, the animal's heart rate plunges from a blurring 500 to 600 beats per minute to a modest 25 beats or less, its metabolism drops to 1/25 of its normal level, and its body temperature chills to within freezing. The body temperature of the Arctic ground squirrel, the most northerly ranging ground squirrel, may even dip below the freezing point, to 27°F (−2.9°C).

Once a ground squirrel is deep in hibernation, it appears dead. The animal is usually curled into a tight little ball, with its head tucked between its legs and its long,

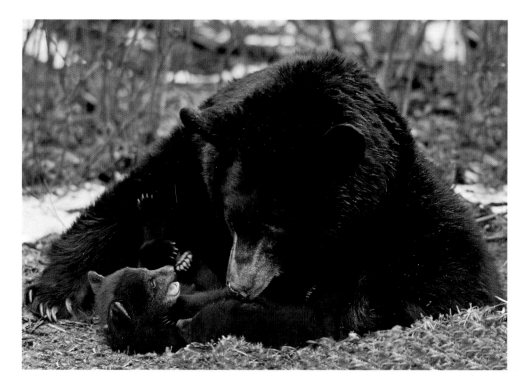

bear with six cubs was reported from an area northwest of Moscow, Russia, and in 2018 another six-cub litter was seen in the Carpathian Mountains in Romania. Polar bears have smaller litters than the other northern bears, usually one or two cubs. Triplets occur in less than 4% of polar bear families, and a litter of four cubs has been reported once, although it may have resulted because one or more of the cubs was adopted.

A mother bear's age and weight influence the size of her litter. In general, older bears are heavier and have larger litters. This trend is seen in polar bears and brown bears, but the best documentation comes from American black bears. In a study of Pennsylvania black bears, the average age of a female with a single cub was four years old. If the litter contained two cubs, her average age jumped to 6.3 years, and in three-cub litters, the mother's average age was 6.7 years. The largest litters, those containing four and five cubs, were produced by the oldest females, which had an average age of 8.9 and 11 years, respectively. In the same study, veteran biologist Gary Alt found an association between the mother's weight in late fall, roughly at the time of implantation, and the size of the litter she subsequently produced. Females producing five cubs weighed a whopping 365 pounds (165.6 kg), those with four cubs averaged 300 pounds (136.1 kg), 263 pounds (119.3 kg) for litters of three, 245 pounds (111.1 kg) for litters of two, and only 228 pounds (103.4 kg) for litters with a single cub. Mother black bears in Pennsylvania are often heavier than those in many other areas of North America because of a fat-rich diet of acorns and beechnuts.

It appears that as a mother bear ages, she matures reproductively and is then able to produce larger litters. Older females are more experienced at finding food, and

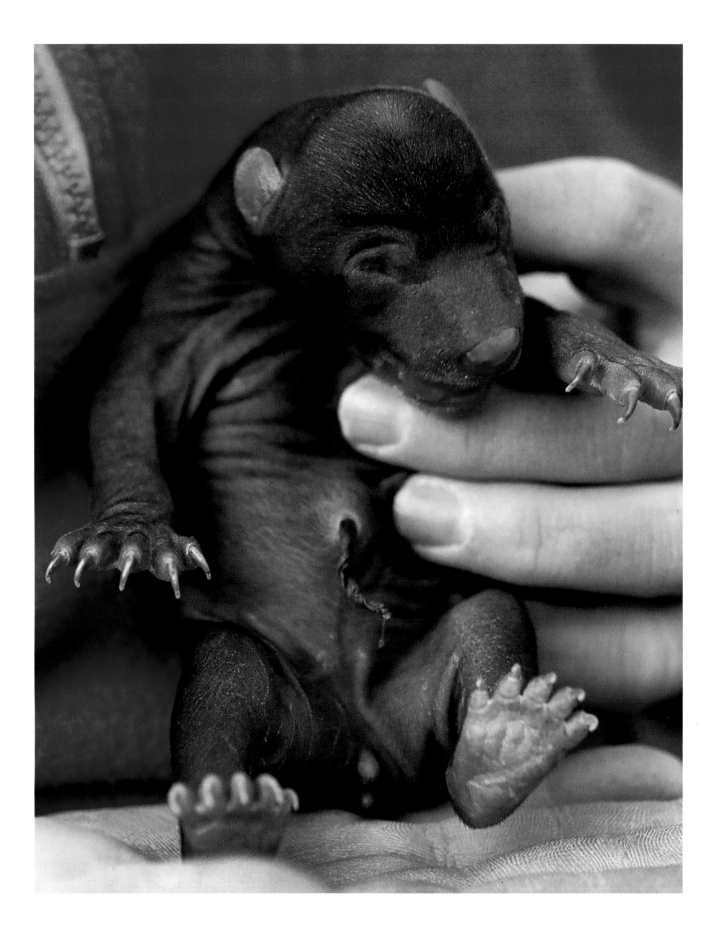

their improved nutritional condition further contributes to their ability to have larger litters. The habitat also influences the size of a mother's litter. Female bears that live in food-rich habitats produce more cubs than females that live in habitats where food is scarce and poor in quality. This last point is discussed in greater detail in Chapter 4.

Like many mammals, the mother bear licks her newborns thoroughly to clean away the embryonic membranes. The licking dries the cubs' fur and improves the pelt's insulation. In many carnivores, as the mother licks her offspring, she learns to recognize the young animal's individual odor, and at the same time she is coating her youngster with the odor of her own saliva. For a mother bear, however, individual recognition of her cubs while she is in hibernation is probably not important, since she never leaves them. In fact, a hibernating bear's sense of smell may be impaired.

The discovery that hibernating bears may be unable to recognize the odor of their own offspring was made accidentally when biologists tried to introduce young orphaned cubs to foster mother black bears that were still in their winter den. When an orphan bear cub was tossed into an occupied den or left just outside the den entrance, almost invariably the foster mother would first sniff the cub and then scoop it into the den and adopt it. Apparently, the bear could not identify the orphan by its odor and assumed that the cub was one of her own.

The researchers tried a similar tactic with mother bears after they had left their winter dens and come out of hibernation. This time the adoption attempts failed. As soon as a mother bear smelled the foreign cub, she recognized that the orphan was not her own and killed it immediately.

Besides licking the birth fluids from her cubs and consuming the embryonic membranes, a mother bear also eats the afterbirth. In a recent authoritative review of reproduction in female mammals, biologists Virginia Hayssen and Teri Orr offer four possible reasons why a mother bear might consume the placenta. An obvious one is that it keeps the winter den clean and eliminates unwanted odors that could attract a predator. It might also offer nutrition during a time of fasting. As well, since the placental tissues are permeated with hormones such as prostaglandins and oxytocin, these hormones may play a role in shrinking the uterus and preparing the mammary glands for nursing. Finally, endogenous opioids in the sloughed placenta may lessen the pain after birth.

◀ A newborn American black bear cub has surprisingly long, sharp claws, which it uses to crawl through its mother's thick fur

The Baby Bruin

It's hard to think of a more photogenic animal than a two-month-old bear cub, but "homely" is the word that best describes a cub's appearance at birth. A newborn bear cub is extremely small—the size of a chubby eastern chipmunk. Although it is covered with very short hair, it looks almost naked. Newborns are toothless, their eyes are sealed shut, and their ears are just fleshy tabs on the sides of their head. What they lack in looks, they make up for in voice; these little bruins can scream like banshees.

Newborn brown bear and polar bear cubs weigh between 20 and 28 ounces (570–794 g). American and Asiatic black bears cubs are smaller yet, and in Pennsylvania the average cub is 9 inches (23 cm) long and weighs a mere 13 ounces (360 g). Asiatic black bear cubs are a similar size.

SHELTERING FROM SCARCITY

MOST POLAR BEARS stay active throughout the winter. Typically only females hibernate while they are pregnant, giving birth to their cubs, and nursing them for the first several months. In the 1950s, a Belgian oblate priest, Father Franz van de Velde, traveled extensively with Inuit hunters in the Canadian Arctic and made detailed notes on the polar bears he encountered. On a number of occasions, he and his Inuit companions flushed adult bears, both males and females, as well as subadults, out of snow dens in the middle of winter. The good Father knew that winter dens were not just used by pregnant polar bears.

With the advent of satellite tracking in the 1990s, bears could be followed in the darkness and hazardous weather of an Arctic winter, when tracking by conventional radio telemetry with small aircraft was unsafe. Researcher Steven Ferguson and colleagues looked at the use of "shelter dens" by polar bears in multiple areas in the Canadian Arctic and western Greenland. Polar bears of all ages and both sexes, as well as females with yearling cubs, used such snow shelters for time spans ranging from two weeks to three months during periods of food shortages. Although most shelter dens were located on land, a few were on sea ice. A polar bear might dig a shelter den in autumn or in winter. In autumn, the bears spent an average of 56 days sheltering and exited after freeze up, when hunting seals became easier. In winter, the bears sheltered for 36 to 86 days, often when the presence of relatively unproductive multiyear ice made hunting especially challenging. Winter shelter usage was observed more commonly in the most northern latitudes, those higher than 75° north, while sheltering in autumn dens was a more frequent strategy of southern bears, those at latitudes less than 70° north. The differences related primarily to the sea ice conditions and the availability of vulnerable seals. It seems that when seal hunting is poor and food consumption low, bears everywhere can elect to shift into the energy-saving behavior of hibernation to conserve their fat reserves. In the harsh, unpredictable environment of the Arctic, such facultative hibernation confers an adaptive advantage.

A polar bear may shelter temporarily in autumn or winter when hunting conditions are poor

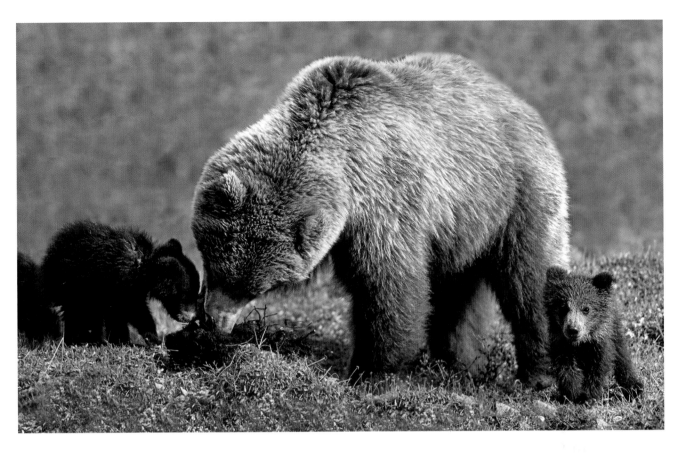

those of either species of black bear. The cubs have grown from near-naked, homely little creatures to bright-eyed, inquisitive little balls of fur. (I promised one bear biologist I would resist the temptation to use the word "cute" to describe bears, but no other word describes a young bear cub better.)

Researchers believe that most bear cubs survive the first few months of life and live to greet the wide-open wilderness when the family first leaves its winter den. Beyond that moment, however, many cubs die. Attacks by murderous male bears, starvation, predatory wolves, and disease claim a third of all American black bear cubs in their first year of life. Most of these cubs die before they are six months old. Many brown bear cubs fare worse than young black bears—up to 40% of them never reach their first birthday. In western Hudson Bay, where the polar bears are stranded ashore for several months in summer, roughly half the cubs die by their first autumn. In some years, none survive. Heavier cubs, as well as those whose mothers are heavier, have a greater chance of surviving through the summer. Researcher Andrew Derocher thinks larger cubs are more likely to survive because they are more resistant to the frigid weather experienced when the family first emerges from their winter den, are better able to travel from the den to the sea ice, and have larger fat stores, which allow them to fast longer during the summer ice-free period. Fatter mothers likely enhance cub survival by being able to provide more milk.

This mother grizzly was digging for sweetvetch roots on the tundra of northern Alaska. Her curious cub was smelling what she was eating, although the young bruin was still exclusively nursing.

Most polar bear mothers leave their winter dens a month or two earlier than either brown bear or black bear mothers. Female polar bears in the southern part of their range, namely in Hudson Bay and James Bay, leave their winter dens between mid-February and the middle of March. Bears from more northern populations in Canada, and in Alaska and Russia, leave a little bit later, from mid-March to mid-April. In the next section, we follow a family of polar bears as they journey out onto the sea ice.

JOURNEY TO THE ICE

After being inside a cramped den for four or five months, a mother polar bear needs time to become mobile again. When she finally squeezes out of her den for the first time, her outing may be a brief one. She rolls in the snow and stretches her thick limbs. With relish, she buries her face in powder snow and licks the flakes from her lips, much as you or I might stand in the spray of a shower to flush away our morning grogginess.

After a day or two, when the female has made several short outings, the tiny white heads of her cubs appear at the opening to the den for the first time. The cubs implore their mother to return to them with repeated calls of "maa maa." In response, the female ambles back to the den, and her comforting presence finally coaxes the cubs to venture outside.

Most polar bear families stay in the vicinity of their winter den for a week or two. On Herald Island, Russia, emerging mother bears sometimes left after just eight days, but some loitered for as long as 27 days. During this time the mother bear is still quite lethargic. Recall that the metabolic rate of an American black bear emerging from hibernation remains at half its normal level for two to three weeks afterwards; likely a similar situation occurs in polar bears. The days a mother polar bear spends near her den may give her time to accelerate her metabolism back to normal. The departure delay may also give cubs a bit of time to develop better motor skills, which may be required to traverse pressure ridges and open leads once the family gets on the sea ice.

Tenacious researchers on Alaska's North Slope used a combination of direct observation for 458 hours and remote video cameras for 5,784 hours to spy on mother bears emerging from their dens. On average, the mothers spent just six days at their den before departing for the sea ice, although the duration varied from 2 to 18 days. Females and cubs remained inside their dens roughly 98% of the time. When they did emerge, the mothers most commonly just walked around a little or rolled in the snow. Walking around was also the most common activity of cubs, but they also sometimes played and nursed. The average temperature on breakout days was −25.6°F (−32°C), and families usually emerged during daylight hours, rarely during twilight or night.

In western Hudson Bay, most female bears have not eaten since the previous summer when the ice disappeared from the bay in late June or July, obligating them to an eight-month fast—one of the longest of any mammal. Scientist and author Andrew Derocher wrote the following in his 2012 book, *Polar Bears: A Complete Guide to Their Biology and Behavior: Pregnant females in western Hudson Bay undergo massive weight changes from autumn to spring. An average pregnant female weighs 635 pounds (288 kg)*

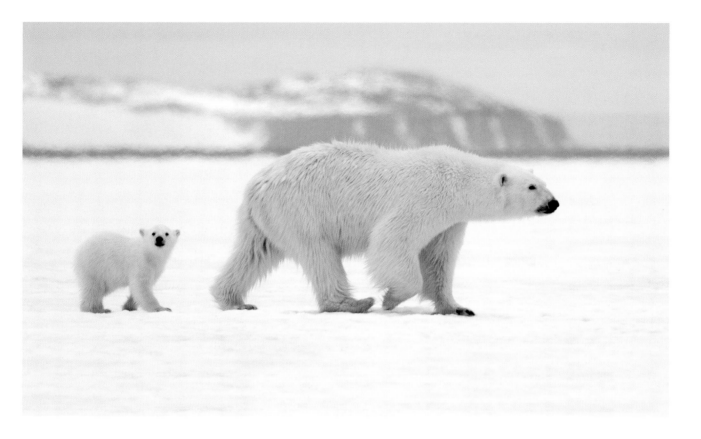

in the autumn and loses an average of 280 pounds (127 kg) or 1.6 pounds per day (0.7 kg/day) over the winter. Normally, 23% to 55% of her autumn weight is lost. The record is 495 pounds (225 kg).

Level shorefast ice is the easiest terrain for a young polar bear cub to traverse. With the young bear's limited endurance, steep pressure ridges and open leads are much more of a challenge.

It is not surprising, then, that when the bears first emerge from their winter dens, they often dig under the snow to eat vegetation. In some areas of Hudson Bay, the hungry bruins eat grasses, sedges, and sphagnum moss. Less frequently, they eat Labrador tea, and they even strip lichens from the trees. The bears eat only small amounts of vegetation, and they likely derive very little nutrition from the plants.

When a polar bear family finally leaves the area of its winter den, it may need to travel far to reach the sea ice and the seals the mother is eager to hunt. Maternity dens in Hudson Bay are often far from the sea, typically more than 30 miles (50 km) inland. The distances are less in the Canadian High Arctic, where most maternity dens are within 10 miles (16 km) of the coast. Mother bears on Wrangel Island, off the northeastern coast of Siberia, den within 5 miles (8 km) of the ocean, and in Norway's Svalbard, the dens are usually less than 0.5 miles (1 km) from the coast. Researcher Derocher found one den in Svalbard that was just 11 yards (10 m) from the shoreline.

As a mother bear leads her family to the sea, progress is slow. Some bears den on 60° to 70° slopes, so the families must first slip-and-slide their way down to more level terrain before they can proceed. Human climbers use ice picks and crampons to traverse such steep slopes. A study conducted in Jones Sound, in the Canadian High

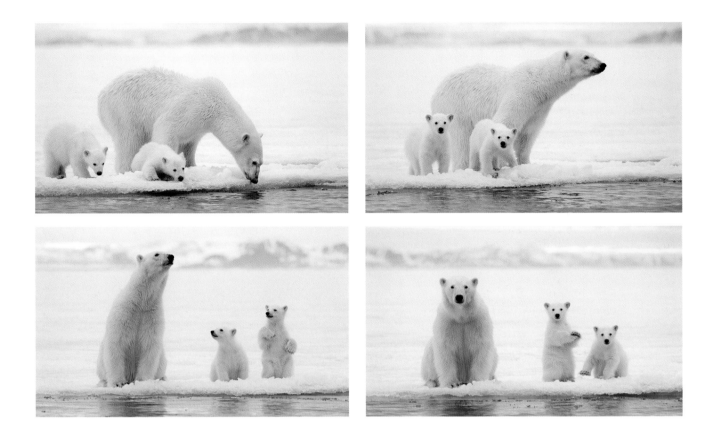

After reaching the edge of the shorefast ice, this mother polar bear faced a wide expanse of open water. She loitered for about 15 minutes before walking away across the ice.

Arctic, found that bears traveled only 1.2 to 3 miles (2–5 km) per day, with frequent stops to rest and nurse along the way. On Herald Island, Russia, where the they den on steep slopes, polar bears may use two or three temporary dens on their way to the ocean. Researcher Nikita Ovsyanikov told me he thinks females sniff the winds coming from the sea to monitor ice conditions.

In Hudson Bay, where the bears travel farthest to reach the sea, the course is not meandering but amazingly straight. Biologist George Kolenosky wrote that *the ability of females to travel direct routes over featureless terrain was remarkable and indicated a highly developed system of navigation. Near the sea, the odor of open water may assist orientation, but inland there appeared to be few navigational aids.*

It is not known how polar bears navigate, but if they are like other animals, they may use a number of methods. It's possible that bears can use the angle of the sun and make adjustments for the season and the time of day, as birds do, to travel accurately in one direction. They might also be able to detect the weak magnetic field of Earth. Many birds rely on a magnetic sense to navigate during migration, and recent research suggests that some mammals also have this sensory ability—migratory greater mouse-eared bats and hunting red foxes.

Regardless of *how* bears navigate, it is clear that they can do so quite accurately. Analyzing over 621 miles (1,000 km) of polar bear tracks made by female bears leaving maternity dens along Hudson Bay, biologists found that all of the mother bears walked

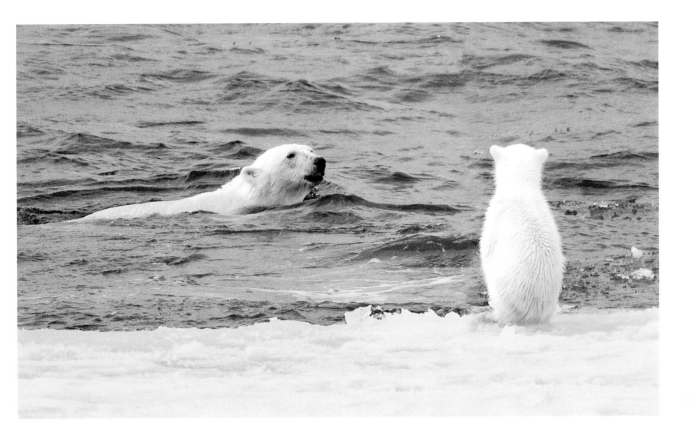

in a northeast direction to reach the ice. This direction guaranteed that the bears always intercepted an area of the bay where there would be seals to hunt.

Along southern Hudson Bay, bear families journey to the ice more or less in a straight line, but the mother will frequently follow streams if they course in the same general direction in which she wishes to travel. Even in areas of tundra, trees and bushes frequently grow along the banks of streams, and the bears may follow these streams to shelter from the wind. The vegetation along streams also traps blowing snow into drifts in which the mother can dig a temporary den if the weather becomes too severe for travel.

The average daytime temperatures during March, when the bears leave their dens along Hudson Bay, are −4°F to −22°F (−20°C to −30°C). One March when I was observing bears, there was a three-day cold spell with record temperatures of −43°F (−42°C). A brisk northwest wind drove the wind chill down to −94°F (−70°C). Polar bear cubs cannot withstand such extreme temperatures. It is likely that during such weather a mother bear digs a temporary den in which to shelter her family until the conditions for travel improve.

Young polar bear cubs cannot withstand temperatures below −22°F (−30°C). Although a polar bear cub's pelt is well developed when the bear family leaves its winter den, the young cubs, like all baby animals, have a high surface area in relation to their body mass, so they lose body heat more readily than adult bears. To compensate, cubs

This mother polar bear and cub were being followed by an adult male bear, and the mother was coaxing her cub to join her in the water and swim to some nearby pack ice, which they eventually did

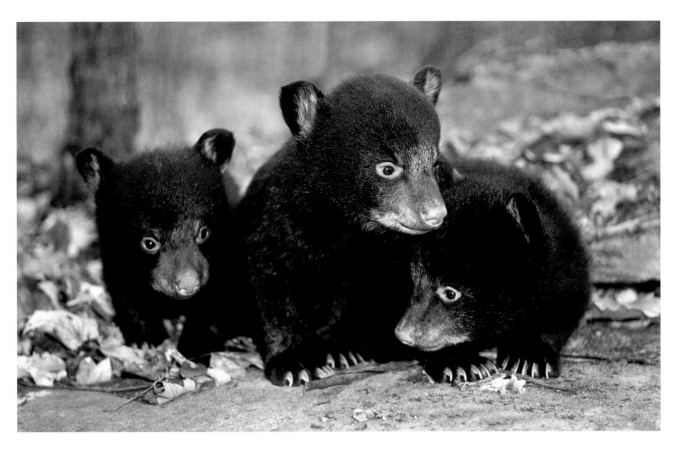

early, the biologists expected the bears to leave early as well, but the bears surprised them and did not leave right away. It seemed the bears were not waiting for the snow to melt as their cue to depart.

The relationship between temperature and den emergence is just as unclear. Logically, warm spring temperatures should induce bears to get up and get moving, and indeed, in black bears in Ontario, Idaho, and Washington, warm temperatures seemed to do just that—bears left their dens soon after the mercury started to climb. In Minnesota, 87% of the bears left their dens within two weeks once the average daily temperature rose above 32°F (0°C). But just when it seems that there might be a general correlation between rising temperature and den emergence, black bears in south-central Alaska throw the pattern off and seem to ignore the thermometer, sometimes remaining in their dens for weeks after daytime temperatures rise above freezing.

A final environmental cue that bears may use to time their den emergence is the photoperiod, which is the number of hours of daylight. It is an important biological synchronizer of animal behavior throughout Arctic and temperate latitudes. It coordinates migration in birds, antler growth in deer, seasonal color changes in weasels, hares, and Arctic foxes, and hibernation in ground squirrels. Daylight does penetrate to the depths of most bear dens, even those covered with a thick blanket of snow. Perhaps the increasing photoperiod functions like an environmental clock and notifies

Small American black bear cubs such as these are still too young to climb a tree to safety or escape from a flooding den; they rely completely on their mother's vigilance for their safety

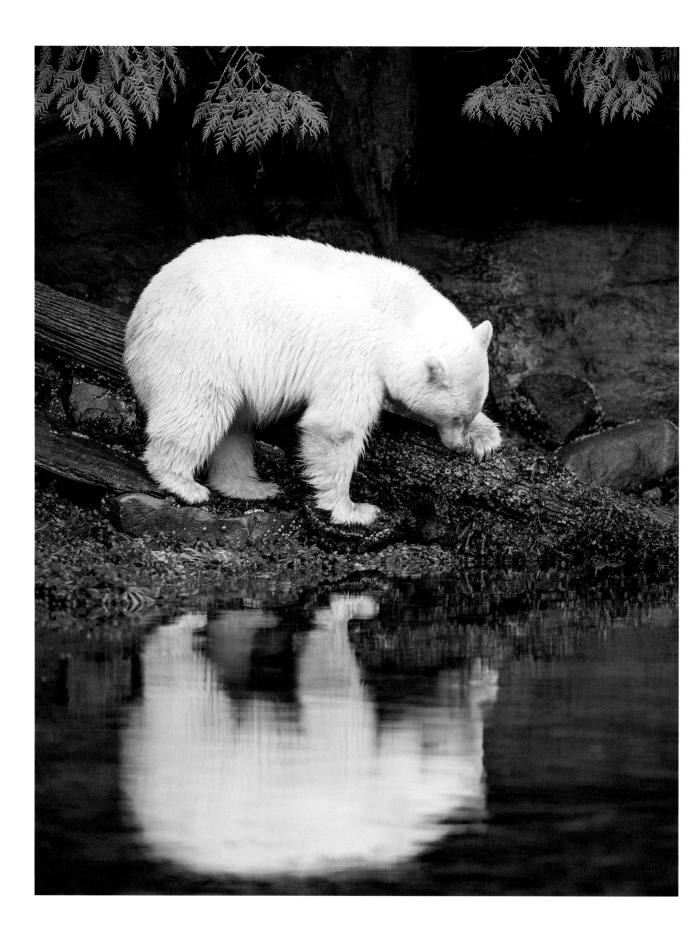

a number of times, and I always marvel at the conviction with which the storytellers recount their tale.

Once they leave the area of their dens, bears scatter in search of food, and it's difficult to predict where they might be found. Female American black bears with newborn cubs are an exception; the mother bear heads straight for the largest tree nearby and builds a nest at its base. In Pennsylvania and Minnesota, a black bear mother usually chooses a large hemlock or white pine. In the mountains of Alberta, she may choose a Douglas fir. Mothers seem to select trees for their large size and bark characteristics.

In northern Ontario, biologist George Kolenosky found that when humans approached a mother and her cubs, the cubs immediately climbed to the top of the tree; the mother often positioned herself below them, 13 to 33 feet (4–10 m) off the ground, and huffed and growled.

When danger threatens a family of bears, the mother bear sometimes simply runs away. In Massachusetts, a pack of hounds chased a mother bear 6 miles (10 km) away from her cubs. The mother returned to retrieve her cubs six hours later.

A tree is also a safe refuge for cubs when the mother bear leaves them to search for food. At times like these, she may stray several miles from her offspring and be gone for up to three or four hours at a time. Normally, cubs are safe when they are left alone in a tree, but one time in Yellowstone National Park, a male black bear spotted a cub hiding in a tree. He climbed the tree and killed and ate the cub.

In April and May, food is often scarce for many black bears and brown bears, and some will continue to lose weight for many more weeks. The situation is quite different for the polar bear. At this time of the year, the polar bear is wandering on the sea ice where there is an abundance of seals to hunt.

◀ Even when a young American black bear cub tries to flee up a tree, it may lack the strength and coordination to master the climb

ORIGIN OF THE SEA BEAR

In Chapter 1, I ended the bear evolution story roughly 3 to 4 million years ago when a common ancestor of the subfamily Ursinae began to branch out and diversify, eventually splitting into six of the species living today. Naturally, not all of the species evolved at the same time. Populations repeatedly shrank and became isolated, then multiplied and expanded. DNA analysis has shown that the different bear species frequently interbred, and that genes flowed extensively between them. As a result, fertile hybrids arose for a while and then disappeared, but for a time they added genetic vigor to the survivors, enabling them to cope with the environments around them, which were continually evolving and changing. The last bear to branch off in the subfamily Ursinae was the polar bear, *Ursus maritimus*, the sea bear.

Before tackling which potential seed population of brown bears likely spawned the polar bear, a topic that is still debated, I want to first review some of the biology and behavior of the brown bear that possibly contributed to the success of this evolutionary offshoot.

In the Smoking Hills of Canada's Western Arctic, I've seen brown bears walking along the coast at the edge of the sea ice within a few hundred yards of basking ringed

▶ The polar bear is a modified brown bear with a longer neck, higher set eyes, smaller ears, and furrier feet

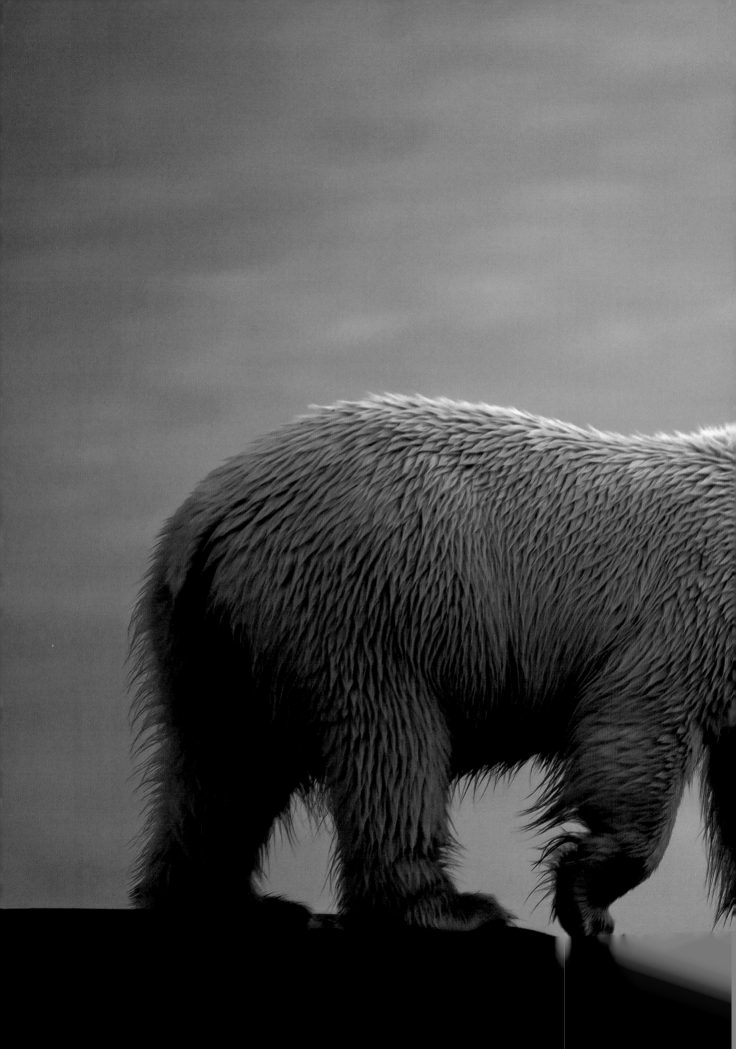

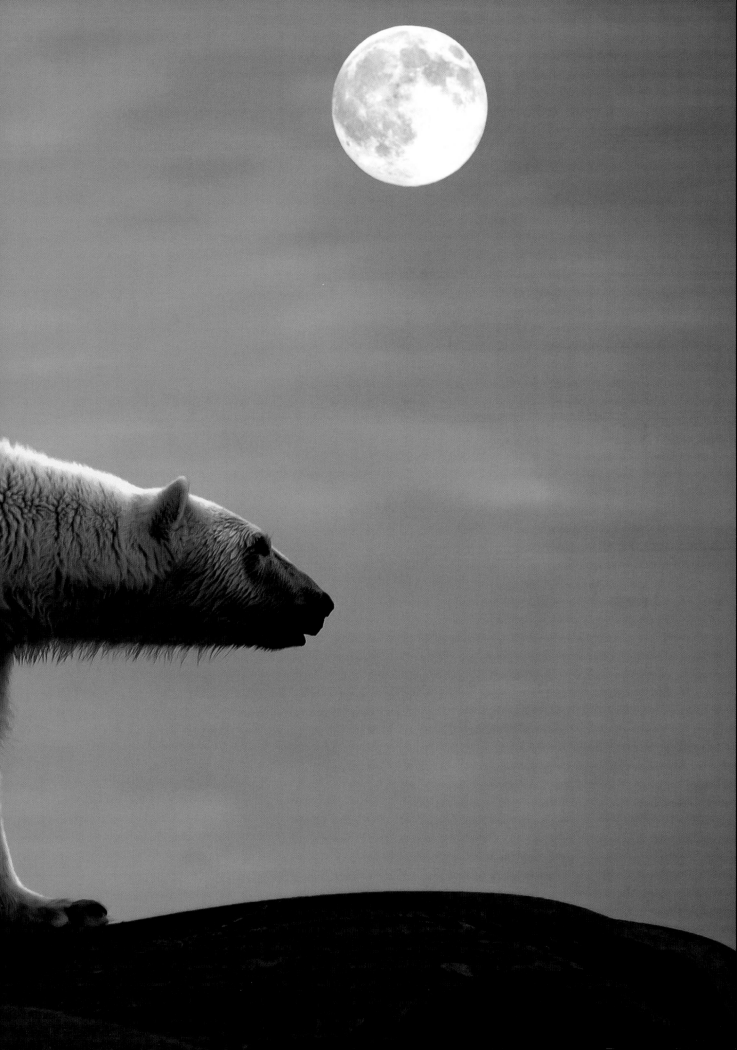

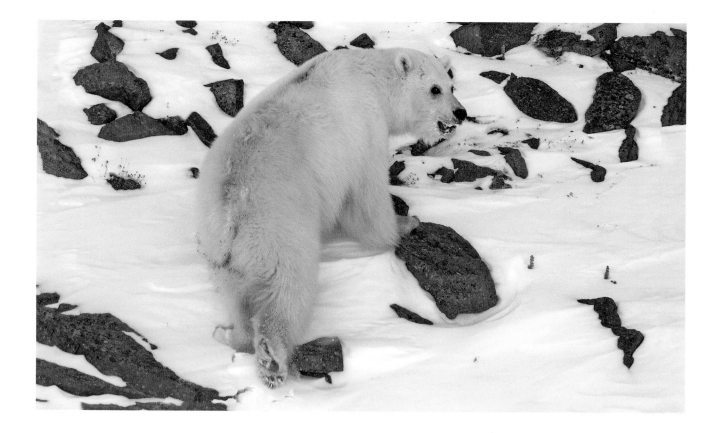

Hybrid polar bear–brown bear seen in April 2012 in the Wynniatt Bay region of northern Victoria Island, Northwest Territories

seals. In the same area, biologist Peter Clarkson has observed brown bears a number of times on the sea ice, several miles from shore. Unfortunately, Clarkson could not determine if the brown bears were hunting seals or searching to scavenge the kills of polar bears. There are stories from local Inuvialuit hunters of brown bears far out on the shorefast ice, hunting ringed seal pups in their snow lairs, and biologist Ian Stirling recorded a brown bear 37 miles (60 km) from the nearest land. Although the bears may have drifted on the ice for part of their journey, the animals clearly do not view sea ice as a barrier to movement.

Further evidence supporting this point came in the summers of 2003 and 2004, when geologists mapping on Melville Island gathered hair samples and photographed one or more grizzlies living on the island at a latitude N 74°27′, the most northerly observation of the species. The observations suggest, at a minimum, that transient grizzly bears are now regular visitors to the Canadian Arctic Archipelago and that travel across wide expanses of sea ice is not a deterrent.

Brown bears occasionally eat the same prey that polar bears eat. In the Okhotsk Sea in eastern Russia, researchers report brown bears scavenging the carcasses of seals and whales washed onto beaches, and the researchers consider the bears to be significant predators on spotted seals that haul out on land in summer to molt. Since some brown bears do hunt seals along the seacoast, it is tempting to speculate that they may also hunt them on the sea ice.

The first proof of this came on May 4, 1991, on the sea ice in Viscount Melville Sound, 310 miles (500 km) north of the brown bear's supposed range in Canada at the time. That day, biologist Mitchell Taylor was flying over the sea ice tracking polar bears. Taylor told me, *When I first saw the grizzly, I thought my eyes were playing tricks on me.* His initial reaction was understandable since a brown bear had never been sighted that far north before. Taylor quickly tranquilized the bear and examined it. It was a healthy adult male weighing a burly 700 pounds (318 kg). When he backtracked the bear, he found where it had been hunting ringed seals, and it seemed to have made at least two kills. Taylor found no polar bear tracks in the snow around the seal kills, so the brown bear had not scavenged from its close relative. This was the first solid evidence that brown bears might hunt and kill seals on the sea ice.

Polar bears are strong swimmers, and this same characteristic is shared by their ancestor, the brown bear. Seabird biologist Ed Bailey reported seeing brown bears on 40 separate occasions swimming between islands used by nesting seabirds along the southern coast of the Alaskan Peninsula. He told me that bears, especially females with cubs, regularly swim to raid seabird colonies as much as 10 miles (16 km) offshore. In another clear example of swimming capability, an adult male brown bear swam at least 7 miles (11 km) through strong tidal currents when it moved from Montague Island in Alaska's Prince William Sound to the mainland.

Clearly, brown bears swim well, hunt seals, and periodically move about on the sea ice, characteristics that polar bears inherited and improved upon. It is likely that the brown bear possessed these aquatic and opportunistic predatory tendencies for hundreds of thousands of years before polar bears arose. But what happened to the brown bear to finally trigger the evolution of its close polar relative?

Recent analysis of the genetics of the six living species in the subfamily Ursinae produced a family tree split into two sister groups of closely related species. One sister group contains the sun bear, sloth bear, and Asiatic black bear, and the other contains the American black bear, brown bear, and polar bear. Each of the species within their respective sister group shares some genes with other members of the group, evidence of interbreeding at some point in their evolution. But the genetics also show common genes shared between the two separate sister groups. For example, Arctic-dwelling polar bears have genes in common with both the sun bear of the tropics and the sloth bear of the Indian subcontinent, even though the three species evolved in geographically and climatically distinct areas. Researcher Vikas Kumar and his colleagues proposed a solution as to how this might have happened. Namely, that genes flowed between an intermediate species, and the most likely candidate is the geographically wide-ranging brown bear, whose range overlaps with the polar bear in the north and the Asiatic black bear in the south. So what is the point of all these genetic determinations? Only that the six current species of bears living in the subfamily Ursinae interbred intermittently in the past, and that the discovery of hybrids living today should not be a surprise.

In Canada's Northwest Territories in 2006, and then again in 2010, hunters killed bears that were a hybrid of a grizzly bear father and a polar bear mother. The popular

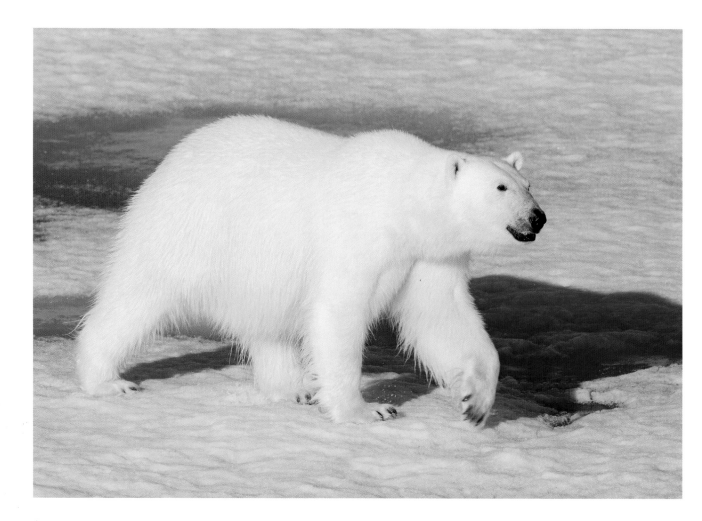

press quickly coined names for the hybrids, calling them "grolar" bears or "pizzly" bears. Since then, at least five additional hybrids have been identified in this Arctic region of Canada. The hybrids are grayish or brownish white—lighter than grizzlies but darker than polar bears. They have a prominent shoulder hump like a grizzly, a neck length that is between that of a grizzly and a polar bear, and intermediate claws—not as long as a grizzly's but not as curved as a polar bear's.

According to DNA evidence, it seems that polar bears and brown bears have mated successfully many times in the last 100,000 years, and these matings have left a strong genetic imprint. The interbreeding likely occurred when climate changes forced the bears to move to each other's habitats. Hybridization is known to occur more frequently in areas where population densities are low and where species are on the edge of their ecological range. In some cases, the infusion of new genes and the transfer of novel traits confers an advantage to the hybrid and its offspring.

It turns out that brown bears in the so-called ABC Islands (Admiralty, Baranof, Chichagof) of Southeast Alaska are more closely related to polar bears than they are to brown bears on the nearby mainland coast. Researcher James Cahill and his colleagues suggest that during the most recent ice age polar bears ranged as far

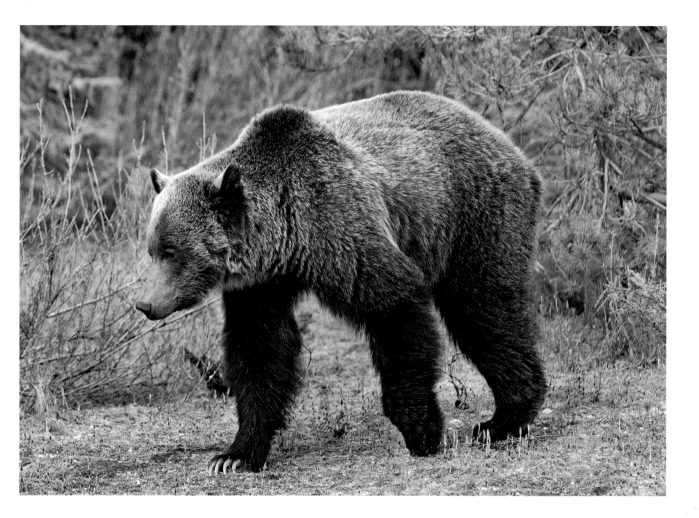

south as the ABC Islands. As the climate warmed and the ice retreated, some of the polar bears stayed behind. These castaways gradually merged with male brown bears that drifted over from the mainland. Cahill wrote: *This process of genome erosion and conversion may be a common outcome when climate change or other forces cause a population to become isolated and then overrun by species with which it can hybridize.*

There is still no consensus as to when the polar bear and brown bear originally diverged, or where that might have happened. The fossil record suggests the separation occurred 150,000 to 800,000 years ago, yet the oldest polar bear fossil, one discovered in Svalbard, is estimated to be just 110,000 to 130,000 years old. Genomic data is even less conclusive, with separation dates ranging from a distant 4 to 5 million years ago to a relatively recent 160,000 years ago, depending on the assumptions the researchers make.

Recently, French researcher Alexandre Hassanin ambitiously undertook a comprehensive review of the many genome studies. He concluded, rather convincingly, that glaciation exerted a major influence in shaping the evolution of the polar bear. The initial divergence from brown bears seems to have occurred between 540,000 and

The subtle differences in body shape between the polar bear and the brown bear are most evident when the two species are seen side by side

630,000 years ago, and it was linked to a glacial period. Following that original separation, interbreeding later occurred between female polar bears and male brown bears during at least two interglacial periods: 340,000 years ago (Marine Isotope Stage 10) in western Europe and 155,000 years ago (Marine Isotope Stage 6) in the ABC Islands. Based on DNA sequences, it's likely that interbreeding also occurred at different times in Beringia and Ireland.

The important take-home message from all of this potentially confusing genome data is that throughout the last few hundred thousand years of the current ice age, polar bears and brown bears interbred repeatedly, and they continue to do so today. All North American brown bears have between 3% and 8% of their genome derived from polar bear ancestry, and this is greatest in the ABC Islands. Extinct Irish brown bears had up to 21.5%, and today's brown bears in the Kunashir Islands north of Japan have up to 12.7%. All of these values from widely separated areas suggests that interbreeding occurred in multiple areas and was not a geographically isolated event.

The canine teeth of the polar bear, as seen in this skull, are longer, sharper, and spaced farther apart than in its ancestor the brown bear

When polar bears initially separated from their brown bear ancestors, roughly 600,000 years ago, how did they modify the basic brown bear body plan? Polar bears have a longer neck than brown bears, making it easier for them to keep their heads above water when they are swimming. Their flattened skull and high-positioned eyes are additional adaptations to their semiaquatic lifestyle, as are their large paddle-like front paws. The white fur of the polar bear enables it to blend better with the ice ridges and snowy hummocks of its environs, and its ears are small to lessen heat loss.

The teeth of the polar bear show the greatest change from the ancestral brown bear. This is not surprising, since the brown bear is a grass-and-root-eating omnivore, and the polar bear is a seal-eating carnivore. The brown bear has large rear molars to crush and pulp vegetation. The polar bear's rear molars are smaller, since it rarely eats plant foods, and the flesh and blubber it does consume require little or no mastication prior to swallowing. The polar bear's premolars and its front molars—in particular, the so-called carnassial teeth—are pointed and sharp edged to shear like scissors through flesh, whereas in the brown bear the carnassials are flattened. In addition, the polar bear's canines, which are used for seizing prey, are longer, sharper, and spaced wider apart than those of the brown bear.

How the polar bear puts all of its evolutionarily acquired attributes to good use is the focus of the next section.

HUNTERS ON THE ICE

In May, the sun never sets on Canada's Lancaster Sound, 525 miles (845 km) north of the Arctic Circle. It was 11:00 p.m. and 5°F (−15°C). From my vantage point atop Cape Liddon, 980 feet (300 m) above the sea ice, I could see the polar bear, and the trail of blood where it had dragged the seal for 100 feet (30 m) across the ice.

The bear looked like a subadult. It had caught an adult ringed seal when the seal surfaced at its breathing hole in the ice. After killing it, the bear played with the dead seal, swatting it with a paw and bouncing on it with its two front feet. Eventually, it began to eat, but it ate only the skin and the blubber. A raven landed nearby, hopped about for a few moments, then flew away. Four glaucous gulls were more patient than the raven, and they waited on the ice for the bear to finish its meal.

The young bear ate for half an hour, then left the carcass to the gulls, and returned to the breathing hole where it had caught the seal. As I have seen polar bears do before, it stalked the hole in the ice as if it were prey. When it reached the empty breathing hole, the bear stared for a moment into the water, then moved off to a nearby ice hummock, possibly searching for other seals. When the young bear squatted to urinate, I knew that it was a female.

Satisfied that there were no other seals around, the hunter returned to her kill and dragged the carcass for a couple of yards. After several bites, she lifted her nose, as if testing the air, and abandoned the dead seal for the final time. For the next hour, she walked slowly beside a pressure ridge that ran for miles across the ice. I lost sight of her as she disappeared into the glare of the midnight sun.

Polar bears primarily use their acute sense of smell to locate seals. Throughout the winter, every ringed seal maintains three or four breathing holes, hundreds of yards apart, by scratching through the ice with the heavy claws on its front flippers. In places where snowdrifts accumulate over a breathing hole, such as in the lee of an ice hummock or pressure ridge, the seal excavates a cave in the snow so that it can haul out on the ice hidden from view. A trained Labrador retriever is able to smell a seal lair more than half a mile away (0.8 km), and I would be shocked if a polar bear could not easily do the same. Researcher Andrew Derocher explained how a bear does it: *All prey emits a cone of scent that widens farther from the source. Once inside the cone, a bear carefully moves from side to side using its olfactory skills to home in on the source.*

The ringed seal is the most abundant seal in the Arctic with an estimated global population of 1.5 million animals (composite)

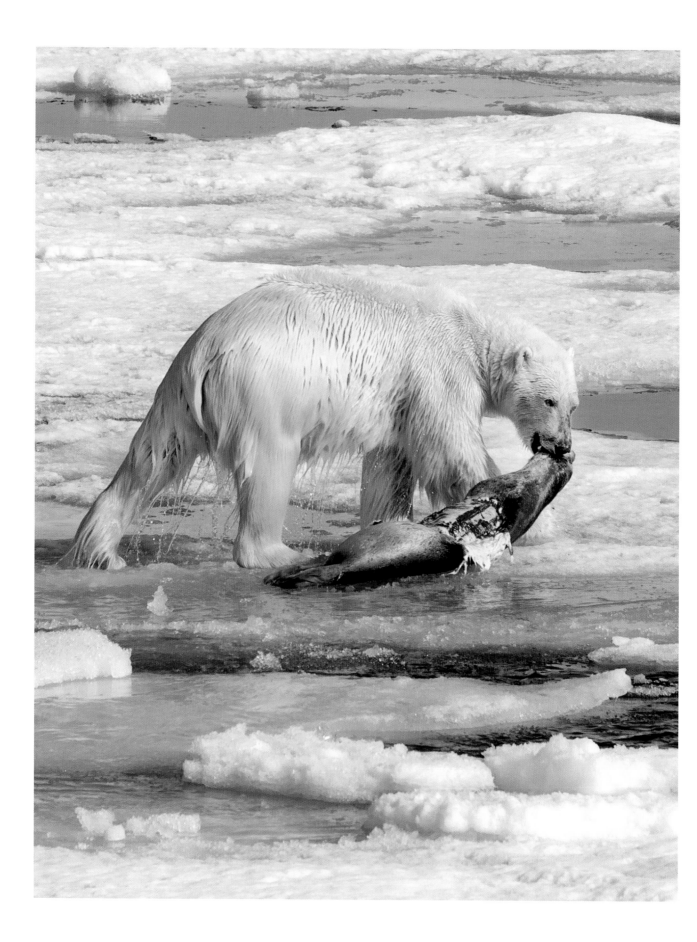

Ringed seals are the smallest, most abundant seal in the Arctic, with adults weighing between 110 and 150 pounds (50–68 kg). Pups are born in early April and eventually weaned six weeks later, in the middle of May. During that time, the pups are sequestered in the relative security of a snow lair, 5 feet by 6.5 feet by 1 foot high (1.5 m × 2 m × 0.3 m), which offers the mother and pup protection from the elements. The mother's relatively small size, and that of her 11-pound (5-kg) pup, is the reason they can use snow drifts to shelter themselves. Typically, the temperature inside an occupied den hovers around the freezing point, even as outside air temperatures may dip to –17°F (–27°C). Although a snow lair offers thermal protection for the tiny seal pup and its mother, it does not necessarily safeguard them from a hungry hunting bear.

Eminent polar bear researcher Ian Stirling believes that the months of April through July, when naïve young seals are abundant, are the most important months of the year for a polar bear. He estimates that a bear will consume roughly 70% of its entire annual energy intake in those few months. It's the time of the year when a bear has the best opportunity to replenish its fat reserves.

Rutting adult male seals also haul out in snow lairs during the May breeding season. Sexually active male seals have a strong, lingering odor which the Inuvialuit call *tiggak*. *Tiggak* seals are not eaten by the Inuvialuit in many areas because of the unpleasant odor and taste of the animal's blubber and meat. When biologist Tom Smith tallied the snow lairs dug into by bears, only 3% were those of rutting male seals, even though male lairs were much more common than this figure suggests. He concluded that polar bears, like the Inuvialuit, do not like to eat *tiggak* seals, and the bears avoid digging into their lairs.

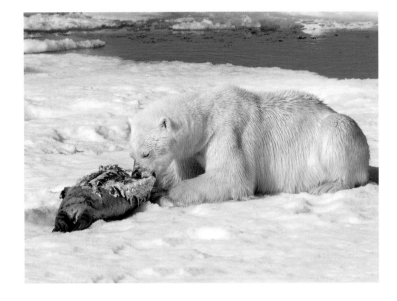

A feeding polar bear uses its incisor teeth like clippers to remove the energy-rich fat from beneath the skin of its prey

Polar bears use two methods to hunt seals on the sea ice: stalking and still-hunting. The most common method is the still-hunt, in which a bear lies on its stomach next to a lair or a breathing hole and waits. Ian Stirling, who spent hundreds of hours bent over a spotting scope intently watching bears hunting on Devon Island, Nunavut, believes that this posture produces the smallest silhouette when viewed by a seal from beneath the ice, and it is also the most comfortable one. Comfort is probably a consideration, since a bear must remain motionless for a considerable time when it still-hunts. On average, a still-hunt lasts 55 minutes, and Stirling timed some that lasted more than two hours. Any movement that a bear makes, even shuffling its feet, might alert a seal and cause it to use another breathing hole or lair. I once had the chance to listen with a hydrophone to the sounds under the sea ice, and I was surprised how much noise it made when a person walked across the surface. A seal would certainly hear any such movement from a bear.

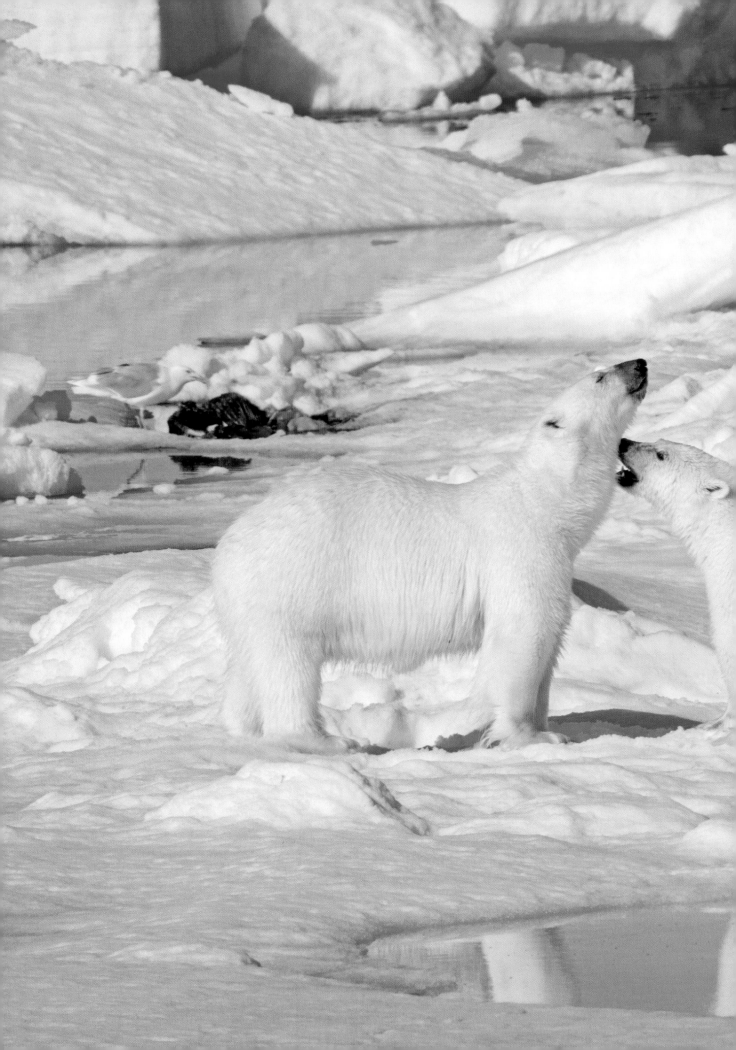

Although polar bears stalk prey much less frequently than they still-hunt, the stalk is the most exciting hunt to observe. In Lancaster Sound, I watched an adult female with two yearlings stalk a snow lair that turned out to contain an adult ringed seal. I wrote in my field notes: *The mother bear turned toward her two yearlings who trailed behind her by about 30 feet (9 m). The young bears immediately froze in their tracks. I was too far away to know if she vocalized to them or whether her gaze was enough to communicate her wishes. She started to stalk, moving one paw at a time, carefully planting each before she advanced another. After a couple of steps, she leaped forward a distance equal to twice her body length and plunged through the roof of the lair. The front half of her body disappeared into the snow. She withdrew in an instant, dragging the seal away from the hole. The cubs rushed to her side.*

Ideally a polar bear can crash through a snow lair in a single pounce, but whether or not it can accomplish this feat depends on the weight of the bear and the depth of the snow covering the lair. The snow on the roof of some seal lairs may be hard packed and 3 feet (0.9 m) thick, so it may take the bear several attempts to break through. The determined animal usually rises on its hind legs and forcefully pounds down on the lair with both front feet together. I watched one small bear pound seven times before the roof of the lair finally collapsed. Another time, I saw a subadult bear climb an ice hummock and leap from the top to break through the roof of a snow cave.

A young ringed seal pup sequestered in a snow lair spends up to 50% of its time in the water, perfecting its swimming skills and making dives as deep as 290 feet (89 m) and lasting up to 12 minutes. Because of this precocious swimming ability, a hunting bear must enter a snow lair as quickly as possible to prevent a seal pup from escaping underwater. Researcher Christian Lydersen of the Norwegian Polar Institute believes ringed seal behavior has been strongly shaped by the intense predation pressure from polar bears, resulting in pups spending a large proportion of time in the water, the development of diving skills at an extremely young age, the use of nine or more breathing holes, and the retention of the pup's white cryptic natal coat long after its thermoregulatory properties have vanished.

When a bear catches a seal, it immediately drags the animal away from the water to prevent it from escaping down the hole. Once the bear has dragged the seal onto the ice, it bites the animal several times on the head and neck. A seal's skull is very thin, and the animal dies within seconds of its capture.

Until roughly 50 years ago, no Western scientist had ever watched the hunting behavior of free-ranging polar bears. In the summer of 1973, Ian Stirling and his wife, Stella, spent several weeks on the southwest corner of Devon Island, in the Canadian High Arctic, where they logged over 600 hours of observations. From those observations and later ones, Stirling documented how polar bears hunt and eat seals, which parts of the seal they prefer, and the frequency with which they steal kills from each other.

In April and May, a polar bear may eat only the blubber, and sometimes the skin, of its kill and leave all of the muscles, bones, and viscera. A newborn ringed seal has just 13% body fat versus a fully weaned pup that is 45% fat. Because a newborn seal pup has so little fat, a bear may not eat any of it. Most of the calories in a seal carcass are in

the blubber. The entire carcass of a yearling ringed seal contains approximately 60,000 kilocalories, of which 41,000 kilocalories, or 68.8%, are contained in the blubber.

Researcher Robin Best calculated that an active adult polar bear requires 12,000 to 16,000 kilocalories per day to maintain its weight. This would be equivalent to a meal of 4 pounds (2 kg) of seal blubber or 11 pounds (5 kg) of muscle. Since a polar bear has a limited stomach capacity—roughly 20% of its body weight—it makes sense for a bear to eat only blubber. By choosing to consume only the high-calorie component of a carcass, a polar bear gains more weight than if it were to eat the less calorically rich parts, such as the muscles and viscera.

There may be a second reason why polar bears sometimes eat only the blubber. When a bear digests fat-rich blubber, the waste products are water and carbon dioxide. The water is used by the bear's body, and the carbon dioxide is expired through the animal's lungs. When a bear digests protein-rich muscle and viscera, however, the principal waste product is urea, which is excreted in the urine along with water. The water that is lost in the urine must then be replaced, and to do that a bear may be forced to eat snow. The energy required to convert snow at a subzero temperature to water at body temperature is substantial, and it greatly reduces the net energy gain derived from the meal.

There is one final point to consider. Subadult bears that are still growing and mother bears nursing rapidly growing cubs need additional protein in their diet. For these members of the bear population, it may be advantageous to eat the muscle and viscera of a carcass, as well as the blubber.

The assumption in all of this, of course, is that a bear can catch enough seals to enable it to be choosy, but that is not always so. Researcher Andrew Derocher sums it up like this: *If there is lots of blubber to eat, eat lots; if there is little blubber, eat protein; if there is nothing to eat, use the fat you have stored.*

Biologists calculate that a bear will kill a seal every 8 to 10 days. If it is a mother bear with cubs, the rate may increase to a seal every four or five days. Over an entire year, a solitary bear without a family to support will kill around 43 seals. Of the total, 47% will be pups caught in April and May, when they are still in their lairs, and 30% will be newly weaned, naïve pups taken in June and July.

Other Meaty Meals

The walrus is the largest prey that a polar bear hunts. An adult is 10 to 11.5 feet (3–3.5 m) long, weighs a strapping 1,800 to 2,600 pounds (800–1,200 kg), and readily defends itself with its pointed tusks. A landmark study done by Wendy Calvert at Dundas Polynya in the Canadian High Arctic took a closer look at how walruses and polar bears interacted in late winter and early spring. Female walruses with calves typically hauled out in groups of four or more animals. The calves always rested closer to the water than the adults, and though the calves often slept, their mothers remained alert. The males, in contrast, were less vigilant and were more reluctant to enter the water. Calvert wrote, *A polar bear could approach a male walrus to within a few meters. When a bear approached that closely, the walrus would back into the water slowly, ready to*

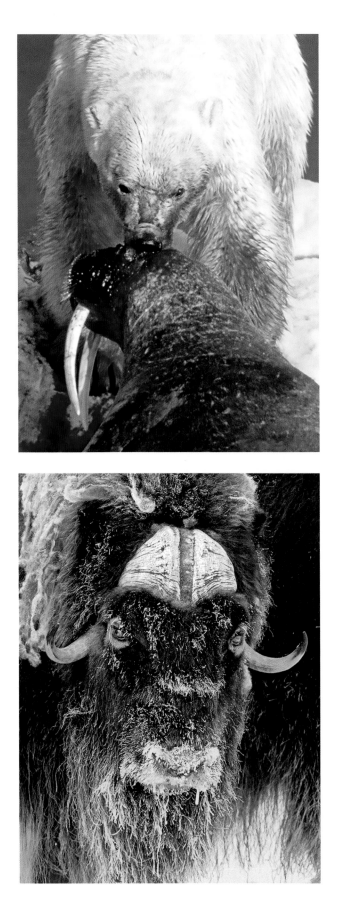

fight with its tusks if necessary. Over a nine-year span, Calvert found evidence of 10 walruses that she believed were wounded or killed by polar bears in the winter and early spring. The study concluded that polar bears may kill more walruses than has been previously suspected, and although calves and subadult animals are most vulnerable, large male polar bears are capable of also killing adult male walruses.

Marine mammals are the mainstay of a polar bear's diet, from the standard fare of ringed seals, to the less frequent dietary delights of bearded seals and harp seals, to the uncommon pleasures of whales and walruses. But the diet of polar bears, occasionally, includes the unusual.

In midwinter, a herd of muskoxen may leave their range on any of Canada's High Arctic islands and travel across the sea ice to another island. Helicopter pilot Steve Miller sighted a group of 9 or 10 muskoxen in the middle of M'Clintock Channel, 30 miles (48 km) from shore, headed for Prince of Wales Island. Out on the ice, the shaggy beasts might easily run into a polar bear. It's not known how muskoxen respond to polar bears in this situation, but it is safe to assume that the animals likely huddle together in the defensive circle that works so well for them against wolves.

When muskoxen are alone, they may be more vulnerable and more likely to be attacked. An Inuit hunter from Grise Fiord watched a polar bear attack a solitary muskox on the ice between Ellesmere Island and Devon Island, and in northeastern Greenland there are several reports of polar bears attacking and killing muskoxen, most often lone adult bulls. It didn't take a great stretch of my imagination to picture polar bears hunting muskoxen, especially once I learned that the shaggy beasts sometimes venture far from land onto the sea ice.

A more atypical polar bear food is kelp, which I still can't quite believe. Arctic researcher Ian Stirling wrote that *in some polynya areas where the water is shallow, such as along the coast of southeast Baffin Island, the kelp fronds lie against the underside of the ice and up into seal breathing holes. Polar bears feed on these plants extensively throughout the winter.*

In Norway's Svalbard Archipelago, kelp is commonly found in the stomachs of polar bears. In one autopsy, 19 pounds (8.5 kg) of the chewy stuff was discovered. An observer watched a female bear, together with her yearling cub, for over 30 minutes while they dove between ice floes to a depth of 13 feet (4 m) to retrieve the salty seaweed. Both bears came up with large tangles of kelp, which they laid on the ice. They ate the best, then dove again for more.

Humans eat kelp for the iodine and other trace minerals contained in the plant, and perhaps polar bears eat it for similar reasons. It's unlikely that we will ever completely understand the life of the polar bear, and it is fitting that there will always be some mystery surrounding the habits of this magnificent carnivore.

Ice Cold Carcasses

Fifty years ago, when Western scientists first began to observe hunting polar bears, everyone believed that subadult bears, being inexperienced hunters, were likely the ones that most often scavenged carcasses left by other bears. It turns out that all polar bears, regardless of their age or sex, would rather scrounge or steal a carcass than hunt for one themselves, and it seems that subadults can be very proficient hunters. One female subadult I watched in Lancaster Sound was such a successful hunter that researchers called her the "killing machine." While we were watching her, she killed four seals in a 42-hour span. We lost sight of her for 14 of those hours, so she may have killed other seals as well. At her last kill, this young bear, apparently satiated, played with the dead seal for 19 minutes before she began to eat. Six times she dragged the carcass back to the breathing hole where she had caught it and dropped it into the water. Each time, she hauled the dead wet seal out of the hole, dropped it on the ice, and stood over it for a time. When she finally abandoned the carcass, she had eaten very little of it.

Such partially eaten carcasses may be stolen or scavenged by any bear that comes along. One carcass that I watched for several days was visited by at least six different bears. In the end, all that remained was some bloodstained snow, a portion of a rear flipper, and a segment of the backbone.

Adult male polar bears are probably the most frequent scavengers. Their large size enables them to drive off most other bears and steal any carcass they want. One large male I was watching in Svalbard stole a carcass from a mother bear and her two cubs just 12 minutes after the mother had caught the seal. In the end, the family got very little to eat. Ian Stirling wrote about a courageous mother bear that defended her kill from an adult male twice her size. When the male first arrived, the female lowered her head and charged him. When the two separated, the female was bleeding freely from a wound on her right shoulder and the male was bleeding from a wound on the right side of his rib cage. The female then charged the male a second time, but he stood his ground and didn't budge. The rival bears stared at each other for about 30 seconds, then the male, the female, and the cub all began to feed on the carcass together. After 21 minutes of feeding, the female and her cub walked away to wash in a nearby pool. When they tried to return to the carcass, the aggressive male chased them away.

◀ This adult male polar bear ambushed a walrus on a large ice flow in the Chukchi Sea; he eventually killed the walrus by biting it repeatedly on the head and face

◀ The Inuit name for the muskox is Oomingmak, which means "the bearded one"

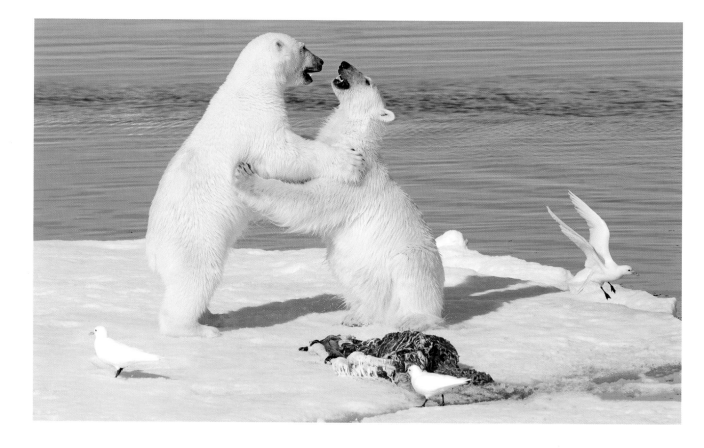

While these satiated two-year-old polar bear cubs played, a trio of scavenging ivory gulls fed on the remains of the seal carcass

It is uncommon for polar bears to cache a seal kill, but they have been reported to do so, under 3 feet (0.9 m) of snow, a couple of times in the Bering Sea. When the prey is small, a bear will usually eat until it is satisfied and then abandon the remains. When the prey is a large one, however, such as an adult bearded seal, which typically weighs 400 to 950 pounds (181–430 kg), a bear may spend a day or more feeding on it repeatedly. In a 2019 paper, Ian Stirling and three coauthors documented 19 instances of short-term hoarding by polar bears between 1973 and 2018 in Svalbard, Greenland, and Canada. Some of the observations included bears scraping snow over the unconsumed adult carcasses of ringed, harp, and bearded seals. In one instance, an adult male polar bear dragged the carcass of a beluga calf inland and covered it with grass, and in Hudson Bay, a cannibalistic adult male covered the remains of a yearling polar bear with seaweed raked from the beach. In every instance, the hoarding animal rested nearby guarding its prize.

When a bear finally leaves a carcass, other Arctic animals capitalize on the food bonanza. Ravens, Arctic foxes, and glaucous gulls are the usual scavengers. In Svalbard, 45 glaucous gulls were seen next to the carcass of a bearded seal. For me, as a photographer, the most handsome of the avian scavengers is definitely the angelic ivory gull. In Svalbard, I have seen these gulls arrive at a kill literally moments after the bear begins to feed. On the African plains, vultures closely monitor the movements of predators, and ivory gulls may do the same with polar bears. Or, as some suggest, the opportunistic

foregut, where their food is bathed in a broth of digestive enzymes and microbes. The microbes, namely bacteria and protozoans, break down the cell walls of plants, releasing the enclosed nutrients, which are then easily digested by the animal. Ruminants also regurgitate their food and rechew it, mechanically breaking it down as much as possible before they pass it along to the microbes. Horses, rhinoceroses, and tapirs have an enlarged chamber at the end of their small intestine, called the cecum, where microbes perform the same function they do in the foregut of ruminants. Rabbits re-ingest some of their feces, exposing their food to digestive enzymes a second time and extracting more nutrients in the process.

Most herbivores have a long digestive tract. The gut of a sheep is 25 times longer than its body. A typical carnivore has a digestive tract that is only four to eight times longer than its body. Clearly, the digestion of meat requires much less intestinal length than the digestion of plants.

Bears don't have a multichambered foregut. They don't rechew their food, have an enlarged cecum, or re-ingest their feces. Like most carnivores, they have a relatively short intestinal tract. All in all, bears are poorly equipped to feed on vegetation, even though it often constitutes the bulk of their diet.

Bears overcome the handicap of their digestive tracts by being selective in what they eat. Often they choose the parts of a plant that contain the least amount of indigestible cellulose, such as the flowers, seeds, fruits, bulbs, and roots. Bears eat the leaves and stems of plants when the plants first emerge, which is when they

Coprophagy is the technical term for eating feces or dung, as this Arctic hare is doing

contain less cellulose, are easier to digest, and contain more nutrients. Fresh green grass contains 14% to 26% protein, and the catkins of aspen poplars have 20%. Newly emergent sedges in the coastal marshes of British Columbia are 26% protein, as are sprouting horsetails in the Rocky Mountains of Alberta; however, the nutritional quality of horsetails decline to 16% in less than a month. During hibernation, bears burn not only fat but also muscle, and they lose on average 10% to 20% of their lean muscle mass, so protein is important in their early spring diet to recover these losses. In Alaska, Grant Hilderbrand found that, in a small sample of six hibernating female brown bears, the animals lost between 49 and 141 pounds (22–64 kg) of lean muscle mass during their winter denning.

The nutritional quality of vegetation changes rapidly in spring, and bears modify their foraging strategies to compensate. Initially they feed on the first shoots of spring, but as these dry out and increase in fiber content, bears may limit their grazing to moist shaded sites where plant maturity is delayed. Bears also tend to shift from grasses and sedges to broad-leafed forbs, which are generally more nutritious later in the growing season.

Eating great quantities of a plant is another way that bears compensate for their inefficient digestive systems. Alaskan biologist David Hatler reported a black bear whose stomach contained nearly five quarts (4.7 liters) of horsetail shoots.

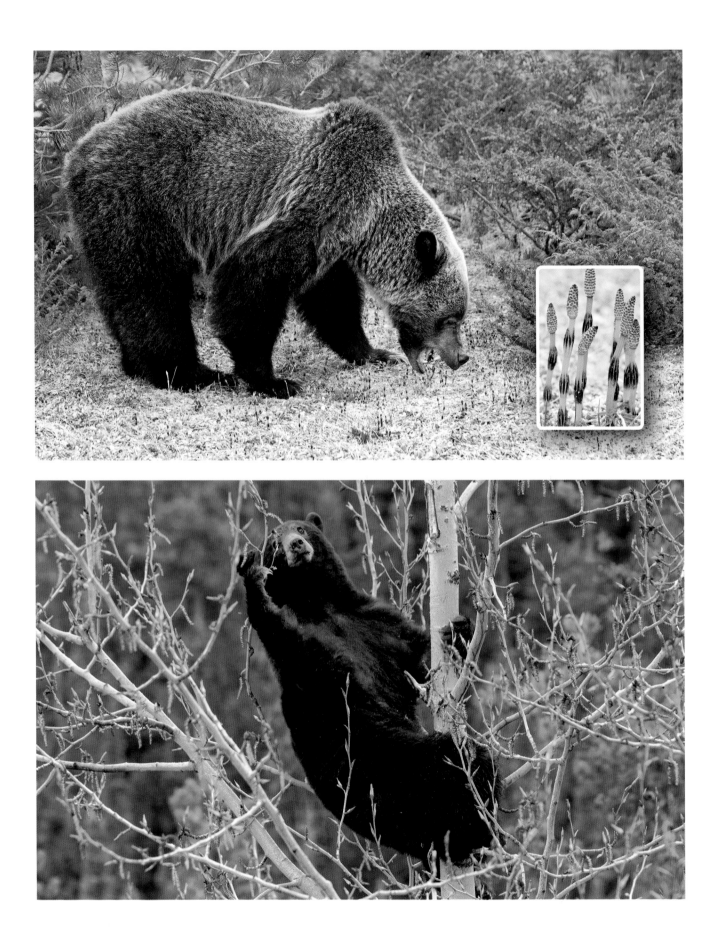

DROPPINGS AND DIGESTIBLES

The diet of bears has attracted more scientific interest than any other aspect of their biology. My reference files just for brown bears include over 200 scientific papers that concentrate on diet alone, and roughly 500 papers more that include some diet information. The reason so much is known about what bears eat is simple: scats, also known as feces, droppings, and dung. Scats are abundant, easy to find, and cheap to analyze. All you need is a strong stomach, an inquiring mind, and a deft hand to tease the turd apart. One researcher, Kerry Gunther, used scat analysis to exhaustively determine the dietary breadth of grizzly bears in the Greater Yellowstone Ecosystem. He began by reviewing scientific papers, books, PhD and MSc theses, and state and federal reports published from 1891 to 2013. In total, the data was drawn from 11,478 scats. Grizzly bears in Yellowstone, as everywhere, are opportunistic omnivores, and from his study, Gunther concluded that their diet included 266 species comprising 175 plants, 7 fungi, 37 invertebrates, 7 birds, 4 fish, 26 wild mammals, 8 domestic mammals, and a single species of amphibian.

A researcher can learn a lot from a bear scat. Viewed under a microscope, the spicules of a feather can identify the type of bird that was eaten. The pattern of scales on a hair can distinguish between a mouse and a moose. Claws, teeth, bones, and beaks are a cinch to identify, as are the seeds of a fruit, the bristles of an earthworm, the antennae of an ant or wasp, and the carapace of a beetle. Scats not only tell you what food a bear has eaten but may sometimes also tell you when the bear ate the food. The remains of fly larvae or scavenger beetles in a dropping are a clue that a bear fed on an animal that may have been dead for some time.

There is one pitfall in using scats to determine a bear's diet. A scat represents the parts of a meal that were not digested. Thus, any food that is completely digested will not be detected. For example, a researcher may never know that a bear ate a mouthful of mushrooms or a large lump of meat because both of these foods may leave no trace in the animal's scats. Nevertheless, scat analysis is an established technique that has taught us much about the diet of bears.

A myth that is fun to dispel is that a grizzly scat is always larger in diameter than that of a American black bear. This is false. The diameter of a bear dropping is dependent primarily upon the size of the bear and what it has eaten, not by the type of bear. Bear scats are often formless, especially those resulting from the digestion of berries, horsetails, and meat. If a scat is well-formed, you can go out on a limb and use the 2-inch (5-cm) rule. A scat with a diameter less than 2 inches (5 cm) is probably from a black bear, and one that is larger probably belongs to an adult grizzly. There's one thing I have learned: you can almost always distinguish between an old scat and a fresh scat by the presence of steam rising from the latter.

Early Spring Diet

Fresh spring growth begins to appear as soon as the snow disappears. In mountain regions, the melt begins in April and May at low elevations and on avalanche slopes, and these are the first areas to attract bears, which feed on the newly emergent grasses

◀ Horsetails are a nutritious early spring food for grizzly bears. Botanists describe the plant as a "living fossil" that was the dominant understory vegetation for 100 million years during the Paleozoic era.

◀ This chocolate-colored American black bear spent over 20 minutes eating aspen poplar catkins

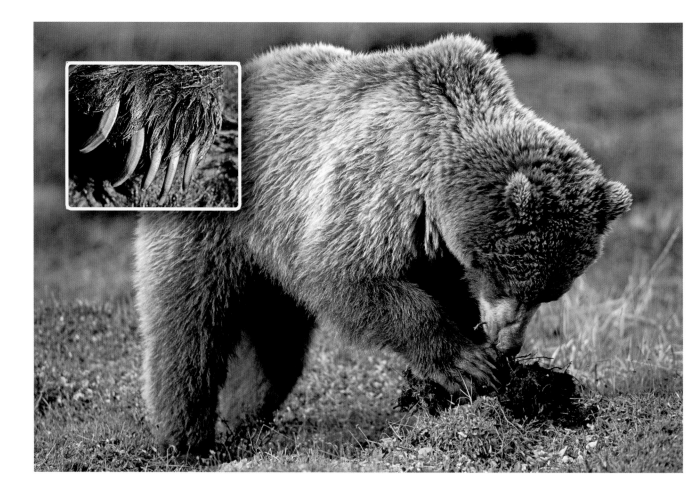

Rake-like claws help this grizzly bear dig for the nutritious roots of alpine sweetvetch

and sedges. In coastal regions, bears are attracted to tidal marshes for the same reasons. Along the tideline, bears can also feed on seaweeds, mussels, and crabs, and a lucky bruin may even find the beached carcass of a whale or a seal. Eastern skunk cabbage is one of the earliest plants eaten by bears in the eastern United States. Despite the plant's fetid smell, it is a botanical wonder. The plant generates its own heat and keeps its flower temperature at a remarkably constant 70°F (21°C), which is sometimes 63°F (35°C) warmer than the air. The heated flower can melt its way through ice and snow. Bears never eat anything but the flowers and young leaves of the skunk cabbage. The older leaves, the stem, and the root of the plant are filled with sharp, microscopic crystals of calcium oxalate, which would inflame the mouth of any bear foolish enough to chew on them.

In spring, both Asiatic and American black bears climb into the crowns of poplar trees, up to 50 feet (15 m) high, to eat the catkins and newly unfurling leaves. As the bears climb, their claws scratch deep furrows in the bark. You can see the evidence of this spring feeding activity many years later, for the scratches remain as black linear scars.

Whereas black bears are built to climb, brown bears are built to dig. The hump on a brown bear's shoulders is a mass of muscle that powers its front limbs. Add to this a formidable set of claws, and you have an impressive digging machine. In Alaska, I watched a female grizzly till up an alpine slope as she dug for sweetvetch roots. The

JUNE

The scientist does not study nature because it is useful to do so.
He studies it because he takes pleasure in it,
and he takes pleasure in it because it is beautiful.
If nature were not beautiful,
it would not be worth knowing and life would not be worth living.

JULES HENRI POINCARÉ, *French mathematician*

IN 1948, THE YEAR I WAS BORN, few zoologists studied animal behavior. Most believed that it was genetically predetermined and driven by instincts, and thus an unproductive field of study. Any reports on animal behavior were largely anecdotal.

In the 1950s, attitudes and biases began to change. Zoologists, starting with the famous Dutch researcher and Nobel laureate Niko Tinbergen began to accept that animals can learn, and that they may also adapt their behavior to their environment. It was the dawn of a new field of science—ethology, the biological study of animal behavior.

As a student of animal behavior, I could live in no better time. In the past 60 years, ethologists have uncovered a wonderful diversity of animal behavior, a repertoire richer with complexities than anyone imagined. Often when I spend many hours concealed in a photo blind observing wildlife, I think of George Schaller, one of the world's preeminent field biologists, and his warning not to ignore the validity of anecdotal observations. He cautions that, although the conspicuous, easily described behavior can be turned into statistics, the difficult and rarely seen is no less real and should not be ignored or considered irrelevant.

The premier driving force in all animals is to procreate, to pass on their genes to as many offspring as possible. Not surprisingly, some of the most interesting discoveries in animal behavior involve reproductive biology, and in bears those discoveries raise several interesting questions. Why are some male bears twice as large as females? Why are some females promiscuous? Why do males chase and kill young cubs? Why do some female bears begin to breed when they are 2.5 years old, whereas others wait until they are seven or eight? And, finally, why would a female bear abandon her cub and let it die? The first half of this chapter looks at these intriguing questions.

◄ Early summer bear habitats in North America have many different faces: the Rocky Mountains (top left), the sagebrush flats of southern British Columbia (top right), the Arctic tundra (bottom left), and the cypress swamps of Louisiana (bottom right)

THE MATING GAME

The breeding season for all northern bears lasts several months. Most brown bears and black bears breed between mid-May and early July, with the greatest activity occurring

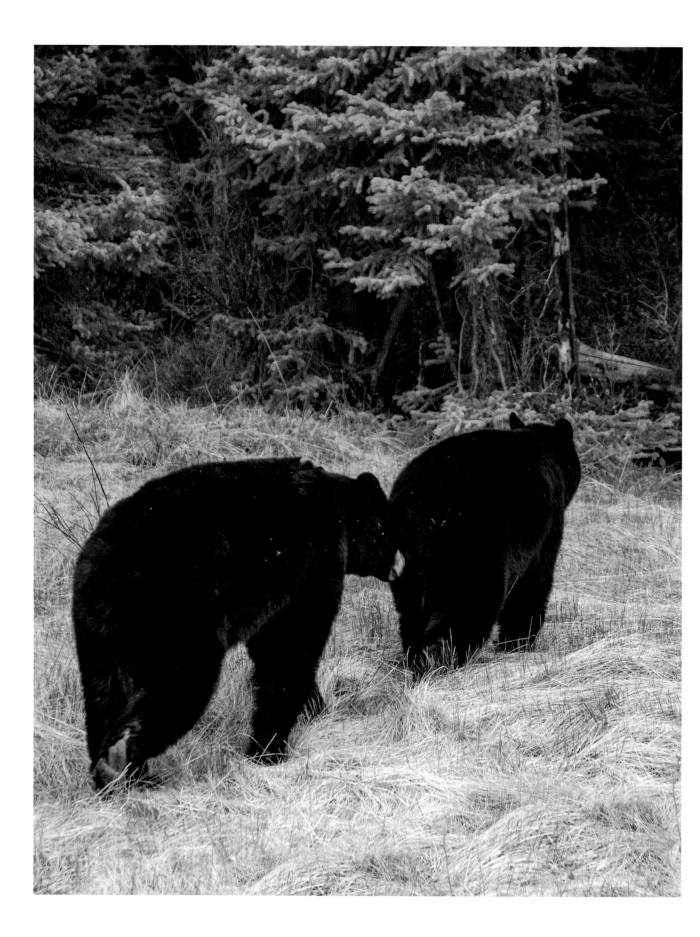

didn't copulate again for three days, but then mated on May 12, 13, and 14. During the matings, the bears stayed coupled for 66 to 150 minutes. While mounted, the male went through successive periods of strong rapid pelvic thrusting lasting two to five seconds followed by periods of rest. Bears are known to be multiple ejaculators and the pelvic thrusting was probably associated with ejaculation. During the 13 days the mating pair was together, 12 different bears approached them, some as close as 55 to 109 yards (50–100 m). When two rival males approached at separate times to within 55 yards (50 m), the defending male charged the challenger each time, wrestled him to the ground, and locked his jaws around his rival's throat. The defeated males always stopped fighting and lay motionless on their back. Within a minute, the victor would release his grip and return to the female, allowing the male to escape relatively unharmed.

Reports of wounds, scars, fractured ribs, and broken canine teeth are widespread in male brown bears and polar bears as well as in both species of black bear. During the breeding season, I have seen male brown bears with injured front legs, broken lower jaws, and gaping facial lacerations. One spring I had a chance to closely examine an adult male polar bear during the breeding season. I wrote in my journal afterwards: *The bear had a number of old scars on his nose and forehead, half of his right ear was missing, and the fourth claw on his left front paw was broken off at its base. There were two fresh puncture wounds on his left shoulder that were draining pus.* The worst injury I ever saw was on a male brown bear along the McNeil River in Alaska in late May. The victim had a large flap of skin and muscle, 5 inches (12.7 cm) wide and about a foot (30 cm) long, running from the right side of its neck to its upper shoulder. The torn flap flopped up and down when the animal ran.

The fact that male bears are so much larger than females is another indication that males compete with each other for the privilege to mate. When male and female animals differ, they are referred to as being sexually dimorphic. The differences between the sexes in bears are in body weight, skeletal dimensions, and the size of their canine teeth. In polar bears, as well, the guard hairs on the rear edge of a male's front

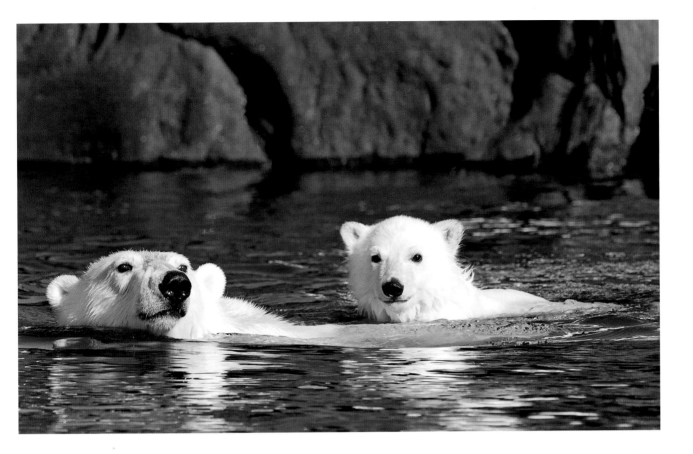

and her spring cub. The sow tried to escape from her pursuer by fleeing up a steep snow slide. The inclined slope and soft snow fatigued the cub, and eventually it stopped after climbing for 30 minutes. The big male caught up to the cub, grabbed it by the head, and shook it until it was dead while the cub's mother watched helplessly from several hundred yards away. Afterwards, the male continued to pursue the female, and the pair disappeared over a ridge.

Less commonly, female bears are the killers. In an incident in Alaska's Denali National Park, a female grizzly with twin cubs of her own killed two cubs belonging to another female when the two families accidentally wandered close to each other. One of the reasons proposed to explain infanticide, especially when the culprit is a female, is to reduce competition for food and space for the killer and her offspring.

The search for a source of nutrition when food is scarce could be a second potential motivation for infanticide. In the Horton River area of the Canadian Arctic, a female grizzly and her three cubs-of-the-year were killed by another bear. All three cubs were eaten, and the mother's body was partially consumed. No culprit was identified, although it was assumed to be a hungry adult male. On Hopen Island, Svalbard, biologist Andrew Derocher reported two instances of infanticide and cannibalism in polar bears. In the first case, an adult male killed three young cubs at a den site and consumed one of them. From the size of the tracks, the culprit

This nervous mother with a yearling cub fled to the water when an approaching male bear was still several hundred yards away

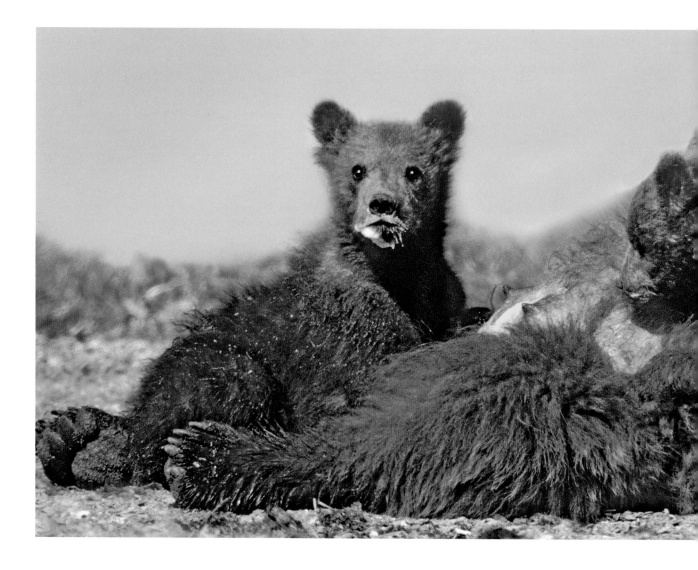

was assumed to be an adult male more than five years old. The second instance, which also occurred on Hopen Island, was captured on video. In this case, an adult male, estimated to be more than eight years old because of the scarring on his body, persistently chased a mother and her 18-month-old cub. The male was dogged in his pursuit and followed the pair when they attempted to escape by swimming among some offshore ice floes. When the fleeing family swam back to shore and ran up a rocky slope toward the base of a steep, unclimbable cliff, the male caught up with them and killed the yearling. The male dragged the carcass down the slope and fed on it. After feeding briefly, he took the remains to an ice floe roughly 200 yards (183 m) offshore where he fed on it for another two days. Little remained of the carcass when he finally left. In another instance in Sweden, researchers reported a case in which an 11-year-old male brown bear killed a mother who was traveling with three young cubs. Examination of the site showed evidence of a ferocious fight. The body

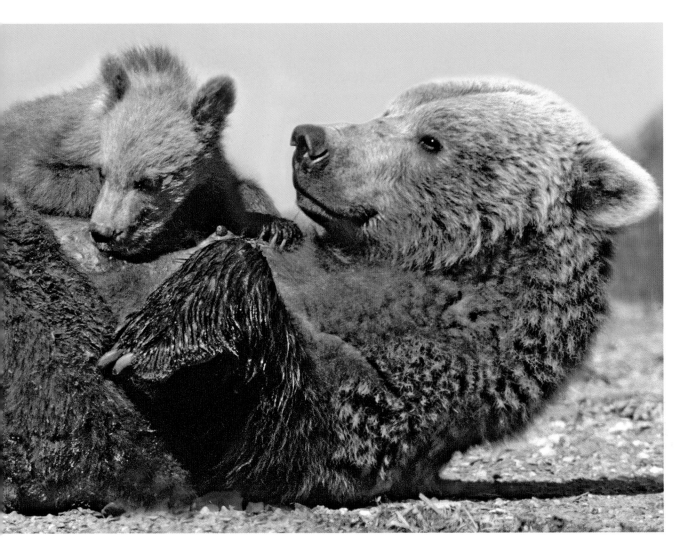

of the killed mother, partially eaten, was covered with moss. Two of her cubs were found alive in a nearby tree.

The most common explanation for infanticide is to create a mating opportunity for a male bear. Killing a cub creates a breeding prospect in the following way: when a female's only cub is killed, she stops nursing, and she comes into heat shortly afterwards; a persistent male may then eventually breed with her. In many species of mammals, the stimulation from suckling young inhibits estrus through the production of hormones such as prolactin and oxytocin. In Sweden, Sam Steyaert reported that within just a day or two of a female losing her litter and the cessation of nursing, her behavior shifted dramatically from the sedentary, secluded movements of a mother protecting her cubs to the roam-to-mate pattern of a female seeking a male partner. In interior Alaska, female grizzlies with cubs stayed within an average home range of 38 square miles (99 sq. km) and moved just 2 miles (3.2 km) a day. The home range of

Nursing brown bear cubs begin to feed on vegetation when they are roughly six months old. A mother bear is less able to protect her cubs when nursing, so she rarely does this when an adult male is nearby.

females that lost their litters expanded fourfold to 160 square miles (414 sq. km), and their daily movements increased to 4.7 miles (7.6 km). Older mothers that lost cubs moved more than younger females, suggesting that older mothers had more experience and perhaps roam more actively.

Steyaert reasons that for infanticide to be an effective male reproductive strategy, three conditions need to be fulfilled: males should kill only unrelated and dependent offspring, the murder of cubs should trigger estrus in the mother, and the infanticidal male should have a high probability of siring the victimized female's next litter. All of these conditions often occur, but obstacles can interfere with the best of plans. A murderous male bent on passion might first have to battle a very dangerous and protective mother bear and risk possible injury from her while attempting to kill her cubs. Even assuming that a male succeeds in dispatching the cubs, possibly by stealth or surprise, he still has to follow the female for some days until she becomes sexually receptive. During this time, she might elude him or, worse yet, be stolen from him by a dominant male.

Mother bears seem acutely aware of the danger that male bears present to their offspring, and they employ a number of defensive strategies, one of which begins even before the cubs are born. When a female bear is in heat, she may breed with three or more different males, and two or three of them may father a cub in the same litter. Such multi-male mating might allow her to increase the genetic diversity of her offspring, but this idea is still controversial. There is no controversy about another benefit of promiscuity: it confuses the paternity of the cubs. It's assumed that male bears recognize which females they mated with, and they don't kill any cubs they may have fathered.

Another strategy mothers employ to reduce the risk of infanticide is in the selection of their winter den site. Female grizzlies in Denali National Park den at higher elevations and on steeper slopes than adult males. Biologist Nathan Libal thought that, to avoid detection by resident males, female grizzlies move through male denning areas before the males arrive, and then delay their spring departure until after the males have abandoned their dens.

Once a mother bear is out and about with her family in spring, she continues to adopt behaviors to combat infanticide. Female polar bears with small cubs-of-the-year tend to hunt in shorefast ice—away from the floe edge and shifting pack ice where most of the male bears hunt. In an interior Alaska study, 60% of brown bear cubs died in their first summer, and two-thirds of the deaths occurred between May 31 and June 16, during the peak of the breeding season. Researcher Craig Gardner compared the behavior of mothers that lost cubs with those that did not. He observed that females with surviving cubs remained within 0.5 miles (1 km) of their den for a longer period after emergence than females that lost cubs. Between den emergence and the onset of vegetation green-up, females with surviving cubs used fewer habitat patches, 6 to 11, versus the 15 to 30 patches used by mothers that lost cubs, and the successful mothers stayed in those habitats longer. He also noted that successful mothers moved less between midnight and midmorning. Elsewhere in Alaska, in May and June, mother grizzlies with cubs choose elevated steep slopes on which to rest during the day and at night. These isolated sites are well away from the normal travel paths used by bears

◀ A young American black bear cub finds refuge in a lodgepole pine tree. The scaly bark makes climbing easier.

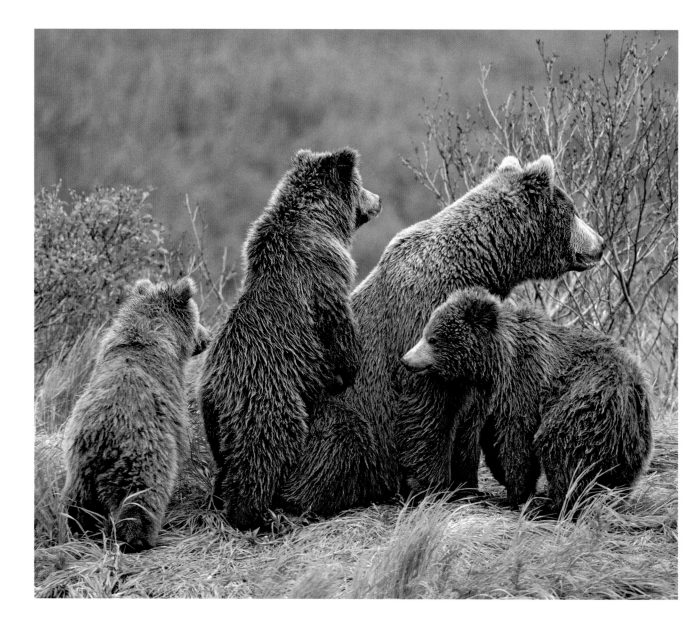

and provide the family with a good vantage point from which to detect other bears, especially adult males that travel widely at this time of the year.

The extreme density of bears along some salmon streams in Alaska can present a heightened risk to a mother with cubs since close encounters with other bears are inevitable and frequent. Surprisingly, some mother brown bears on Admiralty and Chichagof Islands avoid feeding at such nutritionally attractive streams, seemingly for no other reason than to lessen the risk of infanticide. Such a foraging choice can have a serious impact on a female's lifetime reproduction. In most areas where brown bears feed on salmon, the females reach sexual maturity early, they have large litters of cubs, and short intervals between litters. On the ABC Islands, the mother bears that stayed away from salmon streams did not begin reproducing until they were eight years old,

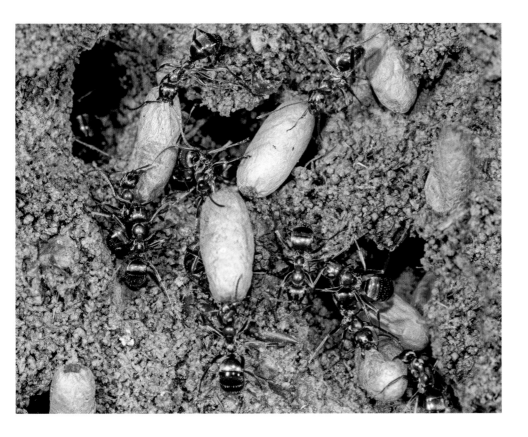

When an ant nest is suddenly attacked by a foraging bear, the first response of workers is to move the colony's larvae deeper underground

Janene Auger discovered that black bears in Utah had a similar summer diet of ants, technically referred to as myrmecophagy, and most commonly foraged for species that nested under rocks. She followed one trail for 165 yards (150 m), and nearly every rock beside it had been flipped over by a bear, although most contained no ants underneath. Most of the rocks were small ones, weighing less than a pound (0.5 kg), but one exceptionally large boulder weighed a whopping 306 pounds (139 kg). The stomach of one 90-pound (41-kg) 2.5-year-old male bear contained 4.6 pounds (2.1 kg) of ants: 7,840 workers and 54,700 larvae, pupae, and eggs, which constituted a third of the bear's daily energy needs. Larval ants outnumbered adults by seven to one, and since larvae are completely digested and never appear in droppings, these insects may play a larger role in a black bear's diet than suggested by scat analysis alone. In Central and South America, two ant-eating specialists, the giant anteater and the northern tamandua, consume 14,253 and 9,000 ants per day, respectively. Auger concluded that black bears appear to be in the same league as these ant predators of the American tropics.

Ants are on the menu of Asiatic black bears and brown bears as well. Japanese researcher Koji Yamazaki watched black bears in Nikko National Park, where the hungry bruins spent seven to eight hours a day feeding on ants, potentially consuming 60,000 of them. The bears foraged for the insects in June and July, possibly as a supplement to their regular summer diet of fruit, flowers, and grasses. They, like bears

In the tropics of Central and South America, the habitats of five ant-eating mammalian specialists overlap; two of these specialists are the giant anteater (top) and the northern tamandua (bottom). In North America and northern Eurasia, there are no ant-eating specialists, but ants form a significant part of the diet of both black bears and browns.

everywhere, concentrated on the ant nests when the numbers of pupae were highest. Pupae are likely preferred over adults because they are higher in energy content, more digestible because they lack a chitinous exoskeleton, lack offensive and defensive traits, and cannot escape by themselves, as they need to be carried to safety by an adult worker.

Brown bears in Europe may feed on ants more than they do in North America because of the abundance of large mounds of red forest ants in Eurasian woodlands. In some northern forests, there may be 73 of these large ant mounds per acre (180 per ha). Mound-building red forest ants concentrate near the top of their mounds in spring to

soak up heat from the sun, and bears are consequently able to harvest substantial numbers of them without consuming much unwanted anthill debris. In central Sweden, researcher Jon Swenson concluded that ants contribute about 20% of a brown bear's annual digestible energy intake.

Although ants are by far the most common invertebrates eaten by bears, the adaptable bruins never miss an opportunity to consume some convenient calories. Black bears in coastal British Columbia forage in the intertidal zone, scraping barnacles off rocks and flipping over cobbles searching for luckless crabs trapped by the receding tide. On Kodiak Island, Alaska, windrows of beached kelp decompose on the shoreline after springtime storms, attracting a rich array of invertebrates, such as beach hoppers, that brown bears lap up with enthusiasm. There are no ants on Kodiak, and the beach hoppers may serve as an ecological substitute. American black bears in Sonora, Mexico, the most southern population of the species, commonly feed on scorpions. After summer rains, male scorpions travel on the soil surface searching for females, and this exposes them to predation. Farther north in California, researchers watched a black bear slowly wade along the vegetated shoreline of a lake feeding on emerging dragonflies. Bears everywhere, relying on their intelligence, memory, and flexibility, find a way to extract nutrition from the most unlikely environments.

JULY • AUGUST

*Those things are better which are perfected by nature
than those which are finished by art.*

CICERO, *Roman statesman, first century BC*

COVERING THE NORTHERN POLE OF THE EARTH is a vast dome of ice that never completely melts. Because it is permanent, it has sometimes been mistaken for land. Unlike land, however, this massive island of ice floats atop the Arctic Ocean and rotates slowly in a clockwise direction, completing a revolution every three to four years. In winter, the ice fuses with all of the polar lands that circle the Arctic Ocean: Canada, Alaska, Russia, Greenland, and Norway's Svalbard Archipelago. In summer, however, the edge of the ice is often miles from the nearest land. Off the north coast of Alaska, for example, the ice edge may be 300 miles (483 km) or more offshore.

In summer, polar bears try to remain on the pack ice as long as they can so they can continue to hunt seals, but in many areas of the North, the ice melts completely and the bears are forced to spend part of the summer on land. This period of compulsory shore leave is naturally longest for those bears that live in the most southern regions, such as those in Hudson Bay, the great body of Arctic water that penetrates the mainland of northern Canada. The bay is covered with ice well into summer, cooling the surrounding land so that the climate is much colder than is usual for such latitudes. As a result, some James Bay polar bears in southern Hudson Bay live at the same latitude as London, England, and as my home in Calgary, Alberta. They display a range of interesting behaviors as they attempt to adapt to the ice-free conditions and relatively warm temperatures of summer life in southern Hudson Bay.

◄ Polar bears begin to abandon the pack ice when the coverage falls below 30% to 50%

BEARS ON THE BEACH

The polar bears of Hudson Bay begin to come ashore in July, after the ice coverage declines to 30% to 50%, although the last of the ice does not disappear from the bay until the middle of August. As the bears come off the ice, they settle into different areas of the coast, depending on their age and sex.

The big adult males position themselves along the shoreline on headlands, or on small offshore islands, settling on top of old beach ridges that are close to the water. These are the preferred sites because they can be reached with the least amount of walking, and they intercept any breeze blowing off the water. Both male and female

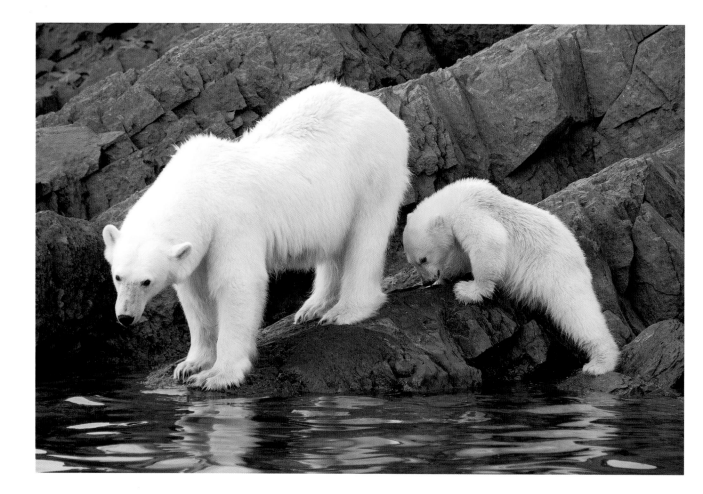

This mother polar bear and cub were stranded on an island in the Svalbard Archipelago, surrounded by a great expanse of open water and many miles from the retreating edge of the melting pack ice

subadult bears hang around the coast with the adult males, but since they are subordinate to them, they end up with all the spots the males don't occupy.

Adult females, both those with offspring and those that are solitary and presumably pregnant, move 12 to 25 miles (20–40 km) inland. They do this for very good reasons. In this part of Hudson Bay, most pregnant adult females spend the summer in the same place where they will eventually den in the winter to have their cubs. Researcher Andrew Derocher believes that when mother bears return to the area in the summer with their cubs, the young female cubs in particular become familiar with the denning area. Later, when the female cubs mature and become pregnant for the first time, they return to the same general area used by their mother. Another reason for mother bears to move their families inland is to avoid encounters with adult males, most of whom stay on the coast. Derocher, who has seen adult males chase females with cubs during the summer, believes that females may settle inland to reduce the risk of infanticide.

Another of the interesting discoveries that Derocher made was that from one summer to the next all the bears return to the same general area where they spent the previous summer. In fact, when he monitored individual bears for six summers in a row, every year he found the bears within 18.5 miles (30 km) of where they had first

been located. Since the bears have hundreds of miles of coastline to choose from when they come ashore, the bears seem to know where they want to go and how to get there. Many return to the same spot year after year.

Polar bears are usually thought of as loners, but once they come ashore, adult males often cluster in groups. The average group has four males in it, but one exceptional gathering that Derocher saw had 14 bears. The composition of these male groups changes constantly throughout the ice-free period. Bears leave one group and join another. When a helicopter would approach a group of males, they might huddle together until they were touching each other, and if they fled, they often ran as a group, shoulder to shoulder. A rare photograph taken by researcher George Kolenosky shows a cluster of nine adult males, sitting on their rumps side by side, facing forward as though they were part of a circus act.

Derocher speculated that adult males gather together to become familiar with each other. Because the bears return to the same spots each summer, and because they are not competing for food or mates at that time of the year, it is a perfect opportunity for them to get to know their neighbors, particularly their strengths and weaknesses. In the final analysis, these friendly get-togethers may actually be a method for adult males to assess and establish rank.

Once the bears have settled into their respective summer locations, they make themselves comfortable. Polar bears in Hudson Bay, and everywhere else in the Arctic, dig shallow pits that resemble the familiar daybeds dug by brown bears and black bears. In areas north of Hudson Bay, snowdrifts may survive through the summer in sheltered ravines and north-facing slopes. When this happens, bears may simply park on top of a snowdrift or dig right in and bury themselves inside a snow den. On northern Baffin Island, snow can usually be found in summer. In a deep ravine, biologist Ray Schweinsburg found 22 snow dens strung along the top of a single snowbank over 0.5 miles (0.8 km). In Svalbard, biologist Odd Lønø saw 15 bears at dens they had dug into snow drifts. The bears used the dens on days when the temperature got warmer than 44.6°F (7°C). On cooler days, they would sometimes lounge at the mouth of their den soaking up the sunshine.

In southwestern Hudson Bay, bears dig earthen dens. Most of these are dug in habitat far inland from the coast. Typical dens are only 3 to 6.5 feet (0.9–2 m) deep, but on high eroded banks along lakeshores, some are more like burrows. The largest may extend 19.5 feet (6 m) into the earth and terminate at permafrost, which helps keep the den interior cool. Ian Stirling tells a funny story about the time he was inside a summer den measuring the permafrost when he suddenly noticed something white moving 3 to 4 feet (0.9–1.2 m) away in an adjacent chamber. He left in a hurry and signaled the helicopter pilot to hover overhead and scare the bear out, where he could tranquilize and examine it. The white mirage in the den turned out to be an adult male bear weighing 1,450 pounds (658 kg)—the largest bear he had ever tranquilized and examined.

The deep burrows may not only keep a bear cool, but may also reduce the mosquitoes, blackflies, and horseflies. I have been in this area of Hudson Bay a few times in

successful. In the small Alaskan stream I monitored for almost a month, I saw one adult female brown bear catch eight pink salmon in just 40 minutes. Along the McNeil River, it is common for bears to catch 50 chum salmon in a single day. According to former refuge manager Larry Aumiller, the record catch at McNeil was made by an adult male bear named Groucho who caught 88 salmon in one day. Groucho also holds the record for the greatest number of salmon caught in one season: 1,018—and those are just the fish that Aumiller saw the bear catch during the daytime. Groucho may have caught other salmon at night. The chum salmon that bears catch at McNeil Falls commonly weigh 5.5 to 10 pounds (2.5–4.5 kg). If Groucho had eaten all of the salmon he caught on the day of his record catch, he would have consumed a minimum of 441 pounds (200 kg) of salmon—a physical impossibility.

Fishing at night also effects the reaction that bears have to each other. In darkness, they may fish less than 16 to 33 feet (5–10 m) apart, and they rarely show any aggression to each other. During the daytime, they are often less tolerant, even though the distance separating them is much greater. Many fishing bears seem to prefer to be visually isolated from each, although they can likely hear their neighbors splashing about.

Biologists naturally wondered why fishing bears were more successful at night. In darkness, salmon schools move closer to shore and are less responsive to shoreline disturbance. Dan Klinka speculates that the bruins may be at an advantage in twilight and darkness because they possess a tapetum lucidum, the reflective layer at the back of the retina that enhances visual sensitivity in low light conditions. Salmon lack a tapetum and may be less visually responsive at night, relying instead on sense organs in their skin that detect movement and vibration in the water to help them evade predators. During the day, salmon tend to shelter in the shadows under logs, but at night they are less wary of shallow water and move into these areas to spawn. Spawning salmon splash around, and bears can use these sounds to target their victims. By shifting from visual to auditory cues, nocturnally foraging bears are able to exploit a time when fish are more vulnerable.

Not all spawning salmon are of equal interest to a hungry bear. As soon as a salmon begins its upstream journey to its natal spawning grounds, it stops feeding and begins to metabolize its own tissues. Ultimately it will lose 80% to 95% of its lipid reserves and 40% to 80% of its total energy value by the time it finally dies on the spawning grounds. Bears can likely assess the differences in energy content among salmon because these differences are visible in the skin pigmentation, body fungus, and wounds of a fish. Researcher Scott Gende thinks that the fishing bruins selectively kill salmon with a higher energy content. If the water is deep, a bear may be unable to visually evaluate the condition of a fish. Only after it has caught the fish can the bear make a decision on whether to eat it. Gende thinks bears consume more of a carcass that is "ripe" and has yet to spawn than they do of one that has finished spawning. Bears will sometimes catch a female salmon, sniff its anus for the presence of eggs, and if it has finished spawning, leave it. Of course, how much of a salmon carcass a bear eventually eats depends upon how hungry the bear is, whether the fish is a male or a female, the stage of the spawning cycle, and how easy the fish are to catch. Early in the season,

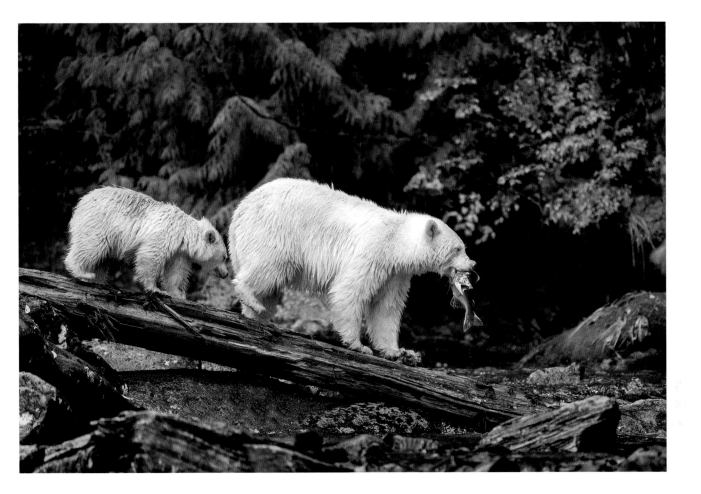

a famished bear may consume the entire salmon, whether it is a male or a female. Later on, when the fishing is easy, and a bear has caught many salmon, it may discard males completely and eat only the fat-rich eggs, brain, and skin of females, leaving the protein-rich flesh untouched (which, incidentally is the part that humans relish).

In a black bear study in Gwaii Haanas National Park Reserve in coastal British Columbia, biologist Thomas Reimchen watched bears catch 16 salmon in a row and release all of them. All the discarded fish were males. Only when a gravid female was caught would the bear take the fish to the river bank, step on its belly, and lick up the eggs that squirted out. After that, the bear would often press its nose to the fish's belly to squeeze out any remaining eggs, eat those, and then return to the river to catch another fish.

The number of fish that a bear captures at a salmon stream is sometimes influenced more by the bear's social rank than by the abundance and vulnerability of the fish. If a stream is dominated by a large adult male, his aggressive behavior may intimidate other bears and negatively impact their fishing behavior. For example, a subordinate bear may visit a salmon stream less frequently than a higher-ranking bear, and it may stay for a shorter length of time. As well, it may limit its fishing activities to smaller

A mother spirit bear caught a dying pink salmon as it swam weakly in a shallow eddy at the edge of a narrow stretch of rapids

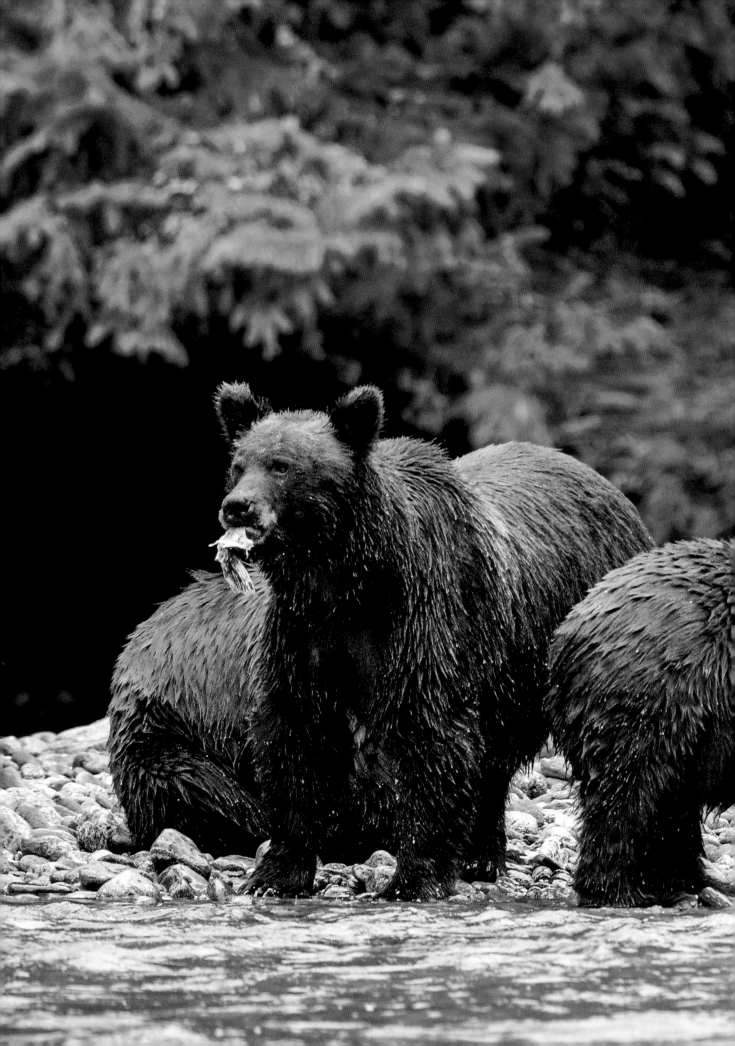

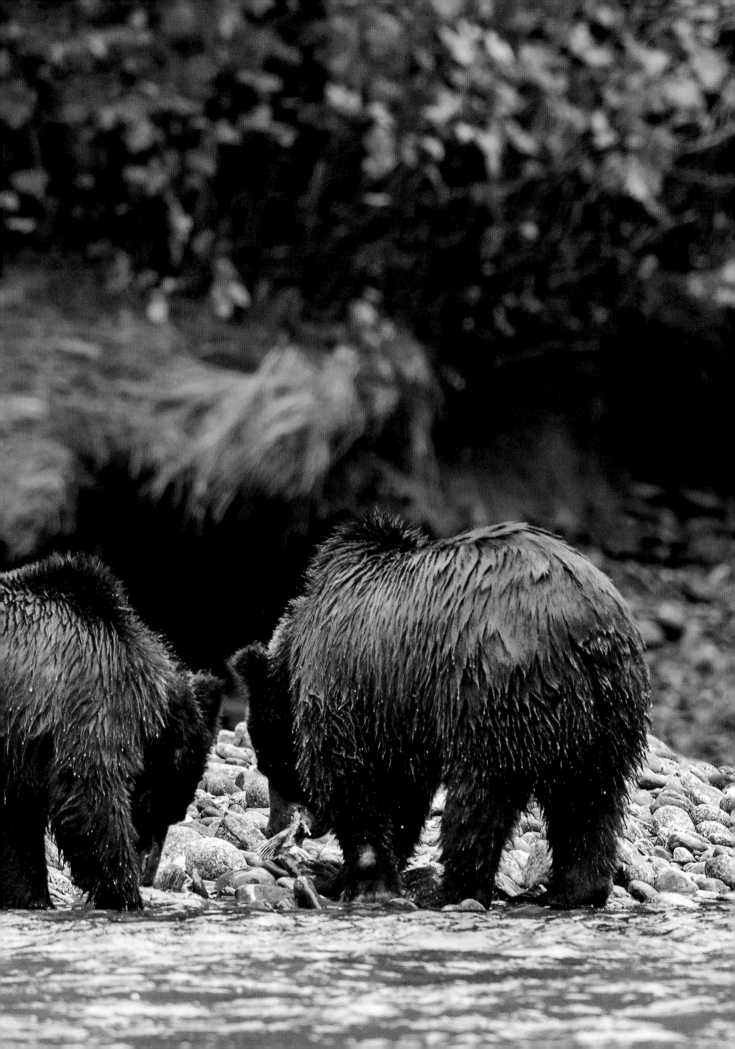

Family of brown bears scavenging the remains of dead chum salmon caught earlier by other bears and abandoned

In the same way that lions, hyenas, and jackals watch the descending flights of African vultures to locate carcasses, opportunistic bears may watch the flying behavior of bald eagles to steal fish from them

stretches of riverbank and carry any salmon it catches farther into the forest to minimize interactions with other bears. Scott Gende thinks that the risks of injury, and even death, for some subordinate bears may be so great that they never venture near a salmon stream at all and choose instead to forage in less productive but safer habitats, such as berry patches. This pattern of avoidance was apparent in a brown bear study in coastal British Columbia where subadults and mother bears with vulnerable cubs foraged almost exclusively during the day, at dusk, and at dawn, when they could visually monitor the movements of large adult males that might pose a danger.

Social dominance not only operates between bears of different ages and sex, but also between bears of different species. On the Kenai Peninsula in Alaska, both brown bears and black bears may fish at the same salmon spawning streams. In these instances, the brown bears are always dominant over the black bears and force their smaller relatives to adopt a set of avoidance strategies similar to those just described for subordinate brown bears. In a Kenai study, Jennifer Fortin found that the diet of the local brown bears was 66% salmon, 13.9% other animal matter (primarily adult moose and calves), and 20% plants and fruit, versus the diet of the resident black bears, which was 8% salmon, 8.4% other animal matter, and 83.6% plants and fruit, especially alpine blueberries, black crowberries, rose hips, Sitka mountain ash, and high-bush and low-bush cranberries. Because the brown bear is so much larger than the black bear, its energy needs are much greater and the use of salmon streams is a necessity. The black bears, on the other hand, being smaller, can meet their energy needs consuming alternative foods such as fruit.

Although bears are often choosy about which fish they catch and which parts of it they consume, discarded carcasses are rarely wasted. A bear will often return later to eat more of a carcass once the salmon run slows down; subordinate bears can do very well by scavenging the carcasses abandoned by others. These lower ranking animals, however, need to be quick to compete with the many avian scavengers that invariably flock around a salmon stream. I have seen cheeky ravens steal a fish from under a bear's nose, and a feeding bruin is often surrounded by a dozen squabbling gulls that attack the remains as soon as the bear turns away. Typically, along most salmon streams in North America, bald eagles course up and down looking for the dead and discarded. Even when a group of gulls are the first to claim a salmon carcass, an interested eagle simply scatters the gulls with a power dive and pirates the booty.

Resource waves occur throughout nature, and many species of wildlife surf them. In Chapter 3, I discussed how bears will follow the snow melt up a mountain slope to take advantage of the green wave of new vegetation or move into shaded sites where the greenery matures later in the season after the vegetation in more open areas has dried out and is less digestible. Bears and salmon streams are another example of consumers

"surfing the resource wave." In response to local water temperatures, salmon spawn at different times in different streams. Bears seeking to maximize their use of salmon spawning streams need to track the variation in spawning times and exploit the different watersheds when they are optimal. Researcher William Deacy calculated that individual salmon runs are available for roughly 40 days, but bears that visited the most spawning sites fed on the fish for as many as 120 days—three times longer than would be possible if the bears didn't surf the wave.

The Salmon Forest

Most people know that Pacific salmon, unlike most other marine fish, die soon after they reproduce. The salmon, swimming upstream on the spawning runs that will end their lives, are part of a conveyer belt of nutrients and energy. Oceanographer Dale Stokes writes in his fascinating book *The Fish in the Forest: Millions of tons of salmon flesh are transported into the nutrient-poor freshwaters that then shape the salmon forest. . . . When a salmon dies, the elements that make up its flesh are absorbed back into the ecosystem through the action of the predators, scavengers and decomposers of the forest.* This sequence of events explains the startling connection between this legendary fish and the verdancy of the temperate rain forests of coastal British Columbia and Southeast Alaska, which are home to monstrous 1,400-year-old red cedars and Sitka spruce that tower skyward for 328 feet (100 m). Scientists were able to discover this remarkable ecological relationship because of nitrogen, which comprises 78% of Earth's atmosphere. The element nitrogen has seven negatively charged electrons and seven positively charged protons, but a variable number of neutrons in its nucleus. Elements with different numbers of neutrons are called isotopes. Nitrogen has two stable isotopes, nitrogen-14, which makes up the vast majority of naturally occurring nitrogen, and nitrogen-15. Conveniently, nitrogen-15 is more abundant in marine organisms than it is in terrestrial ones, so when an organism such as a Pacific salmon, of any species, ends up in the terrestrial environment, it contributes a small amount of nitrogen-15, which can be tracked through the different levels of the food chain. The organisms in each of the levels acquire a so-called nitrogen-15 signature, which reveals how much of their structural nitrogen originated in the ocean. Bears represent one of the major links in this transfer of energy.

In various Alaskan studies, 49% to 68% of salmon, including chum, pink, and sockeye, were transported by bears into the forests adjacent to salmon spawning streams. Thomas Reimchen studied salmon-fishing black bears in Gwaii Haanas National Park, British Columbia. During the middle of the chum salmon run, the small local population of eight bears transferred an estimated 80 salmon carcasses a day into the forest over a 45-day period. Most of the dead fish were left streamside, but some were carried as far as 500 feet (150 m) away from the water. Generally the bears left at least 40% of the carcass uneaten, but sometimes they left as much as 60%. In total, Reimchen estimated the bears abandoned 12,037 pounds (5,460 kg) of salmon on the forest floor, of which 2,866 pounds (1,300 kg) were scavenged mainly by gulls and northwestern crows, with the remaining 8,000 pounds (3,629 kg) being consumed

In streams where salmon spawn, the entire ecosystem benefits from the infusion of marine-derived nutrients

primarily by blowfly maggots. Additionally, the bears caught another 1,030 salmon, which they ate in the stream channel, discarding an estimated 3,907 pounds (1,722 kg) into the water, which was subsequently consumed by a dozen different aquatic invertebrates. The decomposing carcasses released nitrogen and carbon into the water, which was then absorbed by streamside vegetation.

A multitude of studies now unequivocally confirm the nutrient enrichment that salmon carcasses provide to the local ecosystem. In spawning streams, the invertebrate fauna densities are up to 25 times higher. A salmon carcass is an "ecological hotspot" for invertebrate abundance with midges increasing to 84,500 per square foot (7,850 sq. m).

Many levels of the food chain benefit from spawning salmon, including (from top to bottom, left to right) blowflies, rough-skinned newts, hermit thrushes, Pacific wrens, and Steller's jays

• THE FULL MEAL DEAL •

IN THE LAST 10 YEARS, a popular research topic among biologists is macronutrient optimization. This simply means that an animal, in this case black bears and brown bears, will purposefully regulate the amount of macronutrients (i.e., protein, carbohydrates, and fats) they consume so as to maximize dietary efficiency and growth. A common pattern among black bears and brown bears is to seek springtime foods that help to rebuild muscle mass lost during hibernation and help support lactation in females nourishing cubs, and in autumn to consume foods that promote fat accumulation needed for winter hibernation.

Researcher Shino Furusaka's observations support this idea. Furusaka found that Asiatic black bears in Japan tended to eat fresh leaves in May, when the greenery had a high protein level and a low level of fiber. In early summer, when the protein level in the vegetation decreased and the fiber increased, the bears switched to ants. In late summer and early autumn, when the bears were preparing for hibernation, they gorged on berries and acorns, which are high in carbohydrates and fats but relatively low in protein. This seemed intended to maximize fat accumulation. So, were the bears eating those foods because those were the only foods that were seasonally available, or were they sometimes making choices to optimize their nutrition? Joy Erlenbach and her colleagues wanted to answer this question, so they designed a diet study with captive brown bears. When the bears were given unlimited access to proteins, carbohydrates, and fats,

they selected a mixed diet that limited protein intake to an average of 17% and secondarily consumed fats and carbohydrates to maximize their fat accumulation. It is well known that high protein intake can have undesirable metabolic consequences and predispose one to diabetes, kidney disease, and metabolic acidosis. When the bears' diet was manipulated to provide more protein and less fat and carbohydrates, the bears were unable to gain weight as they had done when they could limit their protein intake.

One reason for this is that protein is more difficult to assimilate than fat or carbohydrates. In the wild, bears seem to make the same kinds of dietary choices to maximize their nutrient needs at each particular time of the year. Brown bears feeding on salmon are a good example of this. Even when the bears have unlimited access to the high-energy, protein-rich flesh of salmon, they will leave the spawning grounds to preferentially feed on berries, which build up fat reserves faster than would happen if the bears continued feeding on salmon.

After finding no salmon, this unwary spirit bear walked directly toward me as I sat by the edge of the stream. I had to yell sternly when it was just 20 feet (6 m) away to keep it from approaching any closer.

season progresses and the bears become satiated with salmon, a dominant animal may gradually allow other bears to fish closer to it, and it may even relinquish its fishing spot to a subordinate. It's clear that rank alone does not determine the outcome of every encounter. The stakes involved and the motivation of the animal are also important. For example, a satiated bear is less motivated to defend its position than a hungry one.

There is a second circumstance in which bears may not strictly adhere to the established hierarchy. Bears, like humans, can form alliances to improve their rank. In Chapter 4, I described how some subadult bears stayed together for several years after their family broke up. At a salmon stream, such a pair of subadults has a higher status than a lone subadult, and the two bears can use their enhanced rank to obtain better fishing spots. Another example of an alliance was observed by biologist Tom Bledsoe, who watched an estrous female brown bear that was followed by a male suitor use her association with the adult male to temporarily roust higher-ranking females from choice fishing spots.

Most interesting is the alliance that bears sometimes form with people. Biologist Larry Aumiller, who worked in the McNeil River Brown Bear Sanctuary for decades, knew most of the bears by sight. Aumiller believes bears that are tolerant and unafraid of people may use humans to shield themselves from other bears. One time, Larry and I were watching a female bear named Teddy that was being chased by another female. Teddy, who was quite habituated to humans, ran straight toward us as we sat on a slope beside the river. The other bear, which was more wary of people, stopped the chase when she saw that we were there. It appeared that Teddy had used her tolerance of humans to shield herself from her adversary.

A final factor that can modify a bear's rank is its temperament. Anyone who spends more than a couple of days observing a group of bears at a salmon stream soon discovers that bears are individuals, each with its own personality and temperament. At one end of the scale are bears that are extremely placid and rarely become aroused. I have seen some placid adult females who would allow almost any bear, including subordinates, steal a fish from them. At the other extreme are bears that are quick-tempered and aggressive. These bears will not tolerate another bear anywhere near them when they are fishing, and they are quick to charge and attack any trespasser that dares to provoke them.

The differences in individual temperament in bears may also explain the different reactions that bears display when confronted by a human. Some bears may charge immediately and make contact, whereas others may charge and then veer off or suddenly stop before they reach the person. More tolerant bears may simply walk away when they meet a human, and some timid animals may flee in fright, crashing noisily through the bushes. This individual variability in the behavior of bears explains in part why humans find them so unpredictable.

Bears are frequently classified as solitary animals, but in fact there is no such thing as a solitary animal. Bears may not only end up side by side when they feed in groups, but males and females must come together when they mate, and females and their offspring travel together for years during lactation. In all of these circumstances, bears

◀ When a bear stands on its hind legs, as this subadult brown bear is doing, it's not about to charge but simply trying to see better so it can decide what to do next

need some method to relay their intentions and wishes to each other. They do this with a communication system that uses the animals' eyes, ears, and nose.

THE LANGUAGE OF BEARS

Visual Signals

Carnivores, as a group, use a rich array of visual signals to convey information to each other. Typically, such signals are used to communicate over short distances, generally in face-to-face encounters. Long tails can be held level with the body, tucked between the legs, dragged on the ground, or held erect above an animal's back. Each position conveys a different message. The tail can be further enhanced as a signal if it is tipped with white, as in the cheetah, the African wild dog, and the red fox, or if it ends in a terminal tuft, as in the African lion. Even when an animal's tail is short, as in the bobcat, the presence of a white underside can draw attention to it and make it an effective signaling device. Carnivores also use the position of their ears to relay information, and ear spots or tufts have evolved in a number of species to enhance their conspicuousness.

Carnivores use other visual signals as well. Long, dark hair on the shoulders and back of some species can be raised to make an animal appear more imposing. Those that cower on their back to signal submission often have white belly fur, which accentuates this display. And, finally, many carnivores, especially the social ones, have a rich repertoire of facial expressions, including snarls, licks, and grins to convey a range of intentions.

Bears have short tails and relatively small ears, and they lack accentuating tufts and white belly fur. Nonetheless, they have other markings that are thought to function as visual signals. All Asiatic black bears and many American black bears have a white chest patch, and both species have a tan muzzle that contrasts with the black fur of their face. In addition, American black bears have tan-colored areas above their eyelids, and Asiatic black bears have white or cream-colored fur on their chin and along their lower lip.

A bear can send a visual signal in a number of different ways: through its body posture, the position of its head (held high or low, facing forward or looking away), the position of its ears (held erect or flattened), and the position of its mouth (either closed or open), combined with subtle lip gestures. Biologist David Henry, who has studied both American black bears and red foxes, feels that bear visual communication is very similar to basic canid communication.

Vocal Signals

Vocal signals, in contrast to visual ones, can usually transmit information over great distances and can also be effective where visibility is impaired, for example, in thick vegetation or in darkness. The howls of wolves and coyotes and the roars of tigers and African lions are well-known examples of long-distance vocal communication.

▶ Subtle changes in the position of the tan-colored areas above an American black bear's eyes are likely used in communicating mood and intent

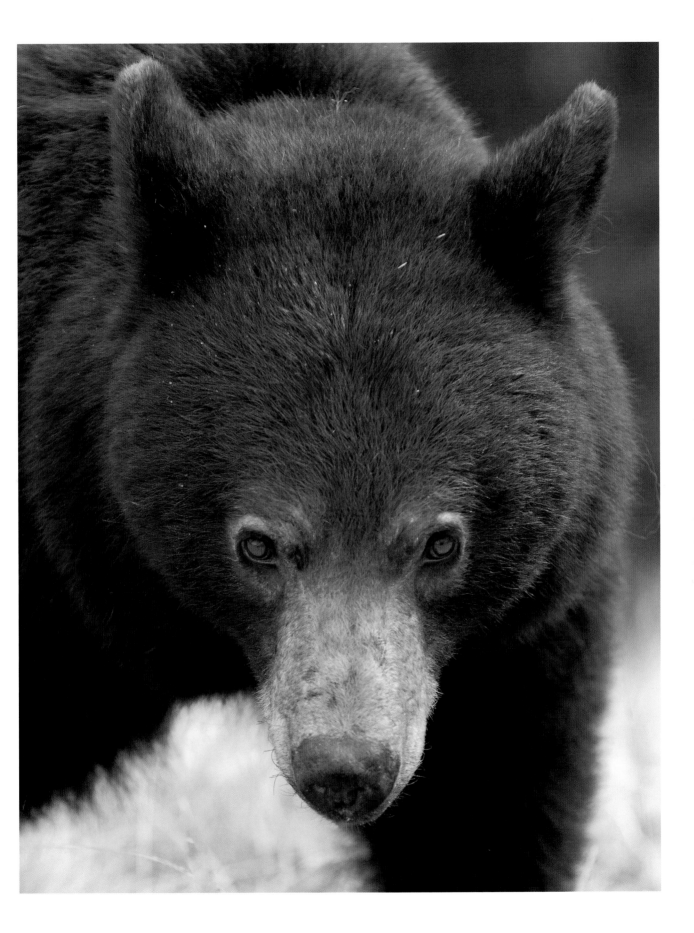

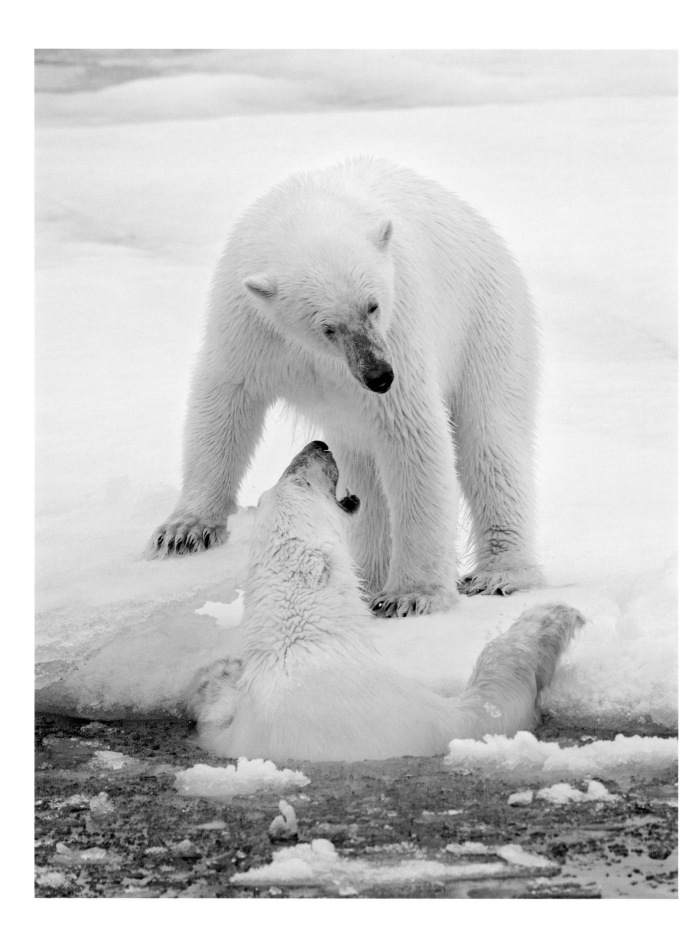

Bear-bitten rub trees are at the top of my list of favorite animal signs. Minnesota biologist Lynn Rogers described how one male black bear bit three different trees along a 0.5-mile (1-km) stretch of dirt road. According to Rogers, the bear stood on his hind legs and rubbed his upper back, especially his neck and shoulders, against the trees. As he rubbed, the bruin frequently twisted his head around to bite the bark. At one of the trees, he dropped down on all four feet and rubbed his hindquarters against the trunk. At a fourth location, the bear rubbed against a fallen wooden signpost. He lay on his back and squirmed with his four feet in the air, twisting occasionally to bite the post. In 2013, Alberta conservation officer Glenn Naylor posted a two-minute video, accompanied by catchy banjo music, on YouTube. Entitled "What Goes On When You Are Not There," the video shows different black bears and grizzlies using a rub tree, as well as other mountain wildlife, such as cougars, white-tailed deer, and elk, lured to the tree for a sniff. In one section of the video, a mother grizzly and her three yearling cubs approach the tree together, bump-and-grind, stretch-and-straddle, and rub-and-roll on the trunk and ground at its base. To date, the video has had over 3.5 million views, with respondents claiming that the hilarious clip looks like the bears are pole dancing. Alberta ecologist John Paczkowski calls rub trees the "Facebook of the Forest." From camera traps, he calculated that the average grizzly spends 8 to 12 minutes at such a tree.

A myth that has persisted for a long time is that a bear will bite or claw at the highest point it can reach on a tree to scare away smaller bears from the area. Any rival bear that later comes along and can't reach as high immediately realizes that it is outranked and leaves. Biologist Gary Alt jokes that if this were so, and he was a black bear that could climb as well as black bears can, the first thing he would do is locate the tallest well-used marker tree in the area, climb up, and chew off the top.

Trees are the most common objects bitten and rubbed by bears, but they will also target trail signs, bridge pilings, rocks, and telephone poles. In one instance, they even chewed on the corner post of a farmer's porch. Bears may rub on trees at any time of the year, but the behavior is most common from May to July, the core months of the breeding season, when it is most often adult males that rub on trees. At other times of the year, adult females, subadults, and even cubs may also do it. In a Yellowstone study, Gerald Green confirmed that rubbing peaked in May and June and declined rapidly after that. The marked trees sometimes occurred in groups, with 15 sites having two marked trees, and another half dozen having three or four.

Researcher Melanie Clapham studied brown bears in coastal British Columbia to evaluate the differences in scent marking among different age and sex classes. She discovered that adult males spend more time sniffing a rub tree and marking it, and they use more complex behavior sequences. The scent-marking sequences in females were more simplistic, and subadults displayed the simplest marking patterns of all.

In a thorough search of an area in the Smoky Mountains of Tennessee, graduate student Tom Burst found 691 trees bitten by black bears. The trees were found along ridge tops, in valley bottoms, and along game trails, hiking trails, and roads. In Minnesota, virtually all of the bear trees were at the edge of openings. In Alaska and

◀ This adult male American black bear stopped beside a trail and began to rub and bite this young spruce tree, most likely a marking behavior

British Columbia, I have found many trees bitten by brown bears, and they were in the same kinds of locales as those chosen by black bears.

It is important not to confuse a bear rub tree with other trees that bears have clawed or bitten. Black bears may climb trees to feed on fresh leaves and catkins, cool off, escape from biting insects, and flee from danger. When they do, they may unintentionally scratch the bark with their claws. In Chapter 4, I described how black bears and brown bears may strip the bark from tree trunks to feed on the underlying sapwood, but trees marked in either of these ways is not a true rub tree.

The marks on a bear rub tree are easy to recognize. Often the bark, and even some of the sapwood, has been completely removed from a section of the trunk, leaving a large oval depression up to 3 feet (0.9 m) in length. Most bite marks occur about 5 feet (1.5 m) above the ground and face toward an open area or trail. A rub tree may be used for many years and develop a thick callus around the site of the damage, making it even more conspicuous. On close inspection, it's possible to see individual tooth and claw marks, and sap often oozes from the site, especially if the tree is a conifer. As further evidence of their repeated use, many bear rub trees have quite visible foot marks, 2 to 3 inches (5–7.5 cm) deep, worn into the ground, leading to the tree. In Yellowstone, the foot mark trails averaged 20 feet (6 m) long. Every rub tree I have ever examined also had strands of hair stuck in the resin or in the cracks in the bark. Some even had mud smeared on them.

A bear rub tree may be any size, from one as small around as your wrist to one that is so large you can't encircle it with your arms. Bears appear to select trees for their strategic location rather than their size. Other considerations may be the texture of the bark and its ability to hold a scent, and its aromatic qualities.

Bear-bitten trees have been called "rub trees," "challenge trees," "scratching trees," "marker trees," and "bear blaze trees." This confusion of names reflects the lack of agreement among early observers about the purpose of this behavior. One hypothesis was that bear trees assist in grooming and help the animals dislodge parasites and remove old fur during the summer molting period. Another was that bear rub trees define the boundaries of an animal's range. Neither of these ideas is fashionable today. It is argued that the grooming hypothesis fails to explain why primarily adult male bears would need to scratch but not females and subadults, and the boundary hypothesis makes no sense since bear trees are found throughout a bear's range and not concentrated along borders, as you would expect if they were boundary markers.

Bear trees clearly serve as signposts. They are visually conspicuous, and since bears rub and bite these trees, the bears' scents may linger and act as an odor signal for other bears in the area. I have never been able to detect any scent at a rub tree, but that doesn't prove anything.

After Tom Burst did a comprehensive survey of bear rub trees in Tennessee, he proposed four possible functions for them: (1) To help adult male bears avoid each other and thus minimize conflicts. Bears using an area would mark the trees, and their odor would then yield up-to-date information about who was in the area and how long ago they visited. (2) To advertise an individual's movements so that any

▶ A rub tree from the Canadian Rocky Mountains that had been used for many years. Large areas of bark were removed from the trunk, and great clumps of grizzly hair were stuck in the resin.

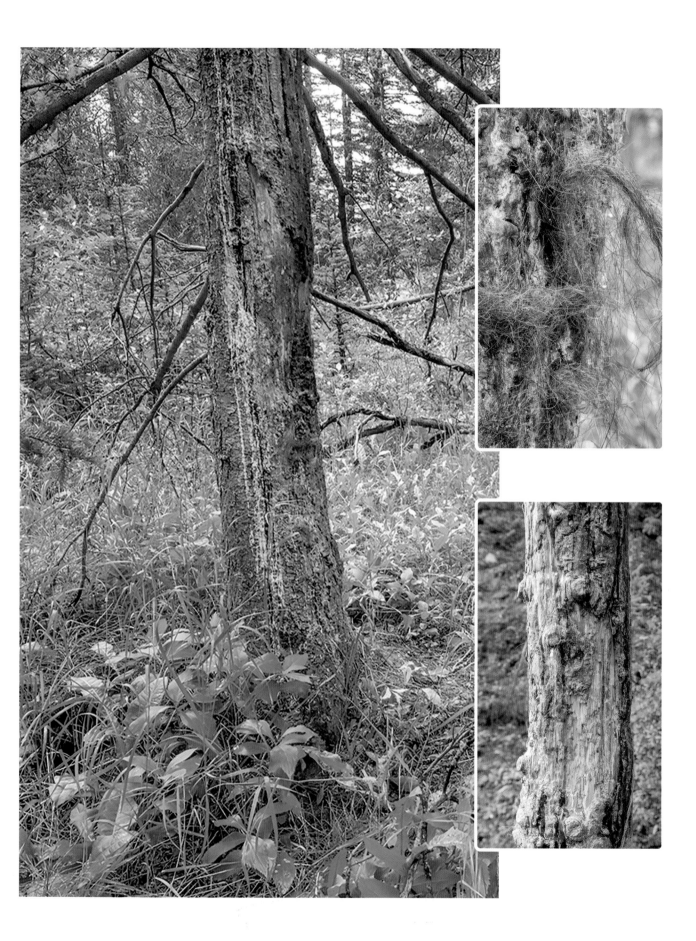

bear that followed behind could change its course if it wanted to find an untouched area in which to feed. (3) To help a bear orient itself in a novel or rarely visited area. (4) To promote estrus in females and synchronize it with the male's presence. Although these ideas are attractive, they are still just hypotheses, and all of them remain largely untested. What is certain is that the trees are a form of olfactory communication, the purpose of which is still unclear.

A DAY IN THE LIFE

In recent decades, our understanding of the daily life of bears has increased greatly. Some of the most innovative field observations were done 30 years ago by Minnesota biologist Lynn Rogers and his assistant, Greg Wilker. Rogers habituated black bears to himself and Wilker so that the two men could tag along with them in the forest and observe the animals at close range, monitoring their every move, right down to the number of bites they took of every food they ate.

Other researchers, namely Dian Fossey studying mountain gorillas and Jane Goodall with chimpanzees, proved that habituated animals could yield rare insight into the fine details of an animal's life. Rogers and Wilker followed a well-established path. The Minnesota researchers habituated their study bears by first establishing a feeding station where the animals received handouts of beef fat. Once the bears became accustomed to people at the feeding station, the researchers approached them in the forest. At first the bears were uneasy, but after roughly 100 hours of contact, they became accustomed to being approached, fed, and accompanied by a human in the forest. Once this stage of habituation had been reached, Rogers stopped feeding the bears. After that, he and Wilker could follow them from less than 30 feet (9 m) and be ignored by the animals.

It took another 100 to 150 hours to further habituate the bears to the foibles of their human observers. During this time, the bears learned not to be frightened by a human sneeze or a cough and not to be startled when an observer tripped or fell, even when the bear was accidentally hit by its human companion. Through all of this, a bear never once attacked the researchers. In the end, Rogers and Wilker sometimes stayed with a single bear continuously for up to 48 hours. They ate with the bear and rested with it. At night they even slept with it, curling up in a sleeping bag as close as 3 feet (0.9 m) from the snoozing bear. Typically, the bears slept from one to two hours after sundown until a half hour before sunrise, remarkably similar to the sleep pattern of humans.

The daily activity pattern of bears varies greatly from one region to another. Some are diurnal, others are nocturnal, and some are crepuscular (active at dusk and dawn). The activity pattern of many bears, in fact, changes throughout the year. In northern Alaska, a female grizzly with cubs-of-the-year was active 14 hours a day in spring and summer, 17 hours in early autumn, and 20 hours in late autumn.

Human activity has a great influence on whether bears are nocturnal or diurnal. Generally, the more that bears are disturbed by humans, the more nocturnal they become. Some remnant brown bear populations in Europe illustrate this point. In

the Cantabrian Mountains of northern Spain and in the Trentino area of the Italian Alps, bears are most active at night and at dusk and dawn, when they are rarely seen by humans. Human disturbance includes hunting, logging, mining, farming, ranching, and oil and gas development. Even the simple presence of a vehicle traveling on a road or a hiker walking on a trail can disturb bears and influence their movements and activities.

The season also determines whether a bear is active at night or during the day. In spring, the Asiatic black bear and the brown bear of southeastern Russia are most active during the day. In the autumn, both species become more nocturnal.

In national parks where bears are not hunted, they are frequently active during the daytime and are a delight for tourists to see

In Tennessee, the black bears are diurnal in the spring and summer and more nocturnal in the autumn. Researchers speculate that the bears' changing diet may explain the shift in their activity pattern. In summer, the Tennessee bears eat berries. Because these fruits are small and dispersed on branches, the bears rely on their color vision to find them, so they forage primarily during the daytime. In southern British Columbia, Michelle McLellan found, when grizzly bears foraged on berries, they were active up to three hours longer than in other seasons. She speculated that the small, dispersed fruit took longer to harvest. In autumn, Tennessee bears gorge on acorns, which are larger than berries and may be perceptible in darkness, allowing the animals to forage at night. Autumn is also when black bears and brown bears spend more time eating in preparation for winter denning. It may be that the added hours of nocturnal foraging simply give the bears more hours in which to eat.

Whether they are active at night or during the day, many black bears and brown bears use a system of well-worn trails that crisscross their home range. Will Troyer described the trails on Kodiak Island, Alaska, in this way: *A striking feature of brown bear country is the characteristic bear trails. These are especially pronounced in marshy ground where the bear trail forms a well-indented path, and from the air these trails appear like so many interlaced highways.*

On firm ground, trails may consist of two well-defined furrows with a high center or a deeply worn, smooth trail. They may be worn 3 feet (0.9 m) deep by continual use, but generally are only 12 to 16 inches (30–40 cm) wide. One often finds trails in which individual foot outlines are preserved, with each bear having trod in the same footprints as his predecessors until the trail becomes a uniform series of holes.

In coastal British Columbia, I found one such bear trail that was a series of depressions, 1 foot (30 cm) long, worn into the soil. The trail led to a pool in the middle of a sedge meadow. A side trail of similar depressions ran off the main trail and ended at a bear rub tree on the edge of the forest. I have always felt that some naïve person finding such a trail could envision that it was made by a tall bipedal creature, larger than a man, and in a flash of imagination, the legend of the Sasquatch was born.

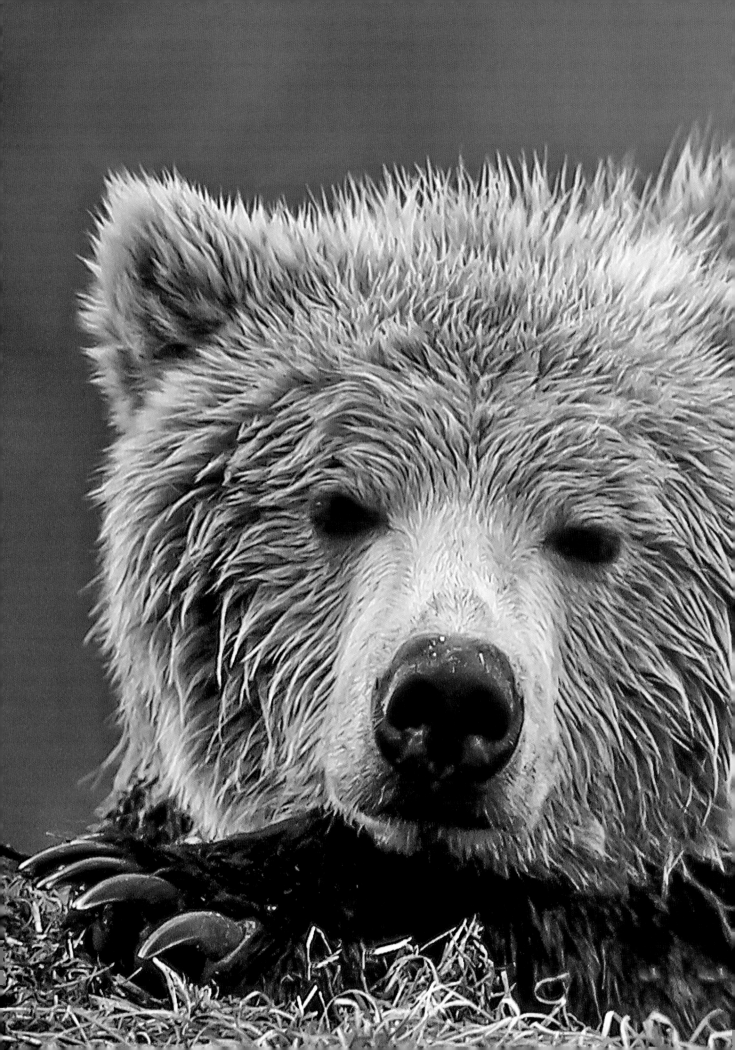

◀ In North America, where brown bears and black bears often overlap, the brown bear is the unchallenged monarch of the treeless Arctic tundra

It is important to appreciate that black bears were excluded from treeless tundra and grasslands because of the threat posed by brown bears, not because they were unable to survive in these environments. Recent evidence suggests that when brown bears disappear from an area of tundra, black bears will leave the security of the trees and move in.

Up until the mid-1800s, a small population of grizzly bears ruled the tundra of northern Labrador and the nearby Ungava Peninsula of Quebec. Regrettably, the great bears disappeared soon afterwards, probably from overhunting, and the tundra was left without a monarch. Beginning about 60 years ago, black bears in Ungava began to venture beyond the tree line in increasing numbers. In 1967, for example, a black bear was seen on the tundra near Povungnituk, about 200 miles (320 km) north of the tree line. In the last 30 years, there have been many sightings of black bears in the Torngat Mountains of Labrador, hundreds of miles beyond the tree line.

The Arctic bruin of Labrador is different from most other black bears. First of all, it's smaller. Adult males average around 220 pounds (100 kg) and the females are a lightweight 130 pounds (59 kg). Compare that to black bears in nearby Newfoundland, where the males and females average 300 and 200 pounds (136 and 90 kg), respectively, with a number of them weighing over 500 pounds (227 kg). Biologists speculate that the Arctic blacks are smaller because they have less to eat.

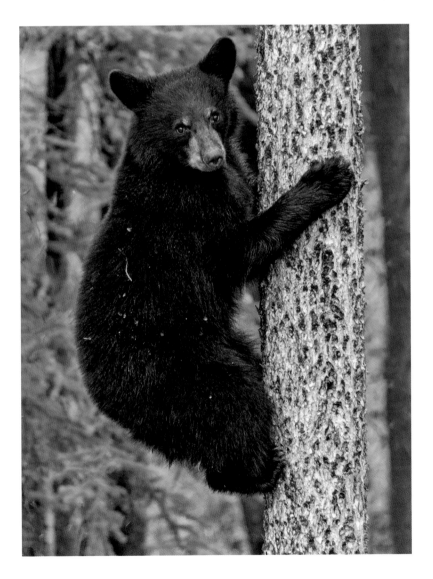

What they eat is also different than most of their kind. The Labrador black bears dig up rodents, grizzly-style, prey on adult caribou and calves, and even venture onto the sea ice to feed on ringed seals.

To find enough food, these adaptable carnivores must tread over great tracts of tundra. Adult males commonly have home ranges of 195 to 385 square miles (500–1000 sq. km). Most American black bear males elsewhere use less than 77 square miles (200 sq. km), and many less than 39 square miles (100 sq. km).

Nothing is ordinary about these black bears, including their hibernation schedule. Once they enter their winter dens in early October, most won't emerge again until the first half of May, and

some may delay until early June. That's over seven months of denning, which is two to three times longer than many southern black bears, and one of the longest periods of any of the northern blacks. Only black bears in Alaska are known to sometimes den for a longer time.

Reliance on aggression is another way that black bears and brown bears differ, and this explains why the smaller blacks are less inclined to attack humans than their larger relatives. When black bears are threatened, they often escape by climbing a tree, and they have probably done this from early in their evolutionary history. A mother black bear whose cubs are safely perched aloft in a tree has a number of options open to her. She can climb the tree herself, she can bluff-charge her enemy and try to scare it, or she can run away. Of course, she also has the option to attack, but that always carries the risk that she may be injured in the skirmish. Since mother black bears rarely attack, even when researchers are examining their squealing cubs, it seems that aggressive behavior has never become ingrained in them by natural selection. In the test of time, the black bears that survived were those that were *not* aggressive, and this behavioral trait has been passed on to succeeding generations.

In contrast, brown bears in North America evolved in open, treeless habitats, and they must have frequently found themselves in vulnerable, exposed situations. The cubs of a brown bear mother have no trees to climb for safety. To protect her offspring, a brown bear mother has no option but to charge. She may bluff first, but when that fails, she fights. For the brown bear, aggressiveness was an essential trait for survival. The late mountain man and wilderness guide Andy Russell wrote that *to compare the grizzly with his lesser cousin, the black bear, is like standing a case of dynamite beside a sack of goose feathers.*

Black bears and brown bears may differ in their distributions in North America for another unexpected reason. Why, for example, did grizzly bears never colonize most of the boreal forest that stretches from Yukon to Newfoundland, or any of the eastern deciduous forests that stretch from Nova Scotia to Florida? Biologist David Mattson offers some plausible explanations. Many of the brown bears living in the Eurasian boreal forest rely on the fat-rich seeds of stone pines, which are absent in the boreal regions of North America. Regarding the eastern deciduous forests, food should not be a deterrent to brown bear occupation. After all, the diet of brown bears in Greece, Slovenia, and the Carpathian and southern Ural Mountains resembles the diet of 80% of black bears in eastern North America, so why did the burly browns never colonize these productive forests? Mattson thinks black bears are able to exclude their larger cousins by out competing them. Black bears have larger litters, reach sexual maturity sooner, and have shorter intervals between litters, all of which enables them to be more flexible and responsive to changes in the environment. As well, the smaller body size of black bears enables them to survive on a lower quality diet than grizzlies, which do best in areas with concentrated foods such as spawning salmon, ungulates, and starchy roots.

◀ Even an adult American black bear will seek refuge in a tree when it feels especially threatened

SEPTEMBER

The grizzly is a symbol of what is right with the world.

CHARLES JONKEL, *American bear biologist*

SEPTEMBER CONTINUES TO BE A LEAN MONTH for many polar bears, especially for those in the south. Those that were forced ashore in July and August when the sea ice melted must wait for the chill of winter to lock their world solid so that they can once again walk and hunt on the frozen ocean.

The situation is quite different for brown bears and black bears. These are the halcyon days of clement temperatures and bountiful food. For these bears, September is one of the most important feeding times of the year.

THE FALL FEEDING FRENZY

When biologists speak about the autumn diet of black bears and brown bears, they talk about two kinds of food: soft mast and hard mast. Soft mast consists of fruits and berries, foods that are typically soft and juicy. Hard mast includes hazelnuts, walnuts, beechnuts, hickory nuts, acorns, and chestnuts.

Bears prefer hard mast, since it often contains twice the fat content of berries, and in autumn, the hungry bruins try to ingest as many calories as possible. A bear's digestive physiology may also shift in autumn to increase the animal's ability to digest fat, and this further facilitates rapid weight gain.

Acorns and Other Nuts

Hard mast is eaten by many bears throughout the animals' range. Brown bears in the Apennine Mountains of central Italy and in the Pyrenees of southern France eat beechnuts, hazelnuts, and acorns. In Japan, Asiatic black bears eat the nuts of oaks, beeches, and chestnuts, which comprise 87% of all the plant matter they eat in the autumn. Throughout the hardwood forests of the eastern United States, hard mast is a staple fall food of black bears.

Brown bears can feed on hard mast only after the nuts have fallen to the ground. The tree-climbing American and Asiatic black bears can go after the acorns and beechnuts before they fall off the trees. This gives them several advantages. In the eastern United States, acorns are a preferred autumn food of many animals, including white-tailed deer, wild turkeys, and European wild boar, but these animals can only eat the

◀ The autumn forests of bear country have many different faces: the maple woodlands of Japan (top left), the tree line of northern Manitoba (top right), the coastal rivers of Southeast Alaska (bottom left), and the boreal forests of northern Saskatchewan (bottom right)

mast once it has fallen to the ground. In the Southeast, over a third of all fallen acorns become infested with the larvae of nut weevils, and they are then further damaged by fungal and bacterial decay. By climbing, the bears obtain the acorns before these infestations lessen the nutritional value of the nuts.

In the Russian Far East, researcher Sergey Kolchin documented a dozen instances in which wild boars, alone and in groups, fed on acorns that fell from trees where Asiatic black bears were actively feeding. Kolchin felt the boars were alerted to the feeding bears by the noise the bears made breaking branches. Adult bears ignored the hogs, but the tusk-wielding animals made cubs anxious, so they stayed up in the trees until the pigs had left.

Biologist Larry Beeman described how black bears forage in trees: *Adult males and females as well as cubs were observed pulling in limbs with their paws and using their mouths to pick cherries, acorns, beechnuts, and hickory nuts. In addition, limbs as large as 4 inches (10 cm) in diameter were torn or chewed off and dropped to the ground. This "pruning" by bears allowed them to consume mast that otherwise would have been unavailable.*

Bears will sometimes wedge the broken limbs under themselves and create a crude nest. In Pennsylvania, Gary Alt found such a nest in a beech tree 46 feet (14 m) off the ground. The nest was 6.5 feet (2 m) in diameter and was constructed of 27 limbs, some as large as 2.75 inches (7 cm) in diameter. The nest was such a sturdy one that a bear used it to den during the first half of the winter.

Tree nests are made by both Asiatic and American black bears. Nests are particularly common in the hardwood forests of eastern Canada and the northeastern United States. A stand of beech trees may contain dozens of tree nests. The nest-building exploits of local black bears were such a common occurrence in 1821 that it is said the town of Antigonish, Nova Scotia, derived its name from the words of the Indigenous Mi'kmaq people meaning "where branches are torn off." Biologists Mei-Hsiu Hwang and David Garshelis suggested that Asiatic black bears are even more arboreal than American blacks, in part because of the adaptations of their feet for climbing, and also due to the greater prevalence of tree-borne fruits in Asian forests.

Light gaps, created by fallen trees, flood the forest floor with sunlight and are an important ecological component of the tropical rain forests. Japanese researcher Kazuaki Takahashi wondered whether the branch-breaking behavior of foraging Asiatic black bears might produce beneficial light gaps, albeit smaller than those in the rain forest. He found the light levels beneath bear-created gaps improved by 15% to 33%, which would accelerate fruiting in woody vines growing in the middle and upper levels of the canopy. He concluded that the breaking of branches was an important disturbance that beneficially affected light conditions and fruit production.

Black bears in Minnesota and elsewhere frequently abandon their home ranges in late summer and move to feeding areas to fatten for winter. Karen Noyce reported that the bears usually left in August and returned six weeks later in September or October. Most traveled southward, with females moving an average of 6 miles (10 km) and males 16 miles (26 km). The longest distance was 104 miles (168 km). This so-called

In this Japanese walnut, I counted four nests like this one in different areas of the same tree—evidence of recent feeding activity by Asiatic black bears

fall-feeding shuffle varied from year to year in timing and destination, although only about 40% of the bears made these movements, usually those with lower fat reserves. Cubs may remember the food-rich areas they visit with their mother and return to them later in life when they are on their own.

Pine nuts are an important fall food for some bears. In the Russian Far East, Asiatic black bears feed on the oil-rich seeds of Korean stone pines, and in Hokkaido, Japan, brown bears feed on Japanese stone pines. In North America, the stone pine species is the whitebark pine; its large, oil-rich seeds, containing 50% fat, are prized by both black bears and grizzlies. In northwestern Montana, black bears that have been climbing whitebark pines to secure the cones have no hair on their front legs. As the bears climb and claw the trees, their front limbs become coated with pine gum, and when enough dirt and debris stick to the gum, the whole conglomeration peels off, taking the animal's hair with it.

In September, whitebark pine seeds are also a strong lure to nonclimbing brown bears, which must scrounge for the few cones that fall naturally from the trees. Unfortunately, in both Russia and North America, any cones that fall to the ground are immediately carted away by rodents. In Russia, the culprit is the Siberian chipmunk, and in North America it is the familiar red squirrel. The bears are not deterred by this, because the rodents save them time. Both Siberian chipmunks and red squirrels cache pine nuts, which bears can then uncover. The Siberian chipmunk removes the nuts

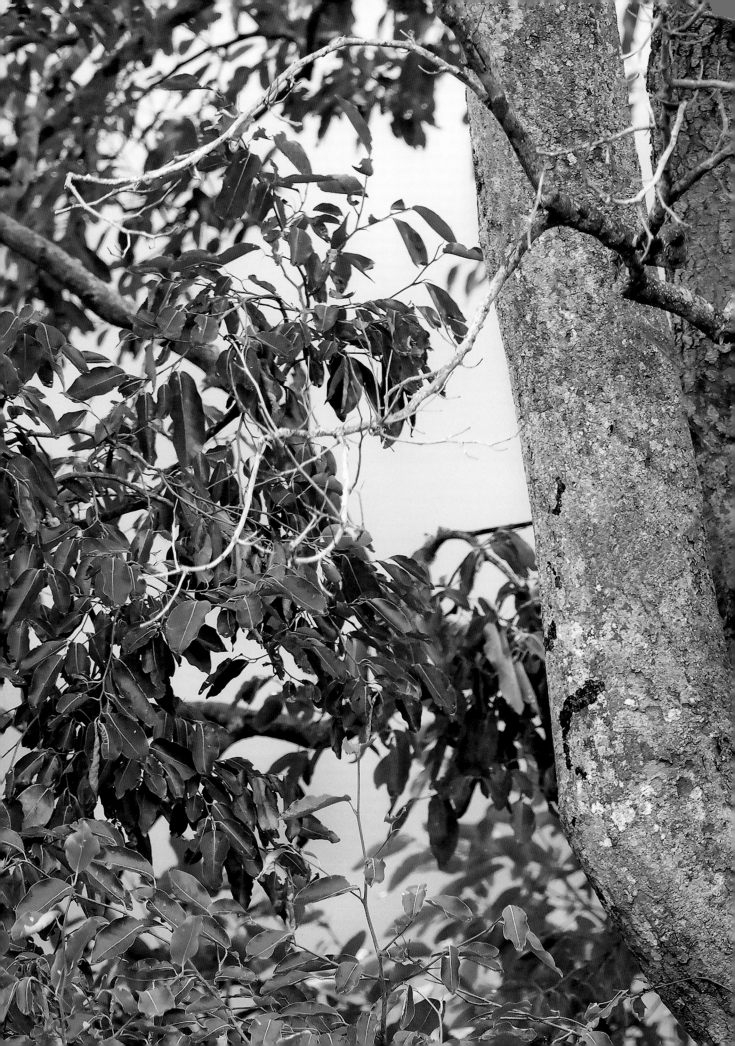

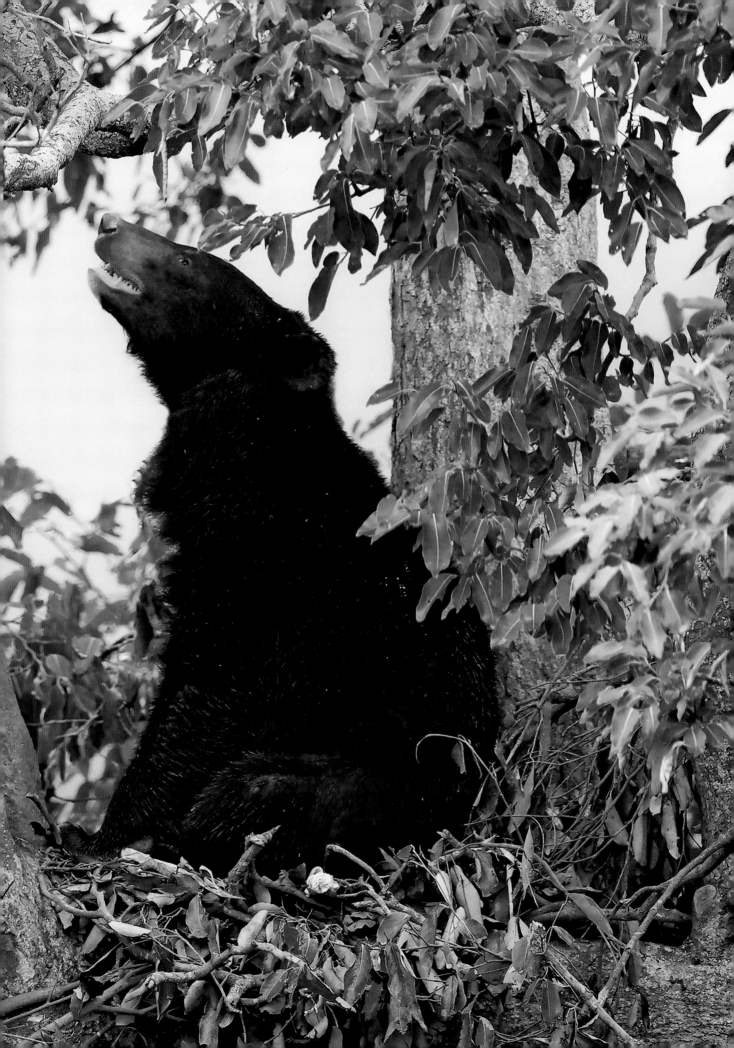

◀ When an Asiatic black bear breaks branches to feed high in a tree, it may inadvertently fashion a nest, which can be used as a temporary place to rest

In the Rocky Mountains, the oil-rich seeds of whitebark pines are a lure to hungry black bears and grizzlies

from the cones and stores them in an underground cache that may contain up to 13.25 pounds (6 kg) of pine nuts, all shelled and ready to be eaten.

In Yellowstone National Park, biologist Katherine Kendall looked at red squirrel caches. The squirrels, unlike Siberian chipmunks, cache the entire cone, not just the nuts, often hiding a dozen cones in a hole up to 8 inches (20 cm) deep. At other times, the squirrels may simply store the cones in a pile at the base of a tree. Kendall found some piles containing 3,000 pine cones after a bumper crop. Bears break open the cones by stepping on them or biting them, then scattering the debris with their nose or a paw and licking up the exposed nuts. The pilfering bruins rarely cleaned out an entire cone cache in a single visit, but they returned repeatedly to large piles.

Bears in Yellowstone also raid cone caches in the spring when they first emerge from their winter dens. Pine nuts help to offset the nutritional stress of this period, especially after a mild winter when there is little carrion available.

Since the 1970s, so many whitebark pines have died from infestations of mountain pine beetles and white pine blister rust that the species is now classified as endangered by the International Union for Conservation of Nature (IUCN). Researchers caution that the plight of the tree may have serious implications for the maintenance and restoration of grizzly bear populations in the lower 48 states.

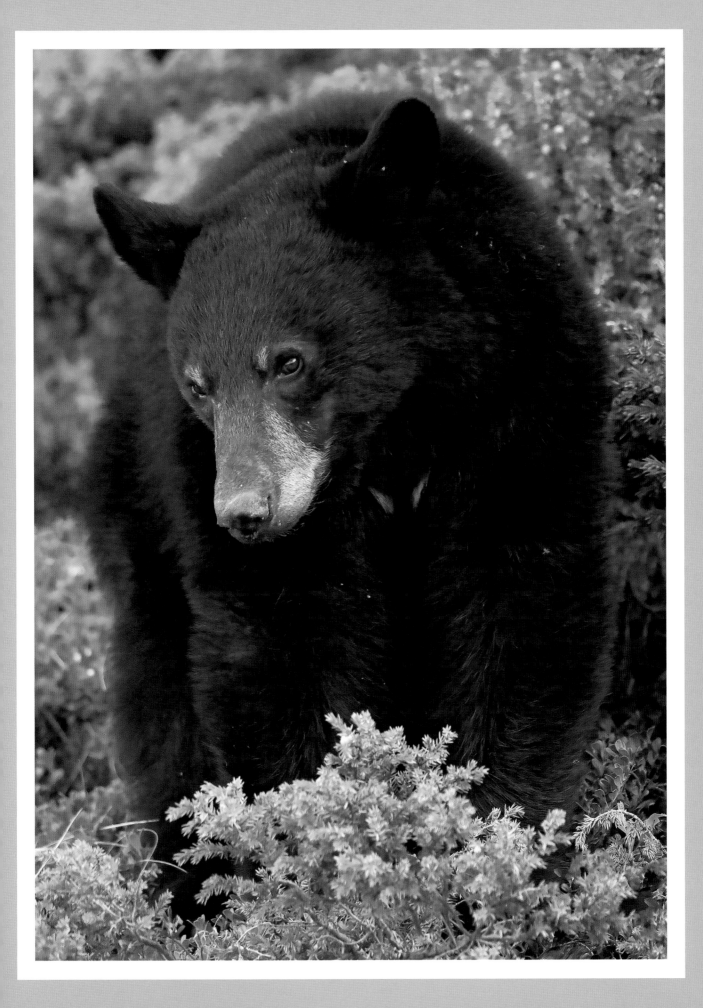

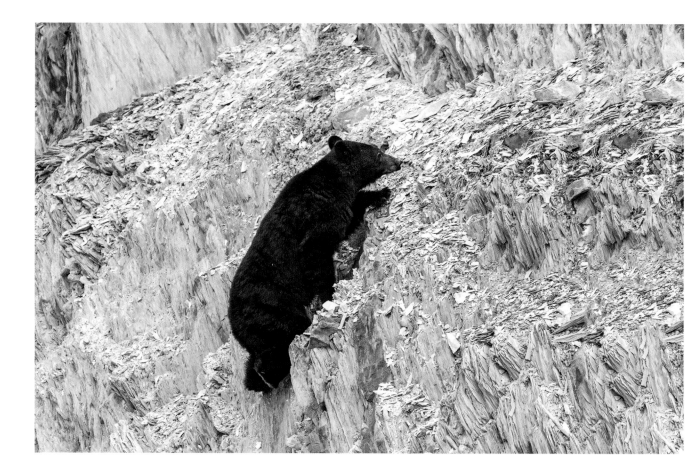

A young bear often learns from its mother which terrains are possible to traverse. This mother American black bear climbing a steep shale slope was followed by a reluctant yearling.

Between bouts of play, the cubs examined every clump of sod their mother overturned. They would thoroughly sniff each clump and sometimes nibble at the remnants.

I was never more impressed by the way cubs learn than when I watched a polar bear and her offspring hunt for ringed seals in the Canadian High Arctic. The bears hunted around one snowdrift complex for over an hour. The mother bear dug into a dozen snow caves without catching a seal. Every time she moved to another drift, her cub lagged behind and explored the hole she had just dug. The cub would disappear completely into the snow cave, presumably investigating every nook and cranny, and in the process learning the subtle sights, sounds, and smells of a seal lair. During its years of family life, a polar bear cub will investigate hundreds, if not thousands, of seal lairs and learn the locations of the exit holes, the depth of the snow on the ceiling, and the many details it will need to know if it is to catch its wary prey.

Later in life, a bear cub may imitate its mother's behavior down to minute details. At McNeil Falls in Alaska, a female brown bear called Lanky and her cub, Teeny, were a good example of this. Of the several dozen fishing spots at the falls, Lanky always used the same one. Once in position, she would stand with her two front feet in the water, then raise one leg and lean forward expectantly. Teeny would sit or lie down behind her while she fished. Years later, when Teeny grew up and returned to the falls without her mother,

she fished in the exact spot that had been used by her mother, and she used the same fishing posture, leaning forward over the water with one paw cocked in the air.

One aspect of conscious thinking that has been investigated in bears is their curiosity. Researchers measure curiosity based on how an animal responds to a novel object placed in its environment. In one study, a pair of captive American black bears was given two lengths of steel chain, two pine blocks, two pieces of water hose, and two wooden dowels. Afterwards, the bears were watched to see how they investigated the objects and how long they stayed interested. Both bears reacted to the test objects in the same manner. Once the object was introduced into their cage, they would approach, sniff the object, manipulate it with their forepaws, and then chew on it.

Since the bears were captive animals, the sterility of their environment may well have increased the time they spent with the novel objects. Nevertheless, it is possible to compare the observations made of the black bears with those made of other captive animals tested in a similar fashion, and thereby gain some insight into the different curiosity levels demonstrated by different animal groups. The bears demonstrated a higher curiosity level than all other carnivores tested, including big cats, raccoons, weasels, and dogs. In some cases, the bears investigated the test objects for twice as long as some of the other carnivores.

Intense curiosity is a characteristic of mammals, and many early researchers, including Darwin, recognized that it was particularly evident in primates. When captive primates were challenged with the same novel objects as the black bears, the primates displayed substantially lower levels of curiosity than the bears did. The higher degree of curiosity displayed by bears does not mean that they are more intelligent than primates. It does mean, however, that their highly investigative nature may predispose them to discover novel food sources in their environment, and this inclination may contribute to their adaptability.

Numerous studies have detailed how local populations of bears learn to exploit a novel food source. Brown bears in coastal Alaska swim to distant islands to raid the nests of seabirds. Rocky Mountain grizzlies feed on aggregations of army cutworm moths under the rocks of talus slopes. American black bears feed on alligator eggs. And polar bears catch ducks on the water, and also climb cliffs to loot seabird nests. The inherent curiosity of bears enables them to take maximum advantage of their environment and capitalize on changes and new developments.

A bear's curiosity sometimes gets it into trouble. The same behavior that drives a brown bear to discover a razor clam hidden in the sand of an Alaskan beach prompts other brown bears to pry open a cooler, panhandle beside the road, or tear the door off of an automobile when there is food locked inside. Years ago, one enterprising black bear in California specialized in assaulting Volkswagen beetles. The bear would climb on the roof of the car and then jump up and down a couple of times until the air pressure inside the car popped open the doors. Who says that bears can't conceive and execute a plan?

Bear biologists love to regale each other with stories about the intelligence of bears—how the animals avoided their snares, learned to raid a trap and steal the bait

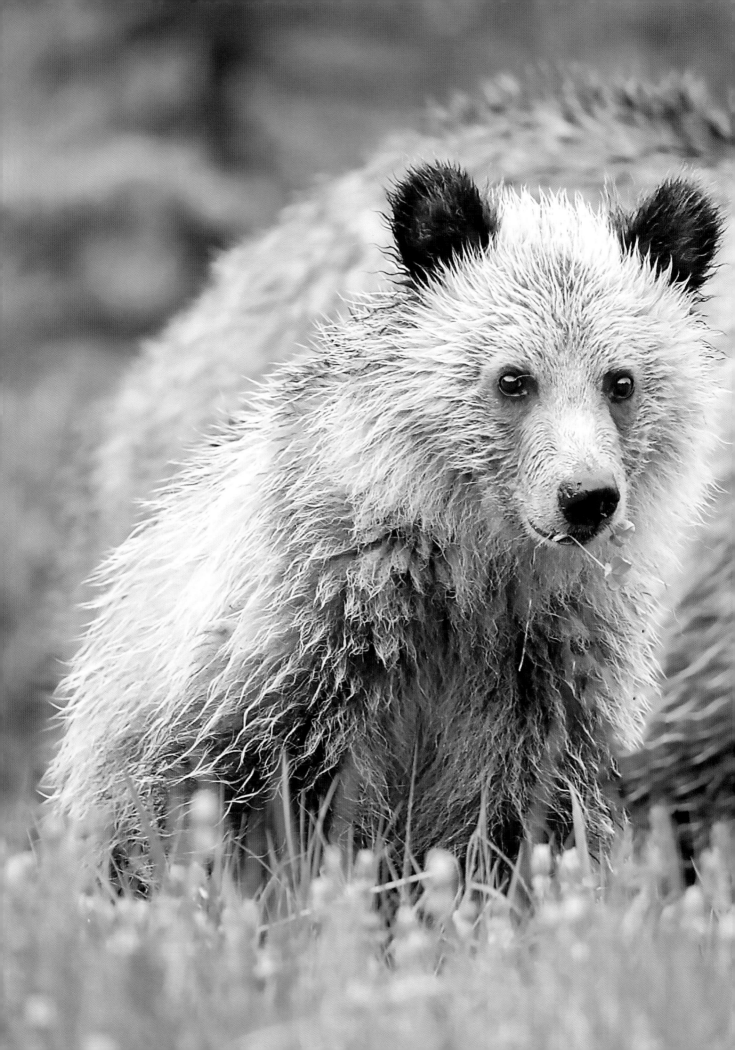

OCTOBER · NOVEMBER · DECEMBER

*If ever you are lost in life, put your ear to the Earth,
and listen to the beat of her heart.*

APHORISM OF THE SAMI, *traditional reindeer herders of Lapland*

IN THE 1970s, RESEARCHER GORDON BURGHARDT and colleagues conducted a survey of visitors who came to Great Smoky Mountains National Park in Tennessee. All of the respondents overestimated the weight of black bears by at least 110 pounds (50 kg), and some guessed the bears weighed over 800 pounds (363 kg). A few even went as high as 2,000 pounds (907 kg). Roughly 1,500 bears live in the park, with the average male weighing 250 pounds (113 kg) and the average female 100 pounds (45 kg).

Bears may not be as big in life as they are in our imagination, but they are still large animals. Black bears weighing over 600 pounds (273 kg) have been reported from Michigan, Newfoundland, New York, Quebec, Louisiana, North Carolina, and California. In Pennsylvania, Gary Alt knew of "a bunch" of bears weighing over 700 pounds (318 kg), even a few over 800 pounds (363 kg). Brown bears weighing 1,500 pounds (680 kg) have been recorded in the coastal regions of both Alaska and Russia, and polar bears can reach similar weights. On Southampton Island in northwestern Hudson Bay, biologists captured an adult male polar bear that weighed 1,770 pounds (803 kg)!

All bears except polar bears are at their heaviest weight during late fall. The bears have fed voraciously for weeks in preparation for one of the most important activities in a bear's life—denning.

◀ One of the peak times for auroral activity is during the autumnal equinox, when bears are preparing for hibernation

BEDDING DOWN FOR WINTER

By late autumn, food becomes scarce for many black bears and browns. Berries and nuts have dried up, frozen, or fallen to the ground, eaten by a legion of furred and feathered creatures. Late salmon runs still offer a few bears some final days of fishing, and carcasses from earlier spawning runs can be scavenged. Also at this time of the year, bears may happen upon elk, moose, and deer that have been injured in battles during the autumn rut or wounded by hunters, and these weakened warriors are sometimes easy prey. For the most part, however, bears gradually spend less time feeding, and begin preparing to den.

Naturally, because of the size of tree cavities, they are most often used by the smaller bears in a population, namely, the subadults and adult females. In Tennessee, however, a third of adult males also curl up high inside a tree.

Besides offering greater security, a tree cavity provides a thermal advantage over a den on the ground. A cavity is usually dry and shields the bear from the chilling effect of the wind. These benefits translate into a 15% energy saving for the bear. Energy conserved in this way improves the survival of the young cubs that are born in these dens. Bears in Tennessee recognize the benefits of tree cavity dens because they select these sites more often than any ground den, even though ground dens are five times more abundant than tree cavities. In Virginia, 68% of black bears den in trees. In Louisiana, tree dens were used by 80% of adult females and 68% of all adults. In coastal British Columbia, 55% of black bears curl up inside a tree. And in northern China, 42% of Asiatic black bears wedge themselves into a tree cavity for the winter, using their claws and teeth to enlarge the entrance hole so they can squeeze inside.

If you rely on cartoons for your information about bears, you already know that bears love to den in caves. The cartoons are partly correct. Bears definitely den in caves, or rock cavities, but the cavities that they choose are not spacious enough that they echo inside.

In Croatia, 80% of brown bear dens were in rock cavities. Similar rock dens were used by brown bears in Yellowstone National Park, in the Brooks Range of northern Alaska, and on Admiralty Island in southeastern Alaska. On Admiralty Island, the rock cavities varied from deep caves that were 25 feet (7.6 m) long to small crevices under large boulders. A number of the caves had more than one entrance, and several of them had been slightly modified by digging. From the wear on the rocks, the researchers suspected that some of the caves had been used many times before, possibly for centuries.

Black bears also use rock cavities throughout their range whenever such sites are available. In Pennsylvania, I climbed inside half a dozen such cavities. Many of them had two or three entrances, and some had multiple chambers that were used by different family members over the winter denning period.

In many areas, these same rock cavities are attractive to porcupines as winter dens, and I have always wondered how the bears and the "quill pigs" resolve ownership. Both brown and black bears have been seen with quills in their faces, but it is a surprisingly rare event, considering that bears and porcupines must often confront each other. Researchers in Minnesota found three dens used simultaneously by a porcupine and a black bear. In Alaska, a porcupine provided the bedding for one brown bear that spent the winter in a rock cavity. The bear slept on a thick mattress of droppings, courtesy of the cave's previous occupant.

Most reports that discuss bear denning sites never mention whether bears compete for prime locations. Certainly tree cavities and many rock dens are preferred sites, and if they were limited, you would expect bears to compete for them as they do for many other things. Alaskan researcher Charles Schwartz observed competition among black bears for rock cavities on three different occasions. In two instances, two black bears

◀ A mother American black bear excavated a cavity under this rotten stump and in it gave birth to a single cub

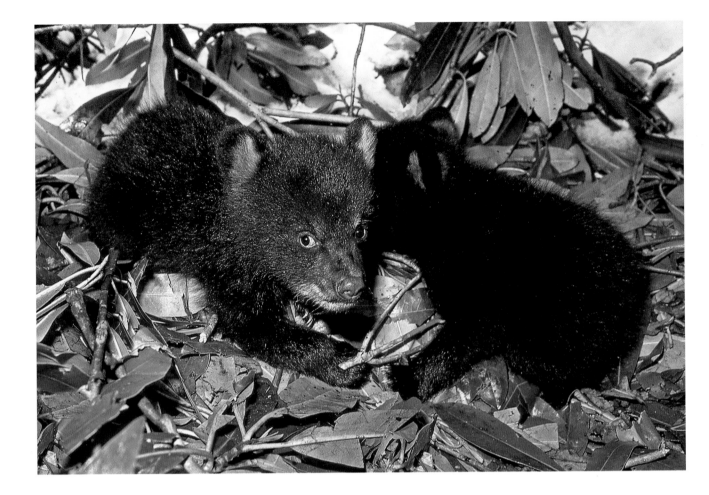

were at the same rock cavity, and in a third case there were three bears loitering around the den. Schwartz did not witness how the bears resolved the issue, but in all cases only a single bear ultimately occupied each cavity. He speculated that when competition for a den site exists, it may be advantageous for a bear to enter it early.

Reuse of tree cavity and rock dens from one year to the next is common in some areas. In Pennsylvania 5% are reused, in Louisiana 15%, in coastal Washington 50%, and on Vancouver Island, British Columbia, 71%. Researcher Helen Davis wondered why a bear wouldn't use the same den every year. She thought that predators such as wolves and other bears might check low-security dens looking for victims and reuse might increase an occupant's vulnerability. As well, repeated use might increase the likelihood of infestation by fleas.

The denning location that surprised me most was the surface nest. To make one, a bear chews off branches from nearby trees and bushes and arranges them in a pile about 5 feet (1.5 m) across. One surface nest I examined had been used by an adult female black bear and her two newborn cubs and was constructed of hundreds of rhododendron branches that had been neatly chewed into 1- to 2-foot (0.3- to 0.6-m) lengths. A bear may line the pile with leaves and grasses. In many ways, a winter nest

resembles an elaborate daybed. The most novel surface nest I know of was built on top of a muskrat house.

Surface nests are used by brown bears in Scandinavia and by both species of black bears in selected parts of their ranges. In the United States, the nests are typical for black bears living in Florida, Georgia, the Carolinas, and other places in the South. In areas farther north, such nests are not as common and are mostly used by adult males.

Surface nests have not been reported for any bears living in Canada or Alaska. It may be that the climate is too severe in these regions for a bear to remain exposed to the elements for the entire winter.

A very common place for bears to den, throughout their range, is a simple hole in the ground, called an excavation den, which the bears dig for themselves. In the eastern United States, bears occasionally enlarge the burrow of a red fox or woodchuck, and in the West, they sometimes expand an old badger or coyote den.

Many excavation dens collapse after a year or two, so a new hole must be dug every fall. Usually the dens consist of a simple tunnel leading to a single chamber. The tunnel is frequently 3 to 6 feet (0.9–1.8 m) long, but one brown bear in the Alaskan Peninsula dug a tunnel 21 feet (6.4 m) long. Some dens have no tunnel at all, and the chamber opens directly to the outside.

Typically, the chamber is egg-shaped—about 5 to 6.5 feet (1.5–2 m) across and 3.5 feet (1.1 m) high. Bears appear to fashion a den so that it is large enough for them to twist around inside, but no larger. In this way, they minimize the size of the air space they must warm. The volume of the average black bear den in Southeast Alaska was 39 cubic feet (1.1 cu. m), and for brown bears it was 65 cubic feet (1.85 cu. m). The average American bedroom is 960 cubic feet (27 cu. m), which means it would be just right for 24 black bears or 15 brown bears to wedge inside.

A grizzly may move a ton (0.9 tonnes) of dirt and rock in digging out its den, and the excavated soil forms a characteristic mound at the mouth of the den that can be recognized from a distance. Even though many dens collapse in the spring, an experienced spotter can locate abandoned excavation dens that are 50 years old.

Many excavation dens are dug beneath the roots of trees or shrubbery, such as willows and alders. The roots form the ceiling of the den, and they stabilize the soil and keep it from collapsing. The overhanging bushes also trap snow drifts and increase the insulation over the den site. According to biologist Lee Harding, the average depth of the drifted snow that covered brown bear dens in the Northwest Territories was 30 inches (76 cm). Away from the dens, the snow was only 6 inches (15 cm) deep. In the Barren Grounds north of Yellowknife, Northwest Territories, grizzlies dug their dens near the top of slopes, under a supporting cover of willows and dwarf birch, and the dens most often faced south. Philip McLoughlan felt the slopes made digging easier and provided good drainage, and the southern exposure shielded the den entrance from the prevailing north winds.

Thermal considerations may also influence the altitude where bears choose to den. In the Canadian Rocky Mountains, both black bears and brown bears den near the tree line between 5,500 feet and 6,500 feet (1,700–2,000 m). At lower altitudes, the

conditions are less favorable. The snow arrives later, and it is not as deep and fluffy, so it traps less air and doesn't insulate as well.

Denning at higher altitudes may confer a second advantage. The air temperature at these heights is often warmer because of a thermal inversion. When this happens, an upper layer of warm air traps an underlying layer of cold air, so the colder temperatures occur in the valley bottom.

Bears dig their dens in about five to seven days, even though they may be in the denning area for several weeks. They rest in daybeds nearby before they begin digging and while they are digging. Sometimes they start a den and then abandon the site before the excavation is completed. These "false dens" are believed to be failed attempts. The soil may turn out to be too crumbly or too moist, further digging may be obstructed by a large rock, or the bear may be young and inexperienced and have chosen a poor location. When this happens, the bear simply moves to another site and starts over again.

Often black bears and brown bears line their dens with some kind of vegetation—generally whatever material is nearby. They rake in grass, leaves, and conifer needles, and they also bite off small branches. They may gather several bushels of bedding and pile it into a nest about a foot (0.3 m) deep. Around some black bear dens, the area looks as though someone has cleared it with a garden rake. One enterprising black bear in Michigan stole hay from a stack in the middle of a farmer's field and carried it 100 yards (91 m) into a swamp to line its winter nest. Gary Alt once found a black bear in Pennsylvania denning inside a huge hay bale in the middle of a farmer's field. When he anesthetized the bear and pulled it out, most of its hair was missing due to a serious case of mange, a skin disease caused by parasitic mites. Denning in a hay bale was probably a good idea, as it provided the sparsely haired bear with some sorely needed insulation over the winter. In a study in the Carpathian Mountains, the bedding inside a European brown bear den was 7 inches (18 cm) deep and weighed 26 pounds (11.8 kg). Even bears that den in tree cavities often scrape wood shavings from the inside of the trunk to line the bottom of the den.

Bears can be very fussy about lining their dens. Biologist Lynn Rogers watched an adult female black bear rearrange the bedding in her den twice. Each time, she would scoop out the den, sending the material flying backward between her hind legs, and then reorganize it again.

Lining a den insulates the bear from direct contact with the ground, lessening the drain on its body heat, and therefore conserving energy. This may explain why, in Croatia, mother brown bears with newborn cubs use more bedding than bears denning alone.

I have discussed the typical types of dens, but being opportunists, bears sometimes choose unusual sites. In the Pocono Mountains in northeastern Pennsylvania, bears regularly den in the crawl space under occupied houses. Often the owners never learn that a bear has spent the winter under their bedroom, and the animal leaves unnoticed in the spring. I crawled under one house and discovered that the bear had

for seclusion and the pressure of human hunting may encourage them to use a small number of areas that are free of disturbance. Female polar bears also show a high degree of fidelity to their maternity denning areas. Once a female successfully rears cubs in a denning area, she returns to the same general area for each subsequent litter, and it is likely that her female offspring use the same denning area as well.

Another factor that probably affects the location of denning areas is the proximity of a major polynya or lead system. Most, if not all, of the core denning areas are near important areas of open water or shifting pack ice where there are seals to hunt when the females leave their dens in March and April.

Ice Denning

For many years, the denning location of Alaskan polar bears was somewhat of a mystery. Alaskan bears belong to two subpopulations, one centered in the Chukchi Sea off the northeastern corner of Russia and the other in the southern Beaufort Sea. The estimated 2,000 to 5,000 animals in the Chukchi subpopulation den primarily on Wrangel and Herald Islands and on the Chukotkan coast of Russia. The denning location of the roughly 1,500 bears in the southern Beaufort Sea region has been changing in recent decades.

In 1974, Alaskan biologist Jack Lentfer documented the first polar bear maternity den located on drifting pack ice. The den was in drifted snow on the leeward side of a pressure ridge, 104 miles (168 km) offshore from the coastal community of Point Barrow, known today as Utqiaġvik. Since then, many dens have been located on the sea ice off the northern coast of Alaska, some as far offshore as 497 miles (800 km).

The sea ice is not a static platform. It moves as much as 3 miles (5 km) a day in the Beaufort Sea, up to 13.5 miles (22 km) per day in the Barents Sea, and as much as 19 miles (31 km) a day in the Greenland Sea. From November 1 to April 1, a hypothetical ice den in the Beaufort Sea could move 404 miles (650 km). A drifting maternity den might transport a mother and her cubs to a poor feeding area, or worse, the den might be ferried into an area where the ice breaks up, prematurely subjecting the cubs to the full force of winter. Even with these potential risks, researcher Steve Amstrup has found no difference in cub production between bears denning on land and those on pack ice.

Scott Schliebe reported that between 1985 and 1994, 64% of females on the north coast of Alaska denned on the sea ice. From 1995 to 2005, the number declined to 36%. Denning on the sea ice is rare in any other population of polar bears. Why, then, was it relatively common in Alaska in the past? Veteran polar bear researcher Ian Stirling thinks the explanation lies with the hunting history of the area. From the late 1800s onwards, the mainland coast, where bears would have normally denned, was inhabited by American whalers and Indigenous hunters armed with firearms. Up until the 1960s, when polar management first began in earnest, females that denned on the coast were often shot, and the coastal denning tradition largely disappeared. Today, the bears can more safely den on land. As well, researcher Anthony Fischbach thinks that Alaskan polar bears are now denning on shore more in response to recent reductions in stable

old ice, increases in loose pack ice, and the lengthening of the melt season. These changes have probably reduced the availability and quality of pack ice denning habitat.

THE CHALLENGE OF LIFE ON THE ICE

Each year, when the sun sets on the North Pole on September 21, it does not appear again for six months. Throughout the Arctic realm of the polar bear, much of winter is a time of darkness. Still, there is often enough light for even a human to easily move about. At noon in late December, at a latitude of 75° north, the southern horizon is brightened by a narrow band of orange light that fades into the deep blue-purple of the upper sky, and by moonlight, there is enough brightness to follow the tracks of Arctic hares and foxes.

On a completely calm day, the average winter temperature in this high latitude is −31°F (−35°C). Add to that temperature the heat drain from an average wind speed of 15 miles per hour (25 km/h), and the conditions are equivalent to −71°F (−57°C). In such cold, even rocks wince, and exposed skin freezes in seconds.

Polar bears are active at this latitude in winter. In fact, one family of bears traveled over the sea ice 620 miles (1,000 km) farther north than this latitude. On December 20, 1957, a female polar bear and her single cub became tangled in the wires of the runway lights of a drifting ice station positioned at 84° north latitude. The event was especially noteworthy since the bear broke the wires and turned off the runway lights just as an aircraft was about to land. To survive under these conditions of darkness and extreme winter temperatures, the polar bear has evolved a number of adaptations in its eyes, feet, and fur.

Vision in Polar Bears

The statement that bears have poor vision and are shortsighted has been repeated so often that it has attained a degree of authenticity. Bears probably see much better than we think, and polar bears, at least, are not nearsighted. For the moment, let's disregard all common assumptions and look at what actually is known about vision in bears, and in particular in polar bears.

The retinas of all vertebrates contain two types of light receptors: cones and rods. Cones are used for daylight color vision and determine the acuteness of an animal's eyesight, whereas rods are used in night vision when light levels are low. Based on the density and distribution of the polar bear's rods and cones, researchers believe that a polar bear has reasonably sharp vision, perceives colors in the red and blue ends of the spectrum, and has modest sensitivity in dim light conditions. Polar bears lack the green color sensitivity that humans enjoy but, as Andrew Derocher suggests, not seeing green well is no great loss for a polar bear living on the sea ice.

The night vision of all bears is further enhanced by a special reflective layer, called the tapetum lucidum, which lines the back of their eyeballs. The tapetum, which is present in many nocturnal animals, reflects light back through the retina, allowing the light a second chance to stimulate the rods, greatly increasing the eye's sensitivity

in low light conditions. The tapetum is responsible for the eyeshine you see when a light, like the headlights of a car or the beam from a flashlight, illuminates an animal at night. These two features, the tapetum and the arrangement of rods in the retina, suggest that bears are well adapted to see under dim light conditions and that the darkness of an Arctic winter is not likely to inhibit the movements of a polar bear.

One can determine whether a bear is nearsighted by examining the animal's eye. The ability to see objects near or far is largely determined by two factors: the curvature of the cornea, which is the clear window at the front of the eye, and the shape of the lens in the eye. When Jacob Sivak examined the eye of a polar bear, he concluded that, if anything, polar bears are slightly farsighted. In the same study, Sivak examined how well a polar bear sees underwater and decided that they, like humans, are adapted for vision in air and that they have none of the adaptations seen in more aquatic carnivores such as seals.

As a former emergency physician, I was particularly interested in why polar bears don't suffer from snow blindness. In humans, the cornea of the eye is injured by excessive amounts of ultraviolet light. The bright snow fields in polar regions present a special hazard. The snow reflects the harmful ultraviolet rays into our eyes and damages the cornea, producing the symptoms of snow blindness: severe pain, excessive tearing, and extreme sensitivity to light. In humans, snow blindness can occur after only a few hours of exposure, yet polar animals may spend months on snow, seemingly without any ill effects. University of California researcher Edvard Hemmingsen compared the corneal sensitivity of Adélie penguins and brown skuas with that of domestic chickens, guinea pigs, and California ground squirrels. Not surprisingly, the two Antarctic birds had greater resistance to corneal damage than either of the two domestic animals did. The shocker was the great resistance of the ground squirrel, which was two and a half times more tolerant of ultraviolet rays than even the penguin.

When the eyes of the ground squirrel were examined closely, a yellow pigment was found in the cornea. It was speculated that the pigment produces a "sunglass effect" that absorbs the ultraviolet rays and prevents damage to the cornea. As well, many mammals have ascorbate, derived from vitamin C, in the outer layers of their cornea, which absorbs damaging ultraviolet light. Studies with polar bears are needed to determine how they prevent snow blindness when they are sometimes exposed to 24 hours of ultraviolet-containing sunshine.

Combating the Cold

The most critical adaptations for a northern animal are those that insulate it against the frigid temperatures. An Arctic mammal's body temperature may differ from the air temperature by as much as 143°F (80°C). This is the same temperature difference that exists between room temperature and a cup of boiling water. A polar bear shields itself from the heat-stealing northern climate with special adaptations in its feet and fur.

The bottoms of a polar bear's feet are heavily furred, insulating them from the ice and snow. This adaptation is also seen in the feet of the Arctic fox. Hairy soles have

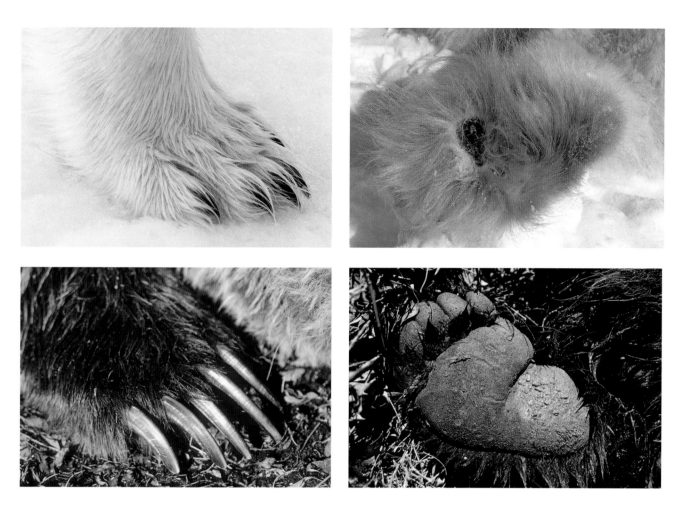

evolved not only in polar animals but also in desert animals; two good examples of this are the sand cat and the fennec fox of North Africa. Desert animals have the reverse problem of the polar bear; they must shield their feet from the searing temperatures of hot desert sands, which can exceed 176°F (80°C).

Even if most of a polar bear's foot pads are covered by fur, it still has some furless areas that come into direct contact with the ground. Studies have shown that Arctic mammals have specialized skin on their feet that can chill to 32°F (0°C) without becoming frostbitten or painful. In contrast, domestic dogs find it painful to stand on ice if they have been raised indoors, and it takes them several weeks to become acclimated to cold winter temperatures. Human feet are the least adapted to survive in the Arctic. We experience intense pain if the skin on our feet drops much below 59°F (15°C).

Not only are a polar bear's foot pads resistant to frostbite but they are also roughened like coarse sandpaper to prevent slipping. When viewed under a microscope, the black skin of a polar bear's foot pads is covered with thousands of tiny bumps. This antiskid feature might never have been examined in detail if it were not for a group of British researchers with the Ford Motor Company who were trying to develop

A comparison of the front feet (left) and hind feet (right) of a polar bear (top) and a brown bear (bottom)

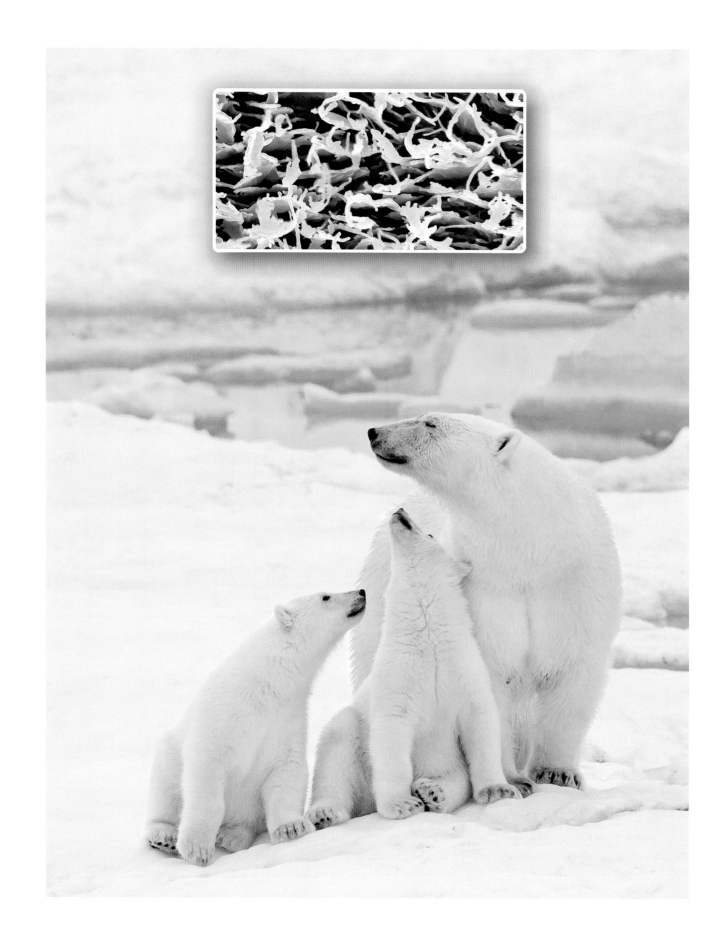

slip-resistant footwear to reduce industrial accidents. The researchers decided to study the polar bear, since it is adapted to a slippery environment. Their findings led them to develop a soft shoe soling that was covered with small conical projections, similar to the pliable foot pads of a polar bear.

The dense, long fur of northern mammals is legendary, and it is the animals' principal defense against the cold. A thick coat of fur traps a layer of warm air next to the animal's skin, and it is this layer of air that insulates them from the cold.

The fur coat of a polar bear consists of an underwool of fine white hair that is penetrated by longer, coarse guard hairs lying on top of the underwool. The guard hairs, which are twice the length of the underwool hairs, are hollow. During the summer months in warm climates, the fur of polar bears caged in zoos may turn green because of algae growing inside the hollow core of their guard hairs. The underwool hairs are not hollow and remain white.

In late autumn, the number and length of the underwool hairs increases so that the density of a bear's pelt increases from 6,450 hairs per square inch (1,000 hairs per sq. cm) to 9,677 hairs per square inch (1,500 hairs per sq. cm), providing greater insulation.

Polar bears are well equipped for the cold with their denser winter coats, but what happens when they plunge into the water? Unlike semiaquatic mammals, such as the muskrat, beaver, and sea otter, a polar bear usually gets soaked to the skin when it dives into the water. These smaller semiaquatic mammals rely on their thick fur to trap a layer of air between their skin and the water to insulate them. The fur coat of a sea otter, for example, has 645,000 hairs per square inch (100,000 hairs per sq. cm), compared with the polar bear's meager 9,677 hairs per square inch (1,500 hairs per sq. cm). By comparison, the average human head has a scanty 2,200 hairs per square inch (341 hairs per sq. cm).

Seals, like polar bears, get wet to the skin, but seals can rely on their blubber layer to insulate them from the cold. Recall that, although a polar bear can pad its body with great amounts of fat, the fat functions primarily as an energy reserve rather than as an insulator against cold temperatures. Water conducts heat 25 times better than dry air, so the heat drain on a swimming bear can be tremendous. Polar bears are not as well adapted to swim in cold water as seals are, and if they remain immersed for any length of time, they lose body heat and must burn their fat reserves to stay warm.

Despite the remarkable morphological, physiological, and behavioral adaptations of the four species of northern bears, only the American black bear is holding its own and not in decline. Chapter 8 reviews some of the major threats facing these charismatic symbols of the northern wilderness.

◀ On a microscopic level, a polar bear hair is a latticework of keratin separated by insulating pockets of air

THE UNBEARABLE FUTURE

Human creatures will forever be fighting and killing one another.
They will destroy the vast forests of the world and when they are filled
with food they will deal out death, labor, terror and banishment to every living thing.
Everything on earth, or under it, or in the waters will be pursued,
disturbed or spoiled or removed from one country to another.

LEONARDO DA VINCI, *fifteenth-century Italian genius*

IN THE MANY BOOKS I HAVE WRITTEN about ecosystems and wildlife, I have tried, whenever possible, to avoid talking about threats. Not because the natural world is free from them, by any estimation, but because the topic of threats is so depressing to tackle. Threats to wildlife and the environment certainly existed when I began writing about the natural world 40 years ago, and the situation has only gotten more dire. There is an elephant in the room, and it, above all else, will dictate the future of not only northern bears but the planet itself—and us with it. That elephant is unrestrained human population growth. It's the emotional topic no one wants to address. As of November 2020, the world population was roughly 7.8 billion, and it is increasing every year by an additional 72 million people. Add to this, the ever-shrinking area of habitable land on the planet because of desertification, rising sea levels, and recurrent lethal heat waves resulting from the incontestable consequences of climate change, and you have more people being squeezed into a smaller and smaller space. It's simple: we are a species out of control, driven as all organisms are by genetically programmed self-interest. But humans have an advantage over all other organisms. We have an immense brain that can logically evaluate simple facts, although our analysis is too often clouded by misplaced cultural priorities, racial prejudices, junk science, and bigoted religious beliefs. We direct our collective intelligence toward disease suppression and enhanced food production when so many challenges could be lessened if there were simply fewer of us crowding the planet. Some population ecologists estimate that the sustainable carrying capacity of Earth is no more than 2 billion hopeful inhabitants, especially if we value sharing the space with a modicum of biodiversity. Yet here we sit with a congested 7.8 billion. Does any intelligent observer really think this is going to end well if we do not change direction immediately? Will Leonardo's 500-year-old prediction unfold while we and our sophisticated computers fiddle and fuss, ignoring the elephant?

Perhaps now you can understand why I always shy away from the topic of threats, because none of them can be meaningfully tackled unless we address the root problem,

◀ A pair of courting ravens cavorting over the temperate rain forests of coastal British Columbia

and that problem is us. We are the ones who spew carbon dioxide and methane into the atmosphere with reckless abandon, heating up the planet. We are the ones who dump chemical poisons into our waterways and oceans, disrupting endocrine systems and threatening the health of all. We are the ones who fell forests to feed extravagant urban sprawl, agriculture, infrastructure, and imprudent resource extraction. And we are the ones who hunt for vanity trophies to prop up feeble egos and poach to line our wallets and perpetuate the practice of medieval medicinal quackery. This is who we are, and this is a brief review of what we are doing to bears.

This is not a good time for bears. The International Union for Conservation of Nature (IUCN), which globally evaluates the status and threats to species, currently lists the four tropical bears as well as the polar bear and Asiatic black bear as vulnerable to extinction. The American black bear and brown bear are of lesser concern but still face some regional survival challenges. Four of the major threats facing all of these charismatic carnivores are habitat loss and fragmentation, chemical pollution, unregulated hunting and poaching, and climate change.

HABITAT LOSS

Bears are wild creature that need wildlands in which to live. When these tracts of habitat are replaced by tree plantations, human settlements, and farmlands, or fragmented by road construction, railways, and hydroelectric developments, bears are squeezed into increasingly smaller isolated islands of wilderness.

Logging and conversion into croplands are major threats in 9 out of 18 countries where Asiatic black bears occur. In four of those countries, North Korea, Pakistan, Cambodia, and Myanmar, the annual rate of forest loss is among the highest on the planet. Even in China and Japan, where the area of forests is increasing in government-mandated efforts to reduce lumber importation, catastrophic flooding, and erosion, many of the new forests are tree farms. These managed woodlands attract hungry Asiatic black bears that feed on the bark when natural foods fail. In Japan in 2006, when a mast failure occurred, over 4,000 black bears were killed when they raided timber plantations and croplands. Japanese researcher Kazuhiko Maita estimated that those "nuisance kills" may have represented 60% of the entire black bear population in his country.

Increasing density of roads and escalating traffic volumes also have predictable lethal side effects. They allow greater access for hunters and poachers, genetically isolate subpopulations, and lead to mortalities from vehicle collisions. When a highway in North Carolina was upgraded from two lanes to four, black bear mortalities increased, even though safe underpasses were available. The road casualties seriously impacted the local bear population.

Even trains kill bears. In Banff and Yoho National Parks in the Canadian Rocky Mountains, more grizzlies die on the railway tracks that dissect the parks than anywhere else. The bears are lured to the tracks by spilled grain accidentally leaking from poorly sealed hopper cars.

that *Traditional Chinese Medicine has neither an empirical nor rational foundation. It is a threat to biodiversity. And it often uses poisons and waste as remedies. So we have enough reasons to bid farewell to it.*

Among practitioners of TCM, the bile of bears is prescribed for a variety of inflammatory diseases. As a former emergency physician, I naturally believe in science. I understand the persuasive power of placebos, but I believe most of TCM is medicinal hocus-pocus. If any of the animal cures actually worked, which Western physician would not want to use it to help his or her patients? None that I have ever known. TCM is discredited because the greater part of it has no scientific merit whatsoever. Nonetheless, today there are thousands of TCM practitioners, and tens of millions of believers among the citizens of China, Japan, South Korea, and numerous other Asian countries, who are willing to pay exorbitant prices for wishful animal remedies in the hope of curing actual diseases.

Unfortunately for wild bears, at least one compound present in their bile has actual medicinal value. It is ursodeoxycholic acid (UDCA), and it has been cheaply synthesized since the mid-1950s. One would have hoped that the synthetic version removed any necessity to use bears as a source of the compound. Today, tablets of synthesized UDCA are marketed under several dozen trade names, including Ursocol, Actigall, and Urso Forte, and are recognized by Western physicians as a legitimate treatment for various liver diseases as well as certain neurodegenerative diseases such as Alzheimer's and Parkinson's. However, despite more than 60 years of synthetic production, many practitioners and followers of TCM still argue that bile taken from any live bear is better than the identical synthetic compound, and it is best if it is taken from a wild free-ranging animal. For them, UDCA taken from the body of a living bear is the "real stuff."

Fifty years ago, belief in the greater potency of actual bear bile over identical synthetic drugs led to the development of bear farms. The first farms appeared in South Korea in the 1970s and in China in the 1980s. Individual wild-caught bears are kept in wire cages smaller in volume than an average refrigerator lying on its side. Often the enclosures are so small that the imprisoned animals can't stand or turn around. The victims have a permanent cannula surgically inserted into their abdomen; this allows bile to be drained repeatedly from their gallbladder. The cramped bears endure pain, chronically inflamed gallbladders, abdominal abscesses, gall stones, and even intestinal herniation. Undercover observers report that the tortured bears often moan continuously, bang their head against their cage, and chew on their own paws in acts of self-mutilation.

Ten years ago, bear farming began to grow in popularity throughout Southeast Asia, curiously coinciding with the rapid growth of affluence in the region. At the time, perhaps 15,000 bears, mostly Asiatic black bears, but also some browns and sun bears, were cruelly caged in farms in China, South Korea, and Vietnam. In response to international outrage and pressure, many of these farms moved their operations to Lao People's Democratic Republic and Myanmar, partly to assuage the critics but also to benefit from the lax regulations and weak protective legislation in those countries.

Bears kept in farms for extraction of their bile, such as these in Myanmar, are imprisoned in tiny cages where they suffer physical and psychological stress until they outlive their usefulness, at which point they are killed for their meat and paws

Nonetheless, many of the facilities continue to be owned and directed by Chinese investors. Today, there are still over 60 bear farms in China housing roughly 20,000 bears, and thousands more are caged in farms in Lao and Myanmar.

The popularity of bear bile as a cure-all has led to its inclusion in products that have never been part of TCM, such as shampoo, lotions, cosmetics, energy drinks, toothpaste, and throat lozenges. As with any commodity, when demand for a product increases, industry attempts to fill the need. This naturally translates into more farms, more caged animals, and more torture. A confined bear may live only five years, and since virtually no breeding occurs on any of these farms, replacement animals must be illegally captured from wild populations that are already dwindling from the effects of logging and habitat loss. The trapping and killing of bears for their body parts continues to be a major threat to Asiatic black bears in half the countries where these animals occur, and it is an equal danger for brown bears in the Russian Far East.

THE BIG MELT

It's amazing how circumstances can change. In the early 1970s, polar bear biologists were most concerned about large-scale industrial development in the Arctic and the risk of an oil spill. Then, no one talked about climate change or global warming. Today, 50 years later, a warming planet is the greatest threat to the bears and their polar ecosystem.

Multiple books have been written on the impact of global warming and climate change on polar bears and the Arctic sea ice, so I will limit my discussion to a brief overview. I heartily recommend Andrew Derocher's book *Polar Bears: A Complete Guide to Their Biology and Behavior* if more information is wanted on this topic.

Since 1948, the year in which I was born, the total planet has warmed by 1.44°F (0.8°C). That doesn't seem like very much, but the rise in temperature has not been the same everywhere on Earth. The increase has been least in the tropics and greatest in the high latitudes of the Arctic and Antarctic, where it has warmed by 5°F to 7°F (3°C–4°C). In the Arctic, the consequences have been most apparent in the seasonal amount of sea ice, which normally reaches its maximum extent in March and its minimum in August or September. The first satellites capable of measuring the seasonal extent of Arctic sea ice were launched in 1979. A year later, on August 26, 1980, the Arctic sea ice reached its minimum for the year and covered 2.70 million square miles (6.99 million sq. km). Since that summer, the seasonal minimum has shrunk dramatically, reaching its smallest extent on September 12, 2012, when it measured 1.22 million square miles (3.16 million sq. km), less than half of what it was in 1979. Since 2012, there has been a slight increase in summer ice extent, as evidenced by the September 15, 2020, measurement of 1.44 million square miles (3.74 million sq. km), but it is still much less than it was 40 years ago and is predicted to continue to decline. In many areas of the Arctic, the ice-free season in summer has increased by 10 to 20 days per decade since 1979, and it has been greatest in the Barents Sea, where the season is now more than 20 weeks longer than it was. Many experts predict that the Arctic will be completely ice-free by midcentury or sooner.

The polar bear is a marine mammal, and its future survival is directly tied to the persistence of seasonal sea ice. Polar bears depend upon sea ice for hunting, mating,

In recent decades, greater and greater areas of Arctic sea ice melt each summer, as shown in this August photo of the Chukchi Sea

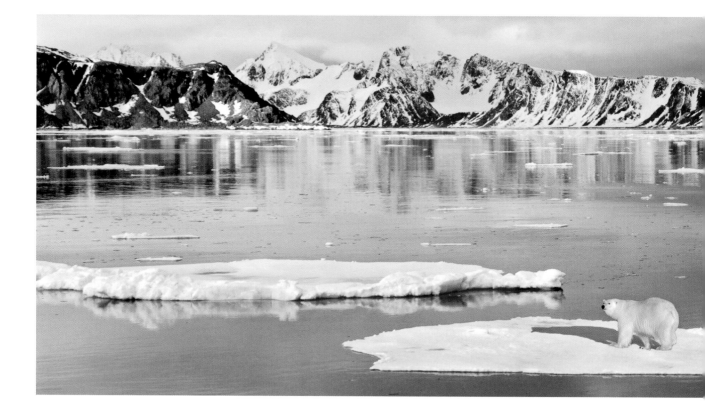

traveling, temporary shelter, and in some cases, even for a den site. Without sea ice, many bears are forced ashore and must fast for extended periods. Experts predict that eventually all bears in the Canadian Arctic will spend a compulsory two to five months on land each summer. The critical seal-hunting period for bears is April to July, and when they are forced ashore prematurely by melting sea ice, they are unable to build up the necessary fat reserves they need to sustain them through the leaner months of the year. Thin mother bears produce fewer cubs and are less able to nurse them in the spring. If a mother is too thin, she will produce no cubs at all. Even bulky adult males cannot fast on shore indefinitely. In Hudson Bay, researchers predict if the summer fast reaches 210 days, 29% to 48% of males will die. By some estimates, as the extent of summer sea ice slowly shrinks, two-thirds of polar bears will disappear by 2050, the last of them surviving in the northernmost regions of Greenland and the Canadian Arctic Archipelago.

The impact of climate change has been studied much less in the other species of northern bears. In Yellowstone National Park, the recent warmer winters have increased the overwinter survival of mountain pine beetles. The insect pests attack whitebark pine trees, in some areas killing 95% of them. The high-altitude trees produce fat-rich seeds vital to local grizzly bears, which depend upon them to build up the fat reserves they need for hibernation. The final outcome of this dietary loss is still unclear.

Researchers in the Cantabrian Mountains of northern Spain predict that the local endangered brown bear population will decline in the next 50 years because

of climate-induced drought negatively impacting blueberry and beechnut crops. Elsewhere in the Central Asian Highlands, brown bear habitat will decline by 11% in the next 30 years in 11 countries, extending from Afghanistan to China, because of warmer temperatures and declining precipitation.

Two other impacts on brown bears from climate change are greater shade-seeking behavior by animals attempting to avoid overheating and shorter denning periods, both leading to greater human-bear conflicts.

Humans and their activities will ultimately determine the fate of all bears. From the earliest times, in every part of the world, there has always been a predator that attracted special attention in the spiritual lives of the people. Invariably this animal was large, powerful, and dangerous, and sometimes it preyed on humans. In the sweltering swamps of New Guinea and northern Australia, this animal was the saltwater crocodile; in India and Southeast Asia, it was the tiger; in the savannahs of Africa, it was the lion; in the forests of central Europe, it was the wolf; and in the verdant rain forests of Central and South America, it was el tigre, the jaguar. In the pack ice, tundra, and northern coniferous forests of Eurasia and North America, this special animal was the bear, the monarch of the northern wilderness.

Bears keep me humble and help me to keep the world and where I fit in the spectrum of life in perspective. We need to preserve the wilderness and its monarchs for ourselves and for the dreams of our children. We should fight for these things as if our lives depended upon it, because they do.

By some estimates, as the extent of summer sea ice slowly shrinks due to climate change, as many as two-thirds of polar bears will disappear by 2050

THE TROPICAL BEARS

For thousands of years, the bear has been our companion on our journey on the Earth.
More than any other mammal, it is the icon and poetry of wildness. . . .
It enters our minds, profoundly influencing our dreams and imagination. . . .
Its fantastic biological reality carries us into that state of grace and
sacredness so necessary for our survival as fully human beings.

FLORENCE SHEPARD, *twentieth-century naturalist and feminist*

AS OUTLINED IN THE PREFACE, among the eight species of bears living today, four live in the polar and temperate latitudes, and were the main focus of this book, and four others live in more tropical climes: the termite-slurping sloth bear, the honey-hungry sun bear, the Andean bear of the cloud forests, and the bamboo-dependent giant panda.

From DNA analysis, geneticists have constructed a family tree for the eight species of bears living today. The giant panda was the first one to branch off from the ancestral line, roughly 18 to 20 million years ago. The Andean bear was next, splitting away 12 to 15 million years ago. The remaining six bear species, including the sun bear, the sloth bear, and the four northern bears, separated from each other in the last 3 to 4 million years.

None of the so-called tropical bears, except perhaps the giant panda, has been studied as extensively as the northern bears, so much less is known about their lives. Although all of them spend time sheltered in a den to give birth to their vulnerable young, none hibernates to avoid inclement weather or a shortage of food. This appendix offers a brief overview of their biology.

◀ The Danum Valley Conservation Area in Sabah Malaysia is a large tract of relatively undisturbed lowland rain forest—a vital home for sun bears

THE ANDEAN BEAR OF THE CLOUD FORESTS

Many years ago, I tramped through a cloud forest on the slopes of the Andes in western Venezuela. The vegetation was thick and dripping, the shadows deep, and the air heavy with moisture. Sunlight rarely reached the ground, so I often gazed upwards into the brightness of the canopy. The tree branches were laden with greenery and covered with aerial gardens of orchids, ferns, vines, and bromeliads. Occasionally birds whose names were as colorful as their plumage—sparkling violetear, bearded helmetcrest, sunangel, and coppery-bellied puffleg—would fly by like flowers on the wing. These lofty, cloud-shrouded forests are home to the Andean bear, the only bear living in South America.

Heyday of the Short-Faced Bears

Today, the Andean bear is a little-known player in the world of bears, yet during the last glacial period of the current ice age, the subfamily to which it belongs, the Tremarctinae, was the dominant group of bears in the Americas. In North America, there was the giant short-faced bear concentrated west of the Mississippi, the lesser short-faced bear in the eastern coastal forests, and the Florida cave bear ranging from the southeast to Idaho. Additionally, in South America, there were five other species of short-faced bears, including the 2,650-pound (1,200-kg) *Arctotherium angustidens,* the largest bear to have ever lived. All of these disappeared by 8,000 years ago. The only remaining relative is the Andean bear of South America, which is thought to have evolved from the Florida cave bear roughly 13,000 years ago, making it the world's youngest species of bear.

The most studied of the Andean bear's extinct relatives is the giant short-faced bear of North America, which lived alongside the brown bear on the continent for thousands of years, but was much larger than most brown bears. This gigantic bear weighed up to 1,763 pounds (800 kg) and stood 5 feet (1.5 m) at the shoulder and could look you in the eye. On its hind legs, the giant stood 11 feet (3.4 m) tall and could reach above a basketball hoop. Initially, paleontologists concluded that this long-legged carnivore was a fast-running, super predator. But this conclusion has been challenged in recent years, and the diet of this impressive carnivore continues to be a contentious issue. The current thinking is that the giant short-faced bear was not a super predator at all but an omnivore with scavenging tendencies. Its long legs evolved not for swift pursuit but to facilitate wide-ranging travels needed to locate scattered carcasses, and its immense size was a tool of intimidation to steal kills from smaller predators such as dire wolves, saber-toothed cats, and America lions.

Fossils of the giant short-faced bear, sometimes called the bulldog bear, have been found from Alaska to Central America. The bears disappeared around 11,400 years ago, during the same sweep of extinction that claimed the mammoths, mastodons, ground sloths, and dozens of other large ice-age mammals.

The Andean Bear Today

The Andean bear is the largest carnivore in South America, weighing twice as much as an average jaguar. Male bears stand about 30 inches (76 cm) tall at the shoulder and weigh between 308 and 386 pounds (140–175 kg), although there are records of males weighing as much as 496 pounds (225 kg). Females are typically two-thirds the size of males.

Andean bears are covered with thick black fur. Because of the white or yellowish markings on its face, it was formerly known as the spectacled bear. Frequently they also have light-colored fur on their throat and muzzle. The appealing facial patterns vary from individual to individual and remain unchanged throughout the life of the animal. Paddington Bear, the anthropomorphic fictional character in British children's literature, is meant to depict an Andean bear.

▶ The Andean bear was formerly known as the spectacled bear because of its facial markings; these markings are highly variable and unrelated to the animal's sex or age

This South American bruin currently occurs on the mountainous slopes of the Andes from Venezuela to Bolivia, with a few scattered bears in northern Argentina. Within its range, the animals use a variety of habitats, from low-elevation desert scrub to tropical alpine meadows, called paramo. Between these two elevational extremes are the moist cloud forests, the habitat most often used by Andean bears.

The Andean bear has been known to science since the mid-1800s, but its biology has only recently been studied in detail, and still in only small portions of its continental range. Many questions still remain.

From the study of droppings, biologists believe that the primary food of the bear is the succulent hearts of bromeliads (the pineapple is a familiar type of bromeliad), as well as young bamboo stalks, palm shoots, and orchid bulbs. During certain months, Andean bears also feed heavily on fruit, especially wild guava, avocados, and figs. The Andean bear, like all of the short-faced tribe, has a short muzzle and strong muscles of mastication, which are needed to chew the tough, fibrous foods it eats. Occasionally, Andean bears also eat insects and small rodents, but such animal foods make up less than 5% of their diet.

The Andean bear readily climbs trees to reach branches heavily laden with bromeliads or fruit. It may forage as high as 50 feet (15 m) off the ground, and once aloft it creates a platform with the bent branches of trees and uses them as a feeding or resting area. Pioneer Andean bear researcher Bernie Peyton found many fig trees in Peru that had been climbed repeatedly over the years, resulting in the bark of their trunks being heavily scarred. He wondered if a bear defined its home range around known groves of fig trees.

The first wild Andean bears were radio-collared in 1999. From those and later studies, we know that the bears have a relatively small home range. Over the course of a year, an average male occupies just 23 square miles (59 sq. km),

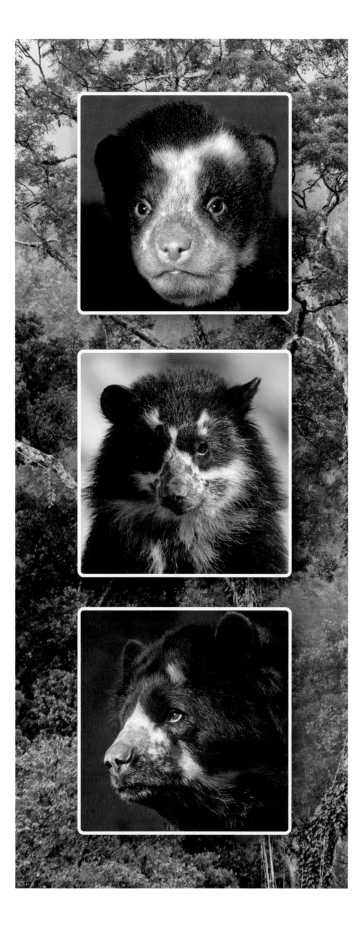

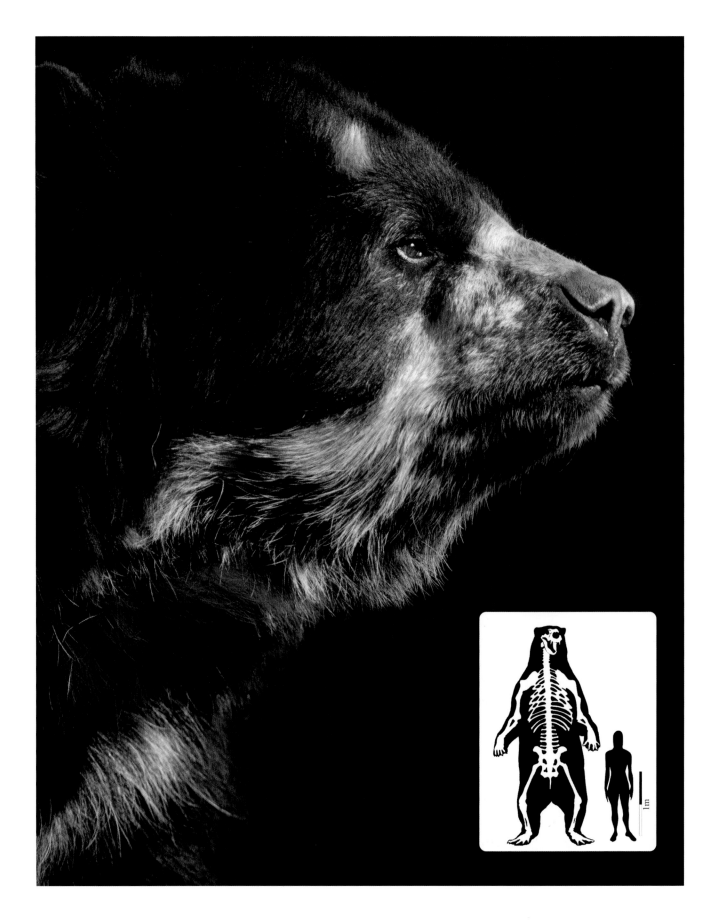

and a female only 6 square miles (15 sq. km). After the winter rains in December to March many trees produce fruit, and a bear's home range may shrink in half. This is also the time when mother bears have their one to three cubs, which they sequester in a rock cavity den for three to four months. Mother Andean bears do not hibernate, and the birthing and early nursing period coincides with the season of greatest fruit abundance.

A Clouded Future

Many Andean peoples attribute magical and curative powers to the Andean bear. In Venezuela, the bear's fat is used for rheumatic problems, and the bones are ground up and mixed with milk and given to infants to strengthen them. Often when a bear is killed, its blood is immediately drunk as a sort of communion to help the hunter become more bear-like. In many regions, the baculum (penis bone) is worn as an amulet for manhood, and the skin and paws are considered trophies and sold in rural markets. Even bear scats are believed to carry power, and farmers feed bear droppings to their cattle to make the animals stronger.

The Andean bear occurs in separated patches of cloud forest extending from Venezuela to northern Argentina

The biggest threat to Andean bears throughout their range is the loss of cloud forest habitat. When people move into these forest areas, the overall range of the bears becomes fragmented, and their travel routes are disrupted. Often the people clear the forest to plant corn and raise cattle, and the bears are naturally tempted to sometimes raid the crops and kill the livestock. In retaliation, people often shoot every Andean bear they see.

There are no reliable estimates of the total number of Andean bears, but the International Union for Conservation of Nature (IUCN) is hopeful that between 13,000 and 18,000 remain, with core populations in Colombia, Bolivia, and Peru. One population of Andean bears that is likely to decline is the one that lives in the forested slopes that buttress the magnificent Inca citadel of Machu Picchu in the Peruvian Andes. Humanity prides itself on its regard and concern for things that are old, and it spends fortunes to restore, protect, and preserve human antiquities such as Machu Picchu, which is a mere 600 years old. The Andean bear lineage is perhaps 13,000 years old, and I'm hopeful that an enlightened society feels the same responsibility for the bear's survival as it does for the survival of the stone and mortar of a lifeless piece of ancient human architecture.

◄ Today's Andean bear is a distant relative of the largest bear to have ever lived, *Arctotherium angustidens*, shown here (inset) compared to the size of an average woman. Both bears belong to the short-faced bear subfamily Tremarctinae.

THE SUN BEAR

The sun bear, which is about half the size of the average American black bear, is the smallest of the eight living bear species and the least understood. As J. A. Mills, a life-long critic of the illegal wildlife trade, noted 30 years ago, "No one has studied it, and no one knows whether there are 50 or 50,000 of them left in the wild." Very slow progress has been made since then. Today, the sun bear occurs in the lowland rain forests

The sun bear of Southeast Asia is the smallest of the world's living bear species; its current distribution is limited to 10 Southeast Asian countries

▶ Biologists use photographs of a sun bear's unique chest markings to identify individuals

of 10 countries in Southeast Asia. Although there are no reliable estimates as to its total population size, conservationists calculate that, because of widespread poaching for the animal's gall bladder for use in Traditional Chinese Medicine and deforestation and habitat loss for the planting of lucrative oil palm plantations, the total number of sun bears has declined by 30% to 40% since the early 1990s. In 2017, the first international symposium on sun bear conservation and management was finally convened, and global concern and knowledge may slowly be growing.

The sun bear is the runt of the bear clan. An adult bear is roughly the size of a large dog—it is 3.25 to 4.5 feet (1–1.4 m) long, 2.25 feet (0.7 m) tall at the shoulder, and weighs between 60 and 132 pounds (27–60 kg). Sun bears exhibit limited sexual dimorphism, and females are only about 10% to 20% smaller than males. The sun bear has the shortest fur of any bear, giving the animal a stocky, muscular appearance. They have black fur, and most individuals also have a large yellowish-white or orange U-shaped chest blaze that is individually unique and can be used as an identifier.

Most bear species can climb trees, but the sun bear is particularly adept at it. The soles of its paws are naked, ensuring a good grip on tree trunks, and its ivory-colored claws are sharp and strongly curved. Whereas the American and Asiatic black bears and the Andean bear may build nests in trees when the animals are feeding on fruit, flowers, or leaves, the sun bear regularly builds tree nests in which to sleep and rest. The small sun bear may feel more secure resting aloft in a tree, especially where predatory tigers, leopards, and Asian wild dogs live in the same forests.

Graduate student Siew Te Wong described the nest-building process by a six-month-old captive female sun bear. *She would shinny up a tree, climb out upon a limb until she reached a convenient fork where there were small leafy branches handy, and proceed to pull the twigs and leaves underneath her belly, lying upon them with her chin in the fork of the limb, her body along its length and all four legs hanging down. If overtaken by rain the procedure was the same and it was ludicrous to see her literally scuttle up the nearest tree and work against time to get a mat of leaves and twigs under her belly while leaving her back to the mercy of the elements; there she would stay with a look of patient misery on her face and not even hunger would get her down until the shower was over.*

The sun bear is primarily active during the day, spending the night inside a hollow log, in a cavity beneath some tree roots, or aloft in a nest or astride a thick branch, as high as 165 feet (50 m) off the ground. When fruit is available, the sun bear may eat virtually nothing else, and it is especially fond of figs. A fruiting fig tree may contain 60,000 fruits, and as many as three sun bears may forage in the same tree. All the fig trees in a patch of forest may synchronously produce a large crop of fruit one year and follow that with several years of poor fruit production. During periods of scarcity, the bears may lose weight and sometimes even starve. When the sun bear is not eating fruit, it uses its strong claws, large canine teeth, and massive jaw muscles to tear apart decaying

sharp splinters, and its stomach is exceptionally muscular, almost gizzard-like, enabling it to churn and mash the bamboo.

After equipping the giant panda with so many anatomical adaptations to its fibrous diet, evolution didn't quite finish the job. Unfortunately, the panda has the short intestine typical of all bears. As described in Chapter 3, many plant-eating mammals have a long intestinal tract to give their body ample time to extract the maximum amount of nutrients from their food, and this is especially important when the animal is eating vegetation that is fibrous and difficult to digest, such as bamboo. Having a short intestine, the giant panda can extract only a portion of the nutrients available in its food, so it must eat great quantities to compensate. The panda must also pass the vegetation through its intestine quickly. As a result, an adult panda may forage for 15 hours a day, eat 22 to 40 pounds (10–18 kg) of leaves and stems, and produce more than 100 droppings. When a panda eats newly emerging bamboo shoots, it may consume even more, up to 84 pounds (38 kg) in a single day—nearly half its body weight.

To balance the low nutrient extraction from its bamboo diet, a panda must keep its energy costs as low as possible, and it does this in several ways. Feeding pandas move just 50 feet (15 m) an hour, occupy an exceptionally small home range of 2.3 square miles (6 sq. km) or less, and restrict themselves to gentle slopes that require a minimum of effort to traverse. As researcher Yonggang Nie reports, pandas are masters of energy conservation. The bamboo-binging bears are inactive 60% of the time, their metabolic rate is just 45% of the value predicted for a mammal their size, and remarkably, by reducing the size of their brain, liver, and kidneys, they lessen their energy needs even further.

Mating and Hibernation

The mating season for giant pandas occurs in March and April. Unlike other male bears, the male panda may advertise his presence to females by calling loudly, sometimes from high in a tree. From his elevated perch, a male's bleating is audible 0.65 miles (1 km) away. The loud vocalizations identify the caller, advertise his body size, and reflect his testosterone level. A male's testosterone level influences the vocal folds in his larynx and alters the quality of his calls, and females seemingly prefer to mate with males with higher hormone levels.

Among the eight species of bears, the giant panda has the largest anal glands, and scent marking plays an important role in its biology. Both sexes scent mark throughout the year, but males are most active, especially during the spring breeding season. They target the trunks of trees adjacent to well-traveled trails and urinate on them, as well as smearing them with sticky anal gland secretions. Most bear species scent mark, but none but the male panda does it by periodically doing a handstand next to a tree and urinating as high on the trunk as it can reach. The high placement broadcasts the scent farther, as well as advertising the size of the male, since the larger the animal the higher it can spray.

A mother panda gives birth in a rock cavity or a tree with a hollow base. Her litter of one or two cubs is born in August or September. Implantation is delayed in the giant panda, as it is in most other bears, so the unborn panda cubs grow for less than two

months before they are born. As a result of such a short developmental period, newborn pandas are the size of a rat and weigh a mere 3 to 4.5 ounces (90–130 g)—1/900 the weight of their mother. Newborn pandas are sparsely covered with fine white hair, but they acquire the characteristic black legs, ears, and eyes by the time they are a month old.

Female pandas stay at their maternity den until their cubs are four to seven weeks old. During this time, however, the mother leaves her youngsters alone in the den each day for two or three hours at a time while she goes off to feed on nearby bamboo. Young panda cubs begin to eat bamboo when they are five or six months old, and they are fully weaned by nine months of age. The panda family eventually breaks up at the start of a new breeding season, when the young are a year and a half old.

Of the eight species of bears in the world, only half of them hibernate. The giant panda is one of those that does not, and there are two good reasons for this. First, the panda already eats as much bamboo as it can just to meet its daily energy requirements. The animal could not eat enough additional bamboo to accumulate the necessary fat reserves it would need to enable it to fast during hibernation. Second, vegetation of adequate nutritional value is available year-round, so there is no need for the animal to become dormant to avoid a time of food scarcity.

This 1.5-year-old giant panda was curious about the noisy calls of a passing flock of red-billed magpies

Future Fears

Scientists estimate that there are approximately 1,600 pandas in the wild today. The greatest threat to their survival is the continued loss of bamboo forest habitat. Although the wild population has increased by 60% since the 1988 census of 1,000 animals, the total area of suitable habitat has continued to decline and become more fragmented, converting panda habitat into isolated islands of forest.

Bamboo belongs to the grass family, but unlike most grasses, bamboo does not flower every year. Most bamboo species that grow in temperate latitudes flower at intervals of 10 to 150 years. Of the bamboo species eaten by giant pandas, most flower at intervals between 30 and 50 years. When bamboo plants flower, they do so in unison over a wide area, and all of the plants in the area die immediately afterwards.

In former times, pandas responded to these periodic bamboo die-offs by moving to unaffected areas. Today, pandas cannot move readily from one mountain area to another because their traditional travel routes are blocked by people and their farms. In addition, there are fewer alternative sites for the pandas to use, and a bamboo die-off can have a devastating effect on an isolated population.

In the mid-1970s, three species of bamboo died in the Min Mountains, and at least 138 pandas starved to death. In the early 1980s, in the Wolong Reserve, one of China's largest panda sanctuaries, there was a substantial bamboo die-off, and plant coverage dropped from 55% to 13%. In response, the pandas moved to lower elevations. Although no pandas starved as a result of the vegetation die-off, a third of them died from natural mortalities and poaching because of their move to lower elevations.

In 1961, the World Wildlife Fund adopted the giant panda as its mascot, and this charismatic black and white bear came to symbolize the conservation movement. Should the giant panda disappear, global conservation would suffer a blow far beyond the borders of China.

The sloth bear, which is found in India, Nepal, and Sri Lanka, was given its common name in 1791 by European zoologist George Shaw, who erroneously believed the animals' thick shaggy fur and long, curved claws indicated it was a kind of tree sloth

THE SLOTH BEAR: THE TERMITE TERMINATOR

The sloth bear is found in the dry deciduous forests and lowland grasslands of India, Nepal, and Sri Lanka. It shares its range with charismatic neighbors: tigers, leopards, striped hyenas, Asiatic wild dogs, Asian elephants, greater one-horned rhinos, pythons, and a dozen deadly venomous snakes.

A guesstimate of its total population ranges from 10,000 to 25,000 bears. With more than 1.3 billion people living in India alone, it will take a concerted effort to preserve the few remaining tracts of wilderness forest where the bear is found.

The sloth bear is medium in size, 4.5 to 5.5 feet (1.4–1.7 m) long from its nose to the tip of its tail. It stands 2.75 feet (0.8 m) tall at the shoulder, and adult males weigh 176 to 320 pounds (80–145 kg), whereas females weigh 121 to 209 pounds (55–95 kg). The smallest sloth bears live in Sri Lanka.

When I saw my first sloth bear in a zoo—which is no place for any species of bear—my first impression was how shaggy and unkempt they look. Their fur, especially around their head and neck, seems to stick up in all directions, and it surprised me that a tropical bear would have fur that was so long and thick. The hair on its neck may be 6 inches (15 cm) long.

Sloth bears have deep black fur, sometimes mixed with gray and brown. Cinnamon-colored variations have been reported on rare occasions. Most sloth bears have a white or yellow V-shaped mark on their lower neck and chest, and all have a sparsely furred grayish-white muzzle.

Little was known about the biology of sloth bears until 1990 when Anup Joshi radio-collared eight bears in Nepal's Royal Chitwan National Park—the first study of its kind ever conducted on this species. Since then, researchers have discovered many interesting biological details. Sloth bears live in tiny home ranges, one of the smallest of any of the bears. In Sri Lanka, for example, the average male covers just 1.5 square miles (3.8 sq. km) in his annual wanderings, and the average female just 0.8 square miles (2.2 sq. km).

Typically, sloth bears breed from May to July with two or three males sometimes competing to mate with the same female and fighting with each other for access. In the end, the female may breed with more than one partner, which, as in the northern bear species, may confuse the paternity of her cubs and lessen the risk of infanticide later on. She gives birth to her small litter of one or two cubs from November to February in an excavated hole or natural hollow. The mother stays with her cubs almost continuously for the first 9 to 10 weeks, and only toward the end of her vigil does she come out briefly to feed. Protecting her cubs from hungry tigers and leopards is the likely reason she is so cautious. When the family finally abandons the natal den when the cubs are roughly three months old, the cubs often ride on their mother's back as they move around her home range. They will continue to do this until they are six to nine months old and almost a third of their mother's size. The family finally breaks up when the young are 1.5 to 2 years old.

Adapting to an Unusual Diet

What is most fascinating and unusual about the sloth bear is its diet, the adaptations it evolved to cope with its diet, and the influence that its diet has on how young bears travel with their mother.

The sloth bear's diet varies seasonally and geographically. In some parts of its range, 90% of what it eats is fruit, especially wild figs, while in other areas it specializes in terrorizing termite colonies. Its diet also varies from season to season, and in most areas the bears feed on fruit whenever it is available, otherwise the mainstay of their diet is a combination of termites, ants, bees, and honeycombs.

In Nepal, termite nests may be totally subterranean or they may be large, visible pillars, up to 6.5 feet (2 m) tall. The bears dig a hole into the base of the pillar to reach the

A specialist termite predator, the sloth bear excavates termite colonies most frequently during the monsoon season, when the wet earth is softer to dig

insects inside. The underground colonies are probably located by smell, which is how other ant and termite predators find these insects. Once the bear sniffs out an occupied underground colony, it digs straight down up to 6.5 feet (2 m) to reach the tasty tidbits. In such a deep hole, the digging bear may be completely lost from sight. To make excavation easier, the bears often increase their termite attacks during the rainy monsoon season when the soggy soil is easier to dig.

All bears have an acute sense of smell, so it is not surprising that a sloth bear can locate termites with its nose. In fact, I have watched an American black bear locate an underground ant nest in a similar way. The sloth bear's keen sense of smell is not its only adaptation to a termite diet.

The bear has large, floppy lips, a mobile snout sparsely covered with hair, closeable nostrils, absent upper incisor teeth (which creates a gap at the front of its mouth), and a high, arched palate. This unique suite of adaptations helps it to become the ultimate termite terminator. The bear's floppy lips make it easier for the animal to capture fleeing insects. Its lightly furred snout is less likely to become gummed up with the defensive secretions sprayed by angry termites. Its closed nostrils prevent soldier termites from launching a counterattack, and its missing upper teeth and high arched palate enable it to create a vacuum and an orifice through which it can efficiently suck up the insects. The bears are also equipped with 3-inch (7.5-cm) long raking front claws that help them tunnel through the sunbaked soil that encases many termite colonies.

For centuries, hunters have located sloth bears by the loud huffing and puffing noises the animals make when they are vacuuming up termites. The noise can be heard several hundred yards away. Some researchers speculate that the conspicuous feeding noises may alert other bears and keep the animals spaced apart.

The most intriguing behavioral trait shown by sloth bears is the way young bears ride on their mother's back. On rare occasions, mother polar bears and brown bears will let their cubs ride on them, but in the sloth bear it is a regular mode of family travel. Young sloth bears ride crosswise or with their heads facing forward. They may stay mounted even while their mother digs for termites, and they may get showered with dirt, jostled around, and sometimes bucked off by their distracted parent. The piggyback travel arrangement may be one of the reasons mother sloth bears rarely have more than two cubs—there is no room for a third.

Why would a bear that eats termites also carry its young on its back? At first glance you would probably conclude, as I did, that the two behaviors are completely unrelated. Surprisingly, when you look at the behavior of other mammals that specialize in eating termites and ants, you discover that a number of them also carry their young around with them in this way. This is true of the giant anteater of the South American grasslands and the eight species of scaly pangolins found in Africa and southern Asia.

Scientists have tried to explain the association by suggesting that young termite eaters travel with their mothers because termite colonies are often widely spaced, and a mother must hunt over a relatively large area, making it hard for her to continually return to a den to attend to her young. Another explanation is that the behavior evolved as an antipredator strategy. This explanation seems to fit best for the sloth bear. Young sloth bears may be preyed upon by leopards and tigers, and the youngsters offer a less vulnerable target when they are clinging to the back of an extremely aggressive mother armed with long claws and fearsome canine teeth. In addition, sloth bears frequently dig for termites in open grasslands, where there are no trees to provide an escape from danger. Clinging to mother may be the best option a cub has in these exposed locations. No explanation is totally satisfactory in explaining the riding behavior of any of the termite eaters, including the sloth bear.

One final intriguing tidbit of biology concerns the long fur coat of the sloth bear. In the sweltering heat of the tropics, you would think that the bear would become overheated and that such a thick pelt would be maladaptive. Researcher Brian McNab discovered that the sloth bear has a metabolic rate much lower than that of either the brown bear or the polar bear. McNab suggests that ants and termites are usually considered low-energy food sources, and it follows that such a low-energy diet could only sustain an animal with a low rate of metabolism.

The sloth bear is the only bear that routinely carries its cubs on its back, although some of the other species do so periodically

The low metabolic rate of the sloth bear also means that the animal produces less internal heat. Since it generates less body heat, the sloth bear must carefully conserve heat or else its body temperature will drop. It does this by insulating itself inside a thick fur coat. The giant anteater of tropical South America also has a low metabolic rate, and McNab believes that it, like the sloth bear, relies on its long, shaggy coat to maintain its body temperature. Thus, the thick fur coat of the tropical sloth bear, instead of being an evolutionary mistake, turns out to be an ingenious adaptation to a low-energy diet. Nature always seems to get it right.

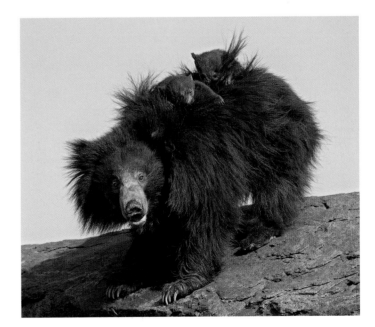

Appendix B

SCIENTIFIC NAMES OF
PLANTS AND ANIMALS

Common name (Scientific name)

acorn (family Fagaceae)
adder, puff (*Bitis arietans*)
alder (*Alnus* spp.)
alligator, American (*Alligator mississippiensis*)
amphipods (class Malacostraca)
ant, red forest (*Formica aquilonia*)
anteater, giant (*Myrmecophaga tridactyla*)
armadillo, nine-banded (*Dasypus novemcinctus*)
ash, white (*Fraxinus americana*)
baboon, olive (*Papio anubis*)
badger, American (*Taxidea taxus*)
bat (order Chiroptera)
bat, greater mouse-eared (*Myotis myotis*)
beach hopper (*Traskorchestia traskiana*)
bear, American black (*Ursus americanus*)
bear, Andean (*Tremarctos ornatus*)
bear, Asiatic black (*Ursus thibetanus*, previously *Selenarctos thibetanus*)
bear, brown (*Ursus arctos*)
bear, Florida cave (*Tremarctos floridanus*)
bear, giant short-faced (*Arctodus simus*)
bear, lesser short-faced (*Arctodus pristinus*)
bear, polar (*Ursus maritimus*)
bear, sloth (*Melursus ursinus*)
bear, sun (*Helarctos malayanus*)
bearberry (*Arctostaphylos* spp.)
bearcat (*Arctictis binturong*)
beauty, spring (*Claytonia lanceolata*)
beaver, North American (*Castor canadensis*)
bee, stingless (*Trigona* spp.)
beechnut (family Fagaceae)
beetle, ground (family Carabidae)
beetle, mountain pine (*Dendroctonus ponderosae*)

beetle, rove (family *Staphylinidae*)
beluga (*Delphinapterus leucas*)
bilberry, bog (*Vaccinium uliginosum*)
bilberry, European (*Vaccinium myrtillus*)
birch, dwarf (*Betula glandulosa*)
birch, yellow (*Betula alleghaniensis*)
bison (*Bison bison*)
blister rust, white pine (*Cronartium ribicola*)
blowfly (family Calliphoridae)
blueberry, alpine (*Vaccinium uliginosum*)
boar, European wild (*Sus scrofa*)
bobcat (*Lynx rufus*)
brant (*Branta bernicla*)
bromeliad (family Bromeliaceae)
caddisfly (order *Trichoptera*)
camel (*Camelus dromedarius*)
caribou (*Rangifer tarandus*)
cat, saber-toothed (*Smilodon* spp.)
cat, sand (*Felis margarita*)
centipede (class Chilopoda)
cheetah (*Acinonyx jubatus*)
cherry, choke (*Prunus virginiana*)
cherry, Japanese bird (*Prunus grayana*)
cherry, pin (*Prunus pensylvanica*)
chestnut (*Castanea spp.*)
chickadee, black-capped (*Poecile atricapillus*)
chimpanzee (*Pan troglodytes*)
chipmunk, eastern (*Tamias striatus*)
chipmunk, Siberian (*Eutamias sibiricus*)
civet, African (*Civettictis civetta*)
clam, Pacific razor (*Siliqua patula*)
cod, Arctic (*Boreogadus saida*)
cod, polar (*Arctogadus glacialis*)
cougar (*Puma concolor*)
coyote (*Canis latrans*)

◀ Wapusk National Park on the coast of Hudson Bay in northern Manitoba is perhaps the only location on Earth where the annual wanderings of three species of bears, in this case the polar bear, American black bear, and brown bear, overlap

cranberry, high-bush (*Viburnum edule*)

cranberry, low-bush (*Vaccinium vitis-idaea*)

crow, northwestern (*Corvus caurinus*)

crowberry, black (*Empetrum nigrum*)

deer, mule (*Odocoileus hemionus*)

deer, roe (*Capreolus capreolus*)

deer, sika (*Cervus nippon*)

deer, white-tailed (*Odocoileus virginianus*)

devil's club (*Oplopanax horridus*)

dog, African wild (*Lycaon pictus*)

dog, Asian wild (*Cuon alpinus*)

eagle, bald (*Haliaeetus leucocephalus*)

eagle, golden (*Aquila chrysaetos*)

echidna (family Tachyglossidae)

eider, common (*Somateria mollissima*)

eider, king (*Somateria spectabilis*)

elderberry (*Sambucus* spp.)

elephant, African bush (*Loxodonta africana*)

elephant, Asian (*Elephas maximus*)

elk (*Cervus canadensis*)

fern (class Polypodiopsida)

fig (*Ficus* spp.)

fox, Arctic (*Vulpes lagopus*)

fox, fennec (*Vulpes zerda*)

fox, red (*Vulpes vulpes*)

fulmar, northern (*Fulmarus glacialis*)

gazelle, Thomson's (*Eudorcas thomsonii*)

genet (genus Genetta)

gibbon (family Hylobatidae)

Gila monster (*Heloderma suspectum*)

goose, snow (*Chen caerulescens*)

gorilla, mountain (*Gorilla beringei beringei*)

grass, scurvy (*Cochlearia groenlandica*)

ground squirrel, Arctic (*Urocitellus parryii*)

ground squirrel, California
 (*Otospermophilus beecheyi*)

ground squirrel, Franklin's (*Spermophilus franklinii*)

gull, glaucous (*Larus hyperboreus*)

gull, ivory (*Pagophila eburnea*)

gum, black (*Nyssa sylvatica*)

hare, Arctic (*Lepus arcticus*)

hare, snowshoe (*Lepus americanus*)

hawk, rough-legged (*Buteo lagopus*)

hazelnut (*Corylus* spp.)

hemlock, western (*Tsuga heterophylla*)

hickory (*Carya* spp.)

hippopotamus, common (*Hippopotamus amphibius*)

horsetail (family Equisetaceae)

huckleberry, red (*Vaccinium parvifolium*)

hummingbird (family Trochilidae)

hyena, spotted (*Crocuta crocuta*)

hyena, striped (*Hyaena hyaena*)

jaguar (*Panthera onca*)

jay, Steller's (*Cyanocitta stelleri*)

kinglet, golden-crowned (*Regulus satrapa*)

kinkajou (*Potos flavus*)

kittiwake, black-legged (*Rissa tridactyla*)

knotweed (*Polygonum* spp.)

koala (*Phascolarctos cinereus*)

larch, Japanese (*Larix kaempferi*)

lemming, brown (*Lemmus sibiricus*)

lemming, collared (*Dicrostonyx groenlandicus*)

lemur, mouse (genus *Microcebus*)

leopard, common (*Panthera pardus*)

leopard, snow (*Panthera uncia*)

lily, glacier (*Erythronium grandiflora*)

lingonberry (*Vaccinium vitis-idaea*)

lion, African (*Panthera leo*)

lion, American (*Panthera atrox*)

liverwort (Marchantiophyta)

lupine (*Lupinus* spp.)

lynx, Canada (*Lynx canadensis*)

magpie, black-billed (*Pica hudsonia*)

magpie, red-billed (*Urocissa erythroryncha*)

maple, red (*Acer rubrum*)

marmot, hoary (*Marmota caligata*)

midges (family Chironomidae)

monkey, golden snub-nosed (*Rhinopithecus roxellana*)

moose (*Alces alces*)

moss, sphagnum (genus Sphagnum)

moth, army cutworm (*Euxoa auxiliaris*)

mountain ash, Sitka (*Sorbus sitchensis*)

mouse, northwestern deer (*Peromyscus keeni*)

muntjac (*Muntiacus* spp.)

murre, thick-billed (*Uria lomvia*)

muskox (*Ovibos moschatus*)

muskrat (*Ondatra zibethicus*)

narwhal (*Monodon monoceros*)

nematodes (phylum Nematoda)

newt, rough-skinned (*Taricha granulosa*)

oak, red (*Quercus rubra*)

onion, nodding (*Allium cernuum*)

opossum, Virginia (*Didelphis virginiana*)

orca (*Orcinus orca*)

otter, North American river (*Lontra canadensis*)

otter, sea (*Enhydra lutris*)

palm, African oil (*Elaeis guineensis*)

panda, giant (*Ailuropoda melanoleuca*)

panda, red (*Ailurus fulgens*)

pangolin (order Pholidota)

penguin, Adélie (*Pygoscelis adeliae*)

penguin, African (*Spheniscus demersus*)

pine, Japanese stone (*Pinus pumila*)

pine, Korean stone (*Pinus koraiensis*)

pine, Scots (*Pinus sylvestris*)

pine, whitebark (*Pinus albicaulis*)

pocket gopher, northern (*Thomomys talpoides*)

poplar, aspen (*Populus tremuloides*)

porcupine, North American (*Erethizon dorsatum*)

python, reticulated (*Malayopython reticulatus*)

raven, common (*Corvus corax*)

rhinoceros, black (*Diceros bicornis*)

rhinoceros, greater one-horned (*Rhinoceros unicornis*)

rice, Indian (*Fritillaria camschatcensis*)

roadrunner, greater (*Geococcyx californianus*)

rodents (order Rodentia)

rose, wild (*Rosa acicularis*)

salmon, chum (*Oncorhynchus keta*)

salmon, coho (*Oncorhynchus kisutch*)

salmon, king (*Oncorhynchus tshawytscha*)

salmon, Pacific (*Oncorhynchus* spp.)

salmon, pink (*Oncorhynchus gorbuscha*)

salmon, sockeye (*Oncorhynchus nerka*)

salmonberry (*Rubus spectabilis*)

seal, Antarctic fur (*Arctocephalus gazella*)

seal, bearded (*Erignathus barbatus*)

seal, harp (*Pagophilus groenlandicus*)

seal, hooded (*Cystophora cristata*)

seal, ringed (*Pusa hispida*)

seal, southern elephant (*Mirounga leonina*)

seal, spotted (*Phoca largha*)

sedge (family Cyperaceae)

serow (*Capricornis milneedwardsii*)

shark, whale (*Rhincodon typus*)

sheep, bighorn (*Ovis canadensis*)

shrew, montane (*Sorex monticolus*)

skua, brown (*Stercorarius antarcticus*)

skunk cabbage, eastern (*Symplocarpus foetidus*)

skunk cabbage, western (*Lysichiton americanus*)

soapberry (*Shepherdia canadensis*)

sparrow, golden-crowned (*Zonotrichia atricapilla*)

spruce, Norway (*Picea abies*)

spruce, Sitka (*Picea sitchensis*)

squirrel, ground (*see* ground squirrel)

squirrel, red (*Tamiasciurus hudsonicus*)

sucker, white (*Catostomus commersoni*)

sweetvetch, alpine (*Hedysarum alpinum*)

takin (*Budorcas taxicolor*)

tamandua, northern (*Tamandua mexicana*)

tea, Labrador (*Ledum groenlandicum*)

tenrec (family *Tenrecidae*)

thrush, hermit (*Catharus guttatus*)

thrush, varied (*Ixoreus naevius*)

tiger (*Panthera tigris*)

tragopan, Temminck's (*Tragopan temminckii*)

turbellarians (phylum Platyhelminthes)

turkey, wild (*Meleagris gallopavo*)

turtle, snapping (*Chelydra serpentina*)

vole, singing (*Microtus miurus*)

vulture, turkey (*Cathartes aura*)

walnut, Japanese (*Juglans ailantifolia*)

walrus (*Odobenus rosmarus*)

warthog, common (*Phacochoerus africanus*)

weasel, least (*Mustela nivalis*)

weasel, long-tailed weasel (*Mustela frenata*)

weevil, nut (*Curculio* spp.)

whale, beluga (*Delphinapterus leucas*)

whale, bowhead (*Balaena mysticetus*)

whale, gray (*Eschrichtius robustus*)

whale, killer (*Orcinus orca*)

wildebeest, blue (*Connochaetes taurinus*)

willow (*Salix* spp.)

wolf, dire (*Canis dirus*)

wolf, gray (*Canis lupus*)

wolverine (*Gulo gulo*)

woodchuck (*Marmota monax*)

wren, Pacific (*Troglodytes pacificus*)

zebra, common (*Equus quagga*)

General

Ewer, R. F. 1973. *The Carnivores.* Weidenfeld and Nicolson, London.

Feldhamer, G. A., L. C. Drickamer, S. H. Vessey, J. F. Merritt, and C. Krajewski. 2015. *Mammalogy: Adaptation, Diversity, Ecology.* Johns Hopkins University Press, Baltimore, Maryland.

Gittleman, J. L., ed. 1989. *Carnivore Behavior, Ecology, and Evolution.* Cornell University Press, Ithaca, New York.

Gittleman, J. L., ed. 1996. *Carnivore Behavior, Ecology, and Evolution.* Vol. 2. Cornell University Press, Ithaca, New York.

Lynch, W. 1996. *A is for Arctic: Natural Wonders of a Polar World.* Firefly Books, Willowdale, Ontario.

Lynch, W. 2001. *The Great Northern Kingdom: Life in the Boreal Forest.* Fitzhenry & Whiteside, Markham, Ontario.

1. Introduction

American Society of Mammalogists. 2019. *Mammal Diversity Database.* http://mammaldiversity.org.

Amstrup, S. C. 2003. Polar bear (*Ursus maritimus*). In *Wild Mammals of North America—Biology, Management and Conservation*, 2nd ed., edited by G. A. Feldhamer, B. C. Thompson, and J. A. Chapman, 587-610. Johns Hopkins University Press, Baltimore, Maryland.

Costello, C., D. E. Jones, K. A. Green Hammond, et al. 2001. A study of black bear ecology in New Mexico with models for population dynamics and habitat suitability. Final Report, New Mexico Game and Fish.

Danvir, R., F. Lindzey, and G. Chapman. 1983. The black bear in Utah: A survey. Utah Cooperative Wildlife Research Unit, Logan. Unpubl.

Derocher, A. E., and W. Lynch. 2012. *Polar Bears: A Complete Guide to Their Biology and Behavior.* Johns Hopkins University Press, Baltimore, Maryland.

Galbreath, G. J., H. Sun, and S. M. Montgomery. 2001. A new color phase of *Ursus thibetanus* (Mammalia: Ursidae) from Southeast Asia. *Natural History Bulletin of Siam Society* 49:107-111.

Garshelis, D. L. 2002. Misconceptions, ironies, and uncertainties regarding bear populations. *Ursus* 13:321-334.

Garshelis, D. L., B. K. Scheick, D. L. Doan-Crider, J. J. Beecham, and M. E. Obbard. 2016. *Ursus americanus. The IUCN Red List of Threatened Species* 2016: e.T41687A114251609. http://dx.doi .org/10.2305/IUCN.UK.2016-3.RLTS.T41687A45034604.en.

Garshelis, D. L., and R. Steinmetz. 2016. *Ursus thibetanus* (errata version published in 2017). *The IUCN Red List of Threatened Species* 2016: e.T22824A114252336. http://dx.doi.org/10.2305/IUCN .UK.2016-3.RLTS.T22824A45034242.en.

Gittleman, J. G. 1999. Hanging bears from phylogenetic trees: Investigation patterns of macroevolution. *Ursus* 11:29-40.

Goodyear, M. A. 2003. Extralimital sighting of a polar bear, *Ursus maritimus*, in northeastern Saskatchewan. *Can. Field-Nat.* 117 (4):648-649.

Halliday, T. J. D., P. Upchurch, and A. Goswami. 2016. Eutherians experienced elevated evolutionary rates in the immediate aftermath of the Cetaceous-Paleogene mass extinction. *Proceedings of the Royal Society B* 283: 20153026. http://dx.doi.org/10.1098/rspb.2015.3026.

◀ The temperate rain forests on the west coast of Canada are the site of the Great Bear Rainforest, a tract of wildlands the size of Ireland meant to protect brown bears, black bears, coastal wolves, and a myriad of other flora and fauna

Hedrick, P. W., and K. Ritland. 2011. Population genetics of the white-phased spirit bear of British Columbia. *Evolution.* http://doi.org/10.1111/j.1558-5646.2011.01463.x.

Higashide, D., S. Miura, and H. Miguchi. 2012. Are chest marks unique to Asiatic black bear individuals? *J. Zool.* 288:199-206.

Johnson, A. C., J. D. Pongracz, and A. E. Derocher. 2017. Long-distance movement of a female polar bear from Canada to Russia. *Arctic* 70:121-128.

Klinka, D. R., and T. E. Reimchen. 2009. Adaptive coat colour polymorphism in the Kermode bear of coastal British Columbia. *Biological Journal of the Linnean Society* 98:479-488.

Kumar, V., F. Lammers, T. Bidon, et al. 2017. The evolutionary history of bears is characterized by gene flow across species. *Scientific Reports* 7:46487. http://doi.org/10.1038/srep46487.

Marshall, H. D., and R. Ritland. 2002. Genetic diversity and differentiation of Kermode bear populations. *Molecular Ecology* 11:685-697.

McClellan, B., and D. C. Reiner. 1994. A review of bear evolution. *International Conference on Bear Biology and Management* 9(1):85-96.

McCrory, W. 2012. Spirit bears under siege: The case for the protection of Gribbell Island—Mother island of the white bear. Report to the Valhalla Wilderness Society, New Denver, British Columbia.

McLellan, B. N., M. F. Proctor, D. Huber, and S. Michel. 2017. *Ursus arctos. The IUCN Red List of Threatened Species* 2017: e.T41688A121229971. http://dx.doi.org/10.2305/IUCN.UK.2017-3.RLTS.T41688A121229971.en.

Merriam, C. H. 1918. Review of the grizzly and big brown bears of North America (genus *Ursus*) with a description of a new genus, *Vetularctos. North American Fauna No. 41.* US Dept. Agr. Bureau of Biological Survey, Government Printing Office, Washington, DC.

Pelton, M. R. 2003. Black bear (*Ursus americanus*). In *Wild Mammals of North America: Biology, Management and Conservation*, 2nd ed., edited by G. A. Feldhamer, B. C. Thompson, and J. A. Chapman, 547-555. Johns Hopkins University Press, Baltimore, Maryland.

Reimchen, T. E., and D. R. Klinka. 2017. Niche differentiation between coat colour morphs in the Kermode bear (Ursidae) of coastal British Columbia. *Biological Journal of the Linnean Society*, 122: 274-285.

Reynolds, H., D. Craighead, M. Proctor, L. Amgalan, and M. Batmunkh. 2010. Gobi Bear Conservation in Mongolia. Gobi Bear Project Team, Ulaanbaatar, Mongolia.

Ritland, K., C. Newton, and H. D. Marshall. 2001. Inheritance and population structure of the white-phased "Kermode" black bear. *Current Biology* 11(18):1468-1472.

Rogers, L. L. 1980. Inheritance of coat colour and changes in pelage coloration in black bears in northeastern Minnesota. *J. Mamm.* 61(2):324-326.

Rounds, R. C. 1987. Distribution and analysis of colourmorphs of the black bear (*Ursus americanus*). *Journal of Biogeography* 14:521-538.

Sato, Y., H. Nakamura, Y. Ishifune, and N. Ohtaishi. 2011. The white-colored brown bears of the Southern Kurils. *Ursus* 22(1):84-90

Schwartz, C. C., D. Sterling, D. Miller, and M. A. Haroldson. 2003. Brown bear (*Ursus arctos*). In *Wild Mammals of North America: Biology, Management and Conservation*, 2nd ed., edited by G. A. Feldhamer, B. C. Thompson, and J. A. Chapman, 556-586. Johns Hopkins University Press, Baltimore, Maryland.

Soibelzon, L. H., and B. W. Schubert. 2011. The largest known bear, *Arctotherium angustidens*, from the Early Pleistocene Pampean Region of Argentina: With a discussion of size and diet trends in bears. *Journal of Paleontology*, 85(1):69-75.

Stirling, I., and A. E. Derocher. 1990. Factors affecting the evolution and behavioral ecology of the modern bears. *International Conference on Bear Biology and Management* 8:189-204.

Troyer, W. A., and R. J. Hensel. 1969. The brown bear of Kodiak Island. US Dept. Interior, Bureau of Sport Fisheries and Wildlife, Branch of Wildlife Refuges, Kodiak National Wildlife Refuge, Kodiak, Alaska. Unpubl.

van Meurs, R., and J. F. Splettstoesser. 2003. Farthest north polar bear (*Ursus maritimus*). *Arctic* 56:309.

Waddell, T. E., and D. E. Brown. 1984. Weights and color of black bears in the Pinaleño Mountains, Arizona. *J. Mamm.* 65(2):350-351.

2. January • February • March

Aars, J., and A. Plumb. 2010. Polar bear cubs may reduce chilling from icy water by sitting on mother's back. *Polar Biol.* 33:557-559.

Alt, G. L. 1984. Cub adoption in the black bear. *J. Mamm.* 65(3):511-512.

Alt, G. L. 1989. Reproductive biology of female black bears and early growth and development of cubs in northeastern Pennsylvania. PhD Dissertation, West Virginia University, Morgantown, West Virginia.

Alt, G. L., and J. J. Beecham. 1984. Reintroduction of orphaned black bear cubs into the wild. *Wildl. Soc. Bull.* 12:169-174.

Arnould, J. P. Y., and M. A. Ramsay. 1994. Milk production and milk consumption in polar bears during the ice-free period in western Hudson Bay. *Can. J. Zool.* 72:1365-1370.

Barnes, B. M. 1989. Freeze avoidance in a mammal: Body temperatures below 0°C in an Arctic hibernator. *Science* 244:1593-1595.

Barry, T. W. 1968. Observations on natural mortality and native use of eider ducks along the Beaufort Sea coast. *Can. Field-Nat.* 82:140-144.

Blix, A. S., and J. W. Lentfer. 1979. Modes of thermal protection in polar bear cubs—at birth and on emergence from the den. *Am. J. Physiol.* 236(1):R67-R74.

Bowen, W. D., O. T. Oftedal, and D. J. Boness. 1985. Birth to weaning in 4 days: Remarkable growth in the hooded seal, *Cystophora cristata. Can. J. Zool.* 63:2841-2846.

Brown, T. A., M. P. Galicia, G. W. Thiemann, S. T. Belt, D. J. Yurkowski, and M. G. Dyck. 2018. High contributions of sea ice derived carbon in polar bear (*Ursus maritimus*) tissue. *PLoS ONE* 13(1):e0191631. http://doi.org/10.1371/journal.pone.0191631.

Derocher, A. E. 1990. Supernumerary mammae and nipples in the polar bear (*Ursus maritimus*). *J. Mamm.* 71(2):236-237.

Derocher, A. E., D. Andriashek, and J. P.Y. Arnould. 1993. Aspects of milk composition and lactation in polar bears. *Can. J. Zool.* 71:561-567.

Derocher, A. E., and W. Lynch. 2012. *Polar Bears: A Complete Guide to Their Biology and Behavior.* Johns Hopkins University Press, Baltimore, Maryland.

Derocher, A. E., and I. Stirling. 1996. Aspects of survival in juvenile polar bears. *Can. J. Zool.* 74:1246-1252.

Farley, S. D., and C. T. Robbins. 1995. Lactation, hibernation, and mass dynamics of American black bears and grizzly bears. *Can. J. Zool.* 73:2216-2222.

Ferguson, S. H., M. K. Taylor, A. Rosing-Asvid, E. W. Born, and F. Messier. 2000. Relationships between denning of polar bears and conditions of sea ice. *J. Mamm.* 81(4):1118-1127.

Freeman, M. M. R. 1973. Polar bear predation on beluga in the Canadian Arctic. *Arctic* 26:162-163.

Hayssen, V., and T. J. Orr. 2017. *Reproduction in Mammals: The Female Perspective.* Johns Hopkins University Press, Baltimore, Maryland.

Heldmaier, G. 2011. Life on low flame in hibernation. *Science* 331:866-867.

Hellgren, E. C. 1998. Physiology of hibernation in bears. *Ursus*10:467-477.

Hissa, R. 1997. Physiology of the European brown bear (*Ursus arctos arctos*). *Ann. Zool. Fennici.* 34:267-287.

Horner, R. A. 1976. Sea ice organisms. *Oceangr. Mar. Biol. Ann. Rev.* 14:167-182.

Jenness, R., A. W. Erickson, and J. J. Craighead. 1972. Some comparative aspects of milk from four species of bears. *J. Mamm.* 53(1):34-47.

Kiliaan, H. P. L., I. Stirling, C. J. Jonkel. 1978. Polar bears in the area of Jones Sound and Norwegian Bay. Canadian Wildlife Service, Progress Notes No. 88.

Kolenosky, G. B., and J. P. Prevett. 1983. Productivity and maternity denning of polar bears in Ontario. *Int. Conf. Bear Res. and Manage.* 5:238-245.

Lowry, L. F., J. J. Burns, and R. R. Nelson. 1987. Polar bear, *Ursus maritimus,* predation on belugas, *Delphinapterus leucas,* in the Bering and Chukchi Seas. *Can. Field-Nat.* 101(2):141-146.

Mads, P. H., L. M. Burt, R. G. Hansen, N. H. Nielsen, M. Rasmussen, S. Fossette, and H. Stern. 2013. The significance of the North Water to Arctic top predators. *Ambio.* 42(5).

Oftedal, O. T., G. L. Alt, E. M. Widdowson, and M. R. Jakubasz. 1993. Nutrition and growth of suckling black bears (*Ursus americanus*) during their mothers' winter fast. *British Journal of Nutrition* 70:59-79.

Oftedal, O. T., and J. L. Gittleman. 1989. Patterns of energy output during reproduction in carnivores. In *Carnivore Behavior, Ecology, and Evolution*, edited by J. L. Gittleman, 355-378. Cornell University Press, Ithaca.

Ovsyanikov, N. 1998. Den use and social interactions of polar bears during spring in a dense denning area on Herald Island, Russia. *Ursus* 10:251-258.

Percy, J. 1989. Piranhas of the frozen seas. *Nature Canada* Winter: 8-9.

Peters, G., M. Owens, and L. Rogers. 2007. Humming in bears: A peculiar sustained mammalian vocalization. *Acta Theriologica* 52(4):379-389.

Ramsay, M. A., and D. S. Andriashek. 1986. Long distance route orientation of female polar bears (*Ursus maritimus*) in spring. *J. Zool.* (A) 208:63-72.

Ramsay, M. A., and R. L. Dunbrack. 1986. Physiological constraints on life history phenomena: The example of small bear cubs at birth. *American Naturalist* 127(6):735-743.

Robbins, C. T., C. Lopez-Alfaro, K. D. Rode, Ø. Tøien, and O. L. Nelson. 2012. Hibernation and seasonal fasting in bears: The energetic costs and consequences for polar bears. *J. Mamm.* 93(6):1493-1503.

Rogers, L. L. 1974. Shedding of foot pads by black bears during denning. *J. Mamm.* 55(3):672-674.

Rogers, L. L., and S. C. Durst. 1987. Evidence that black bears reduce peripheral blood flow during hibernation. *J. Mamm.* 68(4):876-878.

Roots, C. 2006. *Hibernation*. Greenwood Press, Westport, Connecticut.

Schwartz, C. C., S. D. Miller, and A. W. Franzmann. 1987. Denning ecology of three black bear populations in Alaska. *Int. Conf. Bear Res. and Manage.* 7:281-291.

Smith, T. S., J. A. Miller, and C. Layton. 2013. An improved method of documenting activity patterns of post-emergence polar bears (*Ursus maritimus*) in Northern Alaska. *Arctic* 66(2):139-146.

Spady, T. J., D. G. Lindburg, and B. S. Durrant. 2007. Evolution of reproductive seasonality in bears. *Mammal Rev.* 37(1):21-53.

Stirling, I., D. Andriashek, P. Latour, and W. Calvert. 1975. The distribution and abundance of polar bears in the eastern Beaufort Sea. Beaufort Sea Technical Report No. 2. Beaufort Sea Project, Department of the Environment, Victoria, British Columbia.

Stirling, I., W. Calvert, and D. Andriashek. 1984. Polar bear (*Ursus maritimus*) ecology and environmental considerations in the Canadian High Arctic. In *Northern Ecology and Resource Management*, edited by R. Olson et al., 201-221. Edmonton, University of Alberta Press.

Stirling, I., and H. Cleator, eds. 1981. Polynyas in the Canadian Arctic. Occasional Paper No. 45. Ottawa, Canadian Wildlife Service.

Toien, O., J. Blake, and B. M. Barnes. 2015. Thermoregulation and energetics in hibernating black bears: Metabolic rate and the mystery of multi-day temperature cycles. *J. Comp. Physiol. B* 185:447-461.

Toien, O., J. Blake, D. M. Edgar, D. A. Graham, H. C. Heller, and B. M. Barnes. 2011. Hibernation in black bears: Independence of metabolic suppression from body temperature. *Science* 331:906-909.

Watts, P. D., and C. Jonkel. 1988. Energetic cost of winter dormancy in the grizzly bear. *J. Wildl. Manage.* 52(4):654-656.

3. April • May

Alt, G. L. 1984. Black bear cub mortality due to flooding of natal dens. *J. Wildl. Manage.* 48(4):1432-1434.

Andriashek, D., H. P. L. Kiliaan, and M. K. Taylor. 1985. Observations on foxes, *Alopex lagopus* and *Vulpes vulpes*, and wolves, *Canis lupus*, on the off-shore sea ice of northern Labrador. *Can. Field-Nat.* 99(1):86-89.

Bailey, E. P., and N. H. Faust. 1984. Distribution and abundance of marine birds breeding between Amber and Kamishak Bays, Alaska, with notes on interactions with bears. *Western Birds* 15:161-174.

Balcombe, J. 2016. *What a Fish Knows: The Inner Lives of Our Underwater Cousins*. Scientific American, New York.

Barrett-Lennard, L. G., C. O. Matkin, J. W. Durban, E. L. Saulitis, and D. Ellifrt. 2011. Predation on gray whales and prolonged feeding on submerged carcasses by transient killer whales at Unimak Island, Alaska. *Mar. Ecol. Prog. Ser.* 421: 229-241.

Belant, J. L., K. Keilland, R. H. Follman, and L. G. Layne. 2006. Interspecific resource partitioning in sympatric ursids. *Ecological Applications* 16(6):2333-2343.

Best, R. C. 1984. Digestibility of ringed seals by the polar bear. *Can. J. Zool.* 63:1033-1036.

Bidon, T., A. Janke, S. R. Fain, et al. 2014. Brown and polar bear Y chromosomes extensive male-biased gene flow within brother lineages. *Mol. Biol. Evol.* 31(6):1353-1363.

ACKNOWLEDGMENTS

ONE OF THE GREATEST REWARDS of working as a science writer is to work with fellow scientists. Over the years, I have contacted dozens of them. Unfailingly, they listened patiently to my questions, returned my telephone calls, and answered my emails. More than this, they were always gracious and unselfish in sharing their time, experience, and knowledge. I would especially like to thank Steve Amstrup, Gary Galbreath, Dave Garshelis, Joyce Gould, Alexandre Hassanin, John Hechtel, Howard Hunt, Wayne McCrory, Sy Montgomery, Don Reid, Chris Servheen, Ole Jakob Sorensen, Alasdair Veitch, and John Wooding. To all I owe a debt of gratitude.

A few among the many deserve special mention. Dr. Gary Alt, a former black bear biologist with the Pennsylvania Game Commission, discussed bears with me for hours, included me often in his field research, and gave me the confidence to write about bears. Peter Clarkson, a former wolf/grizzly biologist for the Northwest Territories, invited me into his home, loaned me his office, and took me tagging grizzlies. When I first began to work with bears, Dr. Ian Stirling, a former biologist with the Canadian Wildlife Service, was one of the first to help me understand what makes a bear tick and offered me rare opportunities to observe polar bears in the wild. More recently, I joined polar bear biologist Dr. Nick Lunn and David McGeachy in coastal Hudson Bay, where I spent several memorable autumn days. Japanese researcher Dr. Koji Yamazaki was warm and hospitable in inviting me to his study area in Nikko National Park, where we shared some wonderful hikes, and I learned a little more about the secretive world of the Asiatic black bear. In Arizona, black bear biologist Stan Cunningham introduced me to the oak thickets of his beloved state, and closer to home in Alberta, I spent an insightful day with ecologist John Paczkowski learning some of the fine details of bear marker trees. One bear biologist above all others, Dr. Andrew Derocher, deserves my heartfelt gratitude for his tireless help in this project. I have known Andy for decades. Many years ago, I worked with him in the field tagging polar bears. In recent times, he has been an endless source of scientific papers, a valued and enthusiastic technical reviewer, and an all-round fun guy to have in my corner. Our dueling poems, delivered with joyous regularity, often lifted my spirits in ways he will never know when I had labored too long at my computer. All of these respected researchers introduced me to the secret world of bears and helped me understand and appreciate these animals better.

I also owe a debt of gratitude to my longtime friend Joe Van Os of Joseph Van Os Photosafaris, who over the years hired me as a naturalist and photo leader on dozens of trips to Alaska and the Canadian and Norwegian Arctic. My field experience and photo coverage of brown bears and polar bears would be less without his faithful support.

Photographs add strength to every story, and although I took the lion's shares of images in this book, I asked a few others for their help with imagery I thought would enliven the text. Biologist Gary Alt contributed a delightful photo of a newborn black bear cub. Alberta photographer Rob Hadlow gave me a choice among his rare images of an albino American black bear cub. Indian kidney transplant surgeon Dr. Ajit Huilgol provided an exceptional image of a mother sloth bear carrying two cubs on her back. Dutch photographer Rinie van Meurs donated a unique shot of a polar bear confronting a group of walruses. Vermont

◀ In midsummer as the sea ice melts and hunting opportunities decline, polar bears purposefully reduce their activity to conserve energy

photographer Rod Vallee offered me a dramatic image of a polar bear killing an adult walrus in the Chukchi Sea. Biologist Marsha Branigan made it possible for me to include a remarkable photograph, belonging to the Northwest Territories government, of a hybrid polar bear–brown bear. Chinese researcher Dr. Ji-Huan He let me include his electron micrograph of polar bear hair. Argentinian paleontologist Dr. Leopoldo Soibelzon graciously permitted me to add his illustration of *Arctotherium*, an extinct giant bear. And finally, Norwegian researcher Dr. Eva Fulgei donated her map of an Arctic fox's record polar journey. Two others, Greek researcher Alexandros Karamanlidis and Canadian photographer Jess Cavanagh, sent wonderful photographs for me to include, but unfortunately I was unable to slot them into the book. Still, I thank them for their generous offer.

Once I had written the book, I surrendered the text to five respected individuals for technical review: black bear biologist Dr. Gary Alt; brown bear biologist Katherine Kendall; polar bear and brown bear biologist Dr. Andrew Derocher; Dutch writer, photographer, and polar naturalist Rinie van Meurs; and Alaskan physician and self-described science nerd Dr. Beth Baker. Reviewing a manuscript is an onerous and generally thankless job. To my relief, all were gentle in their criticisms and constructive in their suggestions, and I thank them for their attentive and methodical approach to the task.

This is my sixth book with the creative crew at Johns Hopkins University Press. I owe special thanks to science editor Tiffany Gasbarrini, who enthusiastically embraced the project from its beginning. I also owe thanks to editorial assistant Esther Rodriguez and managing editor Juliana McCarthy. One of the first persons to tackle my text once I had submitted it to Johns Hopkins was copyeditor Carrie Love. Her meticulous attention to punctuation, syntax, and the minutiae of well-structured prose was a marvel. I was lucky and grateful to have her help. Thank you also to designer Bea Jackson for her visual mastery, and to art director Martha Sewall and production editor Kyle Kretzer for their contributions to this collaborative effort.

As an old guy, I never underestimate my need to be strong and spry in the field to maximize photo opportunities. Thanks to Wayne Loftus, my friend and personal trainer of 11 years, I can still jump—somewhat nimbly—from helicopters, traipse across the tundra packing heavy camera gear, and trail behind field researchers half my age without collapsing in a wheezing heap.

Most of all, I am indebted to my wife, Aubrey Lang, to whom this book is dedicated. After 45 years together, she is still the most interesting and exciting person I know. She was a constant help in the field and in the office, and her unselfish enthusiasm, editing skills, and photographic eye were a continual source of strength and encouragement. I love her dearly.

PHOTO CREDITS

All of the photographs, maps, and illustrations are © Wayne Lynch except those listed below.

p. 21, Asiatic Black Bear: © Somchai Siriwanarangson / Shutterstock.com

p. 38, Newborn Black Bear Cub: © Gary Alt

p. 55, Polynya Map: © Barber & Masson 2007. In Meltofte, H., ed. 2013. *Arctic Biodiversity Assessment: Status and Trends in Arctic Biodiversity.* Conservation of Arctic Flora and Fauna, Akureyri.

p. 74 Polar-Brown Bear Hybrid: © GNWT / Jodie Pongracz

p. 86, Male Polar Bear Killing an Adult Walrus: © Rod Vallee

p. 90, Map Insert of Arctic Fox's Record Journey: © Eva Fulgei, Polar Research 2019

p. 121, Mother Brown Bear and Twin Cubs in Finnish Taiga: © ArCaLu/Shutterstock.com

pp. 160–161, Polar Bear and Defensive Walrus: © Rinie van Meurs

p. 183, Insert of Army Cutworm Moth: © Robert Webster / xpda.com / Wikimedia Commons Creative Commons Attribution–Share Alike license

pp. 210–211, Asiatic Black Bear in Tree Nest: © vanchai/Shutterstock.com

p. 213, American Black Bear Eating Soapberries: © BGSmith/Shutterstock.com

p. 227, Albino Black Bear Cub: © Rob Hadlow

p. 257, European Brown Bear in Finnish Forest: © ArCaLu/Shutterstock.com

p. 272, Insert of Polar Bear Hair: © Ji-Huan He, *Thermal Science* 2015

p. 282, Myanmar Sun Bear Farm: © Dan Bennett / Wikimedia Commons Creative Commons Attribution license

p. 290, Insert of Arctotherium Illustration: © Leopoldo Soibelzon, *Journal of Paleontology* 85(1) 2011

p. 295, Insert of Chinese Mountain Ranges: © Fauna & Flora International, *Oryx* 43(2)176–178 2009, Cambridge University Press

p. 302, Sloth Bear Digging for Termites: © PhotocechCZ / Shutterstock.com

p. 303, Sloth Bear Mother and Twin Cubs: © Dr. Ajit Huilgol

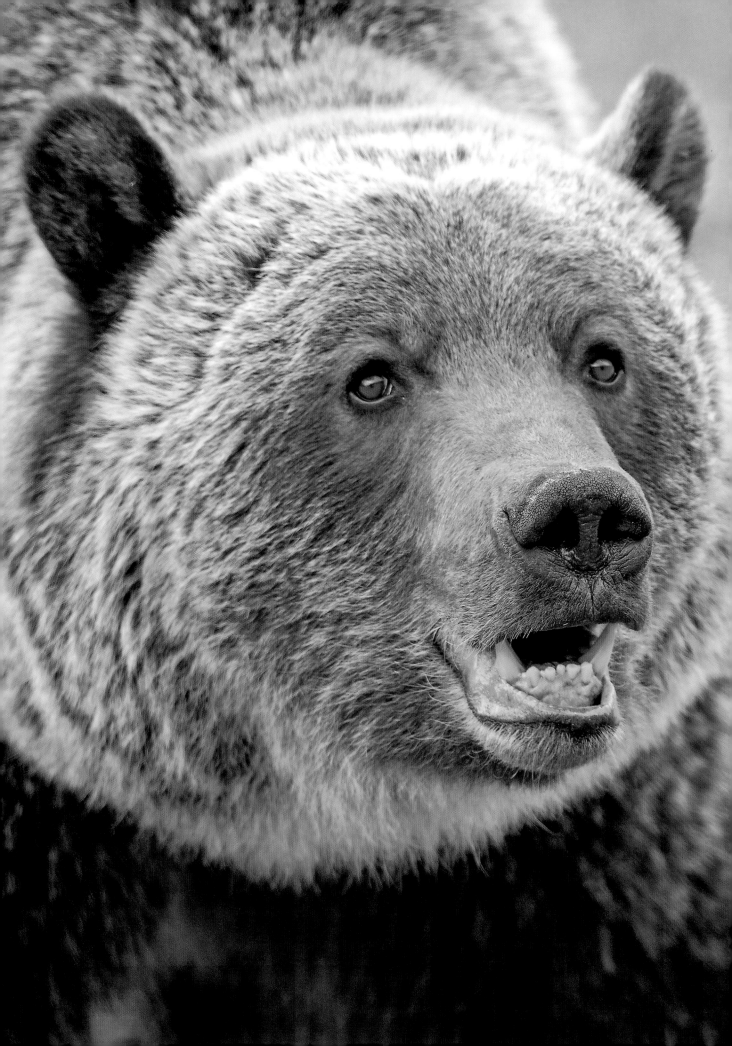

Page numbers in **boldface** indicate photographs or illustrations.

◀ The canine teeth of an adult brown bear can be more than an inch (2.5 cm) long

TRAFFIC, 280
tree nests, 20, 208, **209**,
210–211, 289, 292

United States, 14, 18, 23.
 See also Alaska; Florida;
 Minnesota; Montana;
 North Carolina;
 Pennsylvania; Tennessee;
 Utah; Washington State;
 Wyoming
urination, 189
Ursidae, 5; general description
 of, 5
Utah, 128, 138

vagina, 110
Virginia opossum, 42
vision, 172, 269–270
vocalizations, 186, 188, 298,
 302

walking hibernation, 157. *See
 also* hibernation
wallows, 200
walrus, **2**, **58**, **59**, 85; baculum,
 110; breaking ice, 59;
 habitat, 57; as prey, 85, **86**,
 160–161, 162, 166; threat
 display by, 162
Wapusk National Park, **304**
Washington State, 65, 89, 103,
 105, 137, 168, 248, 252
weight: America black bears,
 26, 204, 245; Andean
 bears, 288; Asiatic black

bears, 19; brown bears,
 16–17, 245; cubs, 123; after
 den emergence, 89; gain,
 220–221; giant panda, 295;
 loss in hibernation, 35,
 48–49, 89; polar bears, 9,
 13, 151, 245; sloth bears,
 301; sun bears, 292; after
 swimming, 164
whitebark pine, 209, **212**, 212,
 215, 284
white suckers, 97
white-tailed deer, 92, 138, **139**,
 141, 193, 207, 228
white whale. *See* beluga
wildebeest, 4
winter sleep. *See* hibernation
wolverine, 89, 98, 142
wolves, 26, 89, 98, 112,
 140, 166, 186, 228, 236;
 predation on bears, 47, 129,
 252, **260**, 261–262, 285
wounds, 46, 87, 108, 133, 142,
 183, 229, 236, 259, 262
Wrangel Island, 14, 49, 162,
 166, 264, 265, 268
Wyoming, 127, 141

Yellowstone National Park, 14,
 71, 95, 98, 112, 135, 139,
 193, 212, 247, 284
Yukon, 14, 64, **120**, 121, 205,
 216

zooplankton, 53, 278